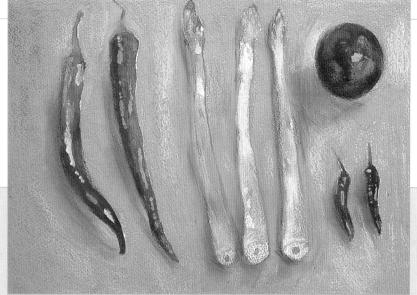

the second second

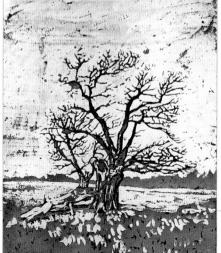

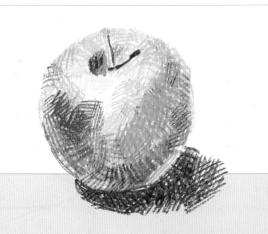

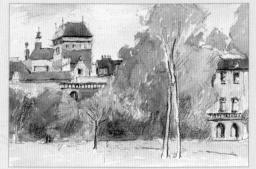

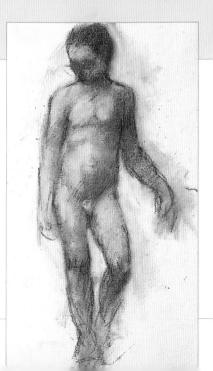

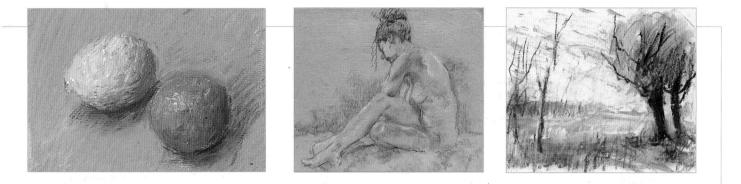

The Encyclopedia of **DRAWING TECHNIQUES**

Hazel Harrison

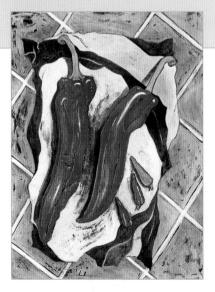

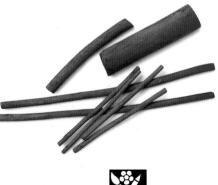

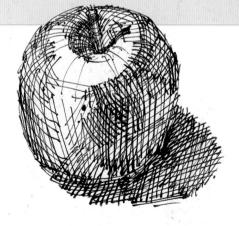

A QUARTO BOOK

Published in 2004 by Search Press Ltd Wellwood North Farm Road Tunbridge Wells Kent TN2 3DR United Kingdom

Reprinted 2005

Copyright © 2004 Quarto plc

ISBN 1-84448-019-4

This book may not be reproduced in whole or in part, in any form or by any means, electronic or mechanical, including photocopying, recording, or by any information storage and retrieval system now known or hereafter invented without prior permission from the copyright holder.

A catalogue record for this book is available from the British Library.

Conceived, designed and produced by Quarto Publishing plc The Old Brewery 6 Blundell Street London N7 9BH

QUAR.EDRT

Project editor: Paula McMahon Senior art editor: Sally Bond Copy editor: Sue Viccars Designers: Tanya Devonshire-Jones, Sally Bond, Michelle Stamp Photographers: Colin Bowling, Paul Forrester Picture reasearcher: Claudia Tate Proofreader: Jenny Siklós Indexer: Pamela Ellis

Art director: Moira Clinch Publisher: Piers Spence

Manufactured by Pica Digital Pte, Singapore Printed by SNP Leefung Printers Limited, China

CONTENTS

INTRODUCTION

BASIC TECHNIQUES AND MATERIALS

- 8 Drawing methods
- 10 Building up colour
- 12 Choosing the right paper

CHAPTER 1

6

14 MONOCHROME MEDIA

PENCILS AND GRAPHITE

- 16 Drawing with pencils
- 17 Holding pencils
- 18 Combining grades

CHARCOAL

- 20 Linear drawing
- 22 Tonal drawing
- 23 Lifting out

CONTE

- 24 Crayons and pencils
- 26 Working on toned paper

PEN AND INK

- 28 Drawing implements
- 30 Line and tone

BRUSH AND INK

- 32 Drawing with a brush
- 34 Blot drawing

WHITE ON BLACK

36 Scraperboard

CHAPTER 2

38 COLOUR MEDIA

PASTELS

- 40 Drawing with pastels
- 42 Blending and colour mixing
- 44 Paper colour
- 46 Vignetting
- 48 Paper texture
- 50 Making corrections
- 52 Wet brushing

OIL PASTELS

- 54 Using oil pastels
- 55 Overlaying colours
- 56 Blending with spirit
- 58 Sgraffito

COLOURED PENCILS

- 60 Pencil choices62 Building up colours and
 - tones
- 64 Paper choices
- 65 Transparent surfaces
- 66 Blending
- 67 Burnishing
- 68 Scratching back
- 69 Squaring up
- 70 Frottage
- 72 Impressing
- 74 Water-soluble pencils
- 75 Line and wash

COLOURED INKS

- 76 Inks and markers
- 78 Overlaying colours

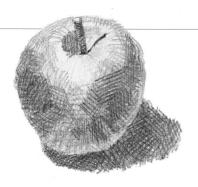

CHAPTER **3**

80 MIXED MEDIA

LINE AND WASH

- 82 Pen and wash
- 84 Pencil and watercolour
- 86 Watercolour and coloured pencils
- 88 Watercolour and pastel

RESIST TECHNIQUES

- 90 Masking fluid
- 91 Masking tape
- 92 Wax/oil resist
- 94 Oil pastel and ink

UNUSUAL TECHNIQUES

- 96 Wash-off
- 98 Ink and bleach
- 99 Conté and oil bar

COLLAGE

- 100 Drawing over paper shapes
- 102 Drawing with torn paper

HOME PRINTMAKING

- 104 Handmade monoprints
- 106 Colour monoprints

CHAPTER 4

108 DIGITAL DRAWING

THE BASICS

- 110 Tools and materials
- 112 Drawing and painting media

BEYOND THE BASICS

- 114 Filters and effects
- 116 Layers and selections
- 118 Working with photographs

CHAPTER 5

122 THEMES

BASIC SKILLS

- 124 Composition
- 126 Keeping a sketchbook
- 128 Choosing the medium

THE HUMAN FIGURE

- 130 Weight and balance
- 132 Seated and reclining figures
- 134 Clothed figures
- 136 Portrait studies

LANDSCAPE AND URBAN THEMES

- 138 Composing a landscape
- 140 Trees
- 142 Landscape details
- 144 Buildings

STILL LIFE AND INTERIORS

- 146 Still life set-ups
- 148 Interiors as still life
- 150 Floral still life

NATURE

- 152 Plants and flowers
- 154 Animals and birds

156	INDEX

160 CREDITS

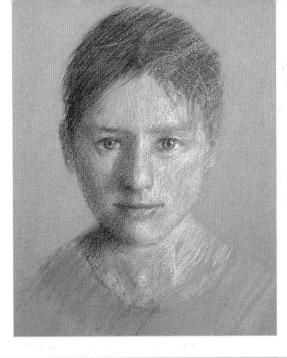

Pastel portrait using the vignetting technique, see pages 46–47 for the demonstration.

Coloured-pencil drawing, see pages 62–63 for the demonstration. Technical expertise and a thorough knowledge of techniques cannot on their own produce great works of art; they must always be the handmaiden of personal vision. But vision itself is not always enough either – you may know what you want to say in your drawings, but find yourself frustrated because you have not yet found a visual language that enables you to say it. Experimenting with different techniques can thus have a liberating effect, helping you to see things in new ways and to explore various pictorial possibilities. If your drawings have previously been restricted to pencil sketches, for example, you may find that a broader medium or a more experimental mixed-media method changes your approach and gives you a better opportunity for self-expression.

INTRODUCTION

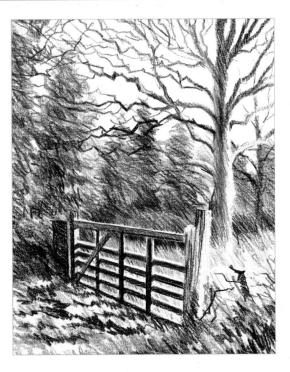

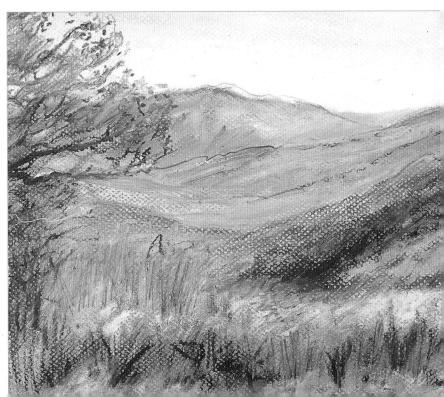

Soft pastels used in conjuntion with pastel pencils, see pages 42–43 for the demonstration. Ink-blot drawing, see pages 34–35 for the demonstration.

Scratching into oil pastel, see pages 58–59 for the demonstration. The Encyclopedia of Drawing Techniques provides a wealth of ideas to stimulate you and extend your approach to drawing. It is divided into four main sections: Monochrome media, Colour media, Mixed media and Digital drawing, with the techniques associated with a particular medium grouped together for easy reference. Each technique is illustrated with step-by-step demonstrations by professional artists, and the book concludes with a Themes section – a gallery of finished drawings showing a variety of different methods and interpretations of a range of subjects.

If possible, try out as many of the techniques as you can, or start by flipping through the pages to find the ones that most appeal to you. There is something for everyone here, allowing you either to extend your repertoire or simply to brush up on a particular drawing method. But never forget that it is your own vision that will mark out your drawings as something special and individual, so treat the

> demonstrations and other images as a springboard rather than trying to recreate them. Although copying is acceptable as a learning method, you will only move into the realm of true picturemaking by developing your own way of doing things – and it is a great deal more satisfying. Producing good art is a continual process of pushing out the boundaries, and hopefully this book will help you on your way.

DRAWING METHODS

The techniques associated with a particular medium are dealt with in their own sections in the main part of the book, but on these and the following two pages, we look at methods that are common to most of the drawing media, such as the use of line and various methods of building up tone.

The most obvious way to express light, shade and form in a drawing is by using shading methods, grading tones from light to dark. You can shade simply by moving the point of the pencil or pen evenly back and forth across the paper, gradually building up to areas of solid tone; you can make looser, more scribbled lines; or you can use hatching and/or crosshatching methods. Hatching involves making a series of semi-parallel lines going in the same direction. In crosshatching, another series of lines is made over the first in the opposite direction. Hatching lines need not be too regular and mechanical – they can be used quite freely, and can help to describe texture as well as form.

Form can also be expressed through line alone, by varying the strength and thickness of the lines so that you 'lose' some of the edges and 'find' others. This is a somewhat trickier method than shading, but it repays practice, as it not only improves your drawing, but also sharpens up your observational skills.

HELPFUL ADVICE

When using either hatching or crosshatching techniques, you will find that the closer the lines are, the darker the tone will be.

Graphite pencils

Ballpoint pens

By shading with medium or soft graphite pencils, a range of tones can be achieved quickly. Charcoal is equally useful for tonal drawing, as it can be smudged and blended with a finger.

Scribbled shading with a ballpoint pen gives an energetic, linear effect.

DRAWING METHODS 9

The classic method of diagonal hatching has been used in this pen-and-ink drawing made with a fine, fibre-tipped pen. The tones here have been built up by hatching and crosshatching, with the lines following various directions. Again, a fine, fibre-tipped pen has been used.

GARY MICHAEL & SEDHU In this powerful charcoal drawing on toned paper, the charcoal has been blended in places, and highlights have been added in white chalk.

A dip pen has been used here, with lines roughly following the forms. Dip pens are not the best implements for tonal drawing, as they require frequent recharging. Dip pens are ideal for linear drawing, as lines can be varied from thin to thick to thin. Notice how the form is suggested by the thicker lines on the side of the fruit.

FURTHER INFORMATION

⇒ PENCILS AND GRAPHITE: COMBINING GRADES 18

⇒PEN AND INK: DRAWING IMPLEMENTS 28

⇒PEN AND INK: LINE AND TONE 30

BUILDING UP COLOUR

Depth of colour can be built up in exactly the same way as depth of tone in monochrome drawing – by shading, hatching and crosshatching. These techniques are especially associated with coloured pencil, as this is essentially a line medium, unlike pastel, which allows colours to be spread in a paintlike manner.

To deepen the tone of a colour, you can simply add further layers of the same one, increasing the pressure on the pencil, or you can work over it with a darker shade of pencil. By laying one colour over another, you can do much more than build up tone - colours can be mixed and amended on the paper surface. To take an obvious example, green can be achieved by laying blue over yellow, and this can be built up or altered again by laying other colours on top. If the strokes are kept relatively light, one colour will show through another while still 'reading' as one area of colour. This is known as optical mixing, and was much used by the Impressionists in their oil paintings.

Similar methods can be used for pastel pencils, oil pastels or soft pastels.

COLOURED PENCILS

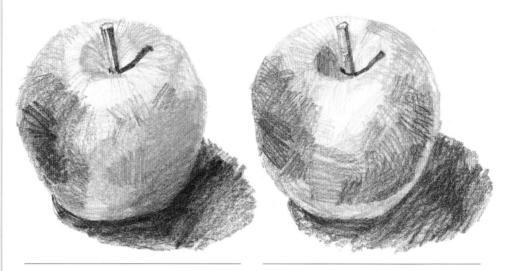

Depth of tone has been created simply by increasing the pressure on the pencil for the darker areas. Here, tone has been built up by laying darker shades over lighter ones, with black also brought in on the side of the apple.

HELPFUL ADVICE

When using soft pastels, you can exploit their soft, powdery nature and mix colours by rubbing them together with your finger or a rag.

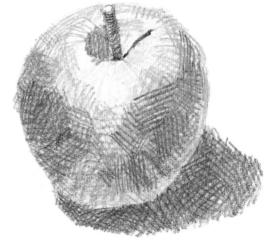

This lively drawing exploits the principle of optical mixing, with loose crosshatching that does not obscure the underlying colours.

PASTELS

In this pastel pencil drawing, areas of solid colour are contrasted with light hatching that allows the underlying colour to show through. This drawing is in soft pastel. The colours have been laid on as blocks and then rubbed into the paper to create a soft effect.

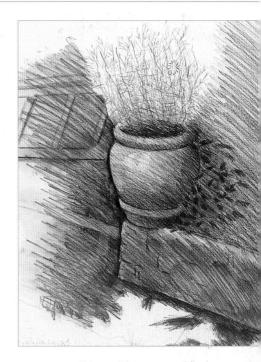

SARA HAYWARD ♦ PLANT POT The direction of the strokes has a bearing on composition as well as on form-building, and in this coloured-pencil study, diagonal hatching has been used to contrast with the verticals and horizontals.

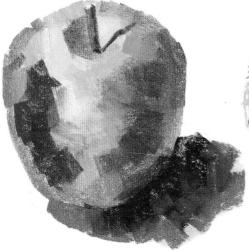

Short strokes have been made with broken sticks of soft pastel and left unblended. Quite heavy pressure has been used to achieve the darker colours.

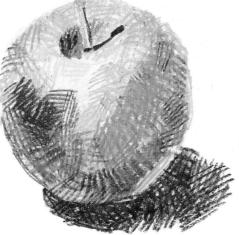

For this oil pastel drawing, the artist has used the same optical-mixing method as in the colouredpencil example on the opposite page.

FURTHER INFORMATION

⇔PASTELS: BLENDING AND COLOUR MIXING 42

⇒OIL PASTELS: OVERLAYING COLOURS 54 ⇒COLOURED PENCILS: BUILDING UP 62

CHOOSING THE RIGHT PAPER

A wide range of surfaces for drawing is available, though the most often used is white drawing paper. This has a smooth surface and is suitable for most drawing media with the exception of pastel, which requires a 'tooth', or texture to hold the soft, chalky pigment in place. But artists often choose a textured surface for other media, for example, coloured pencils or charcoal, as the paper grain breaks up the strokes or areas of tone to produce an attractive broken effect that can add extra interest to drawings. A more practical advantage of textured paper, especially for colour work, is that it allows you to lay on more layers of colour. If you work on too smooth a surface and with too much pressure, the paper can quickly become clogged, resisting further applications of colour. With watercolour or pastel paper, it is more or less impossible to fill the grain of the paper fully, so that the surface will remain workable for several subsequent layers.

In some cases, the colour of the paper is also an important consideration. Pastel papers, which can also be used for coloured-pencil work, are produced in a range of colours from neutral browns and greys to vivid hues. By choosing a paper that contrasts with the dominant colour in the drawing, you can exploit interactions of opposites, while a paper that blends with the main colour allows you to leave areas of the surface uncovered.

If you are using any of the techniques that incorporate a fluid medium, such as watercolour or ink and wash, you may need to stretch the paper to prevent it from buckling. Wet the paper, then place it on a drawing board and stick gumstrip tape around each edge.

HELPFUL ADVICE

Stretching paper is quite easy, but does take some time to dry, so remember to do it several hours in advance.

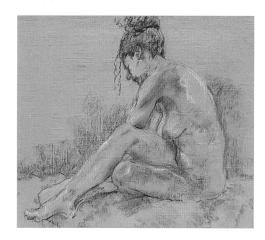

LORNA MARSH NUDE STUDY The paper colour has given a warm glow to this pastel drawing as well as serving a purely practical purpose. Because it suggests flesh colour, the artist has been able to limit her use of applied colour, suggesting the figure very lightly with line and areas of subtle tone.

Specialist pastel papers: pastel artist's sandpaper, velour paper and pastel board

Ingres and Mi-teintes papers for pastel

STRETCHING PAPER

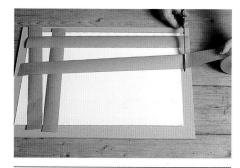

1 Cut the tape into the correct length before wetting either it or the paper.

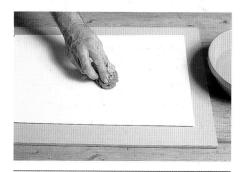

2 Wet the paper on both sides with a sponge (or soak it briefly in a basin or bath).

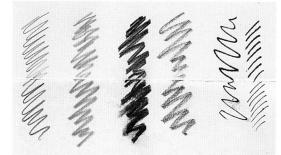

Marks made on smooth paper with the following (from left). 3B pencil, coloured pencil, willow charcoal, charcoal pencil, pen and ink. Those at the top are drawn on a slightly shiny surface, and those at the bottom on standard drawing paper.

3 Wet the sticky side of the tape, then turn it over and stick it all around the edges of the paper, smoothing it with the sponge. Leave to dry naturally.

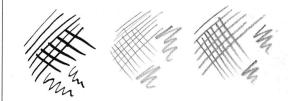

Marks made (from left) with pen and ink, graphite pencil and coloured pencil on smooth drawing paper

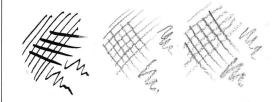

Marks made (from left) with pen and ink, graphite pencil, and coloured pencil on textured watercolour paper

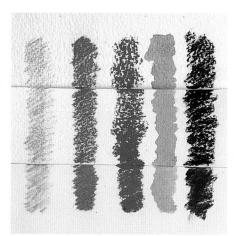

Marks made with coloured pencil, pastel pencil, oil pastel, coloured ink and charcoal stick on three different papers. From top: rough watercolour paper, medium (CP) watercolour paper, smooth (HP) watercolour paper.

Soft pastel and pastel pencil marks onto different tones of Ingres and Mi-teintes pastel papers.

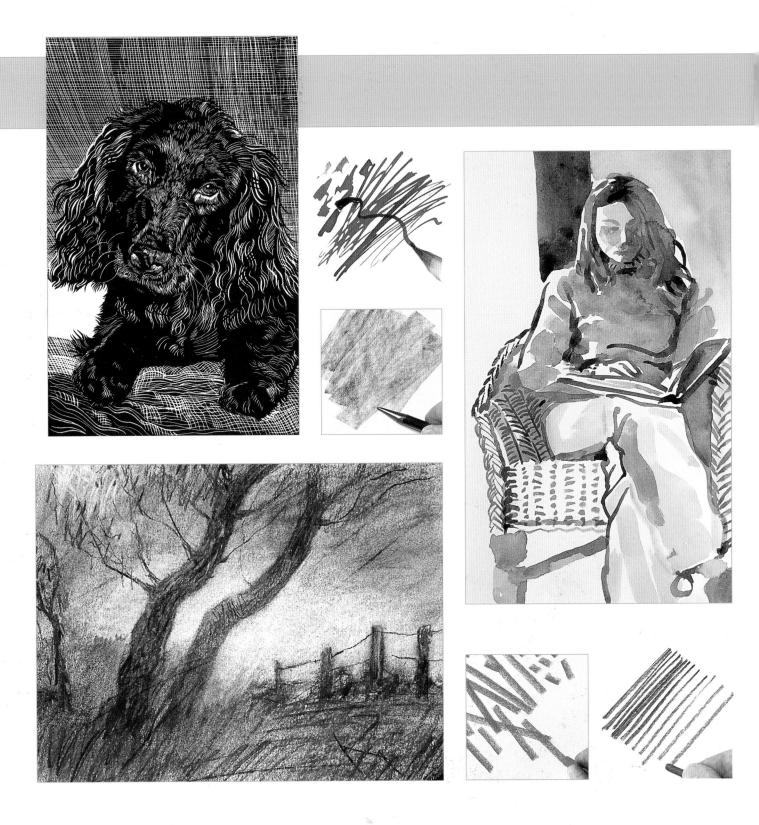

MONOCHROME MEDIA

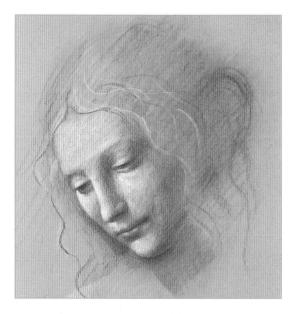

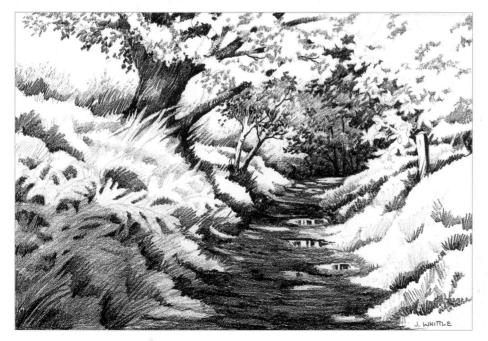

CHAPTER 1

This section introduces the wide ranges of techniques associated with the basic drawing implements, from pencils and charcoal to pens and inks. Many of the methods shown, such as those for building up depth and tone, can be adapted to colour work, but drawing skills are built up gradually. Starting with monochrome drawings will give you a good grounding in the two vital aspects of the artist's craft – analysing and rendering tone, and learning how to use line effectively.

INCLUDES

⇔PENCILS AND GRA	PHITE: Drawing with pencils 16 Holding pencils 17 Combining grades 18
⇔CHARCOAL:	Linear drawing 20 Tonal drawing 22 Lifting out 23
⇔CONTE:	Crayons and pencils 24 Working on toned paper 26
⇒PEN AND INK:	Drawing implements 28 Line and tone 30
⇒BRUSH AND INK:	Drawing with a brush 32 Blot drawing 34
⇒WHITE ON BLACK:	Scraperboard 36

PENCILS AND GRAPHITE Drawing with pencils

When modern lead pencils first became available in the late seventeenth century, they were greeted with ecstasy by artists all over the world, and changed hands for large sums of money. It is easy to see why, as graphite pencils are possibly the most versatile of all the drawing media, capable of almost endless variations of line as well as areas of solid tone, built up by shading.

Pencils are made in a range of grades from hard (4H to H) to soft (HB to 9B). The hard ones are mainly used by draftsmen, and are of limited value to artists, as they produce very faint, sharp lines. HB and B pencils, which are the hardest in the soft range, lend themselves well to hatching and crosshatching methods, as they produce clear, clean lines and smudge less easily than the very soft pencils, but the latter are ideal for building up areas of solid tone from dark grey to near-black.

The standard drawing pencils are encased in wood, but graphite can also be bought as a thick stick without the outer covering. Graphite sticks, which are also produced in different grades, are ideal for drawings that rely more on tone than line. You can cover large areas very rapidly by using the side of the stick, breaking it into two or three pieces if necessary.

Crosshatching with pencil

Side strokes with graphite stick

Point and side strokes with graphite stick on drawing paper

HELPFUL ADVICE

Although graphite can be used on any drawing paper, try working on a textured surface such as pastel paper, which can produce interesting effects.

Short strokes, stipple and scribble marks with pencil

Graphite stick on heavily textured paper

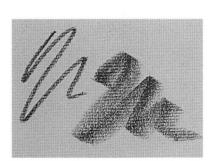

Point and side strokes with graphite stick on pastel paper

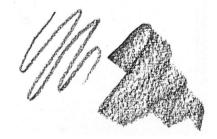

Point and side strokes with graphite stick on textured watercolour paper

Different types of graphite stick

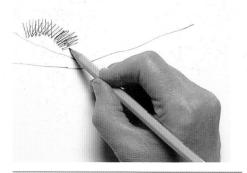

The standard grip, with the pencil held in the same way as for writing, gives the greatest degree of control.

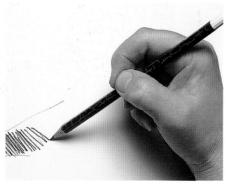

Holding it higher up the shaft encourages you to work more loosely.

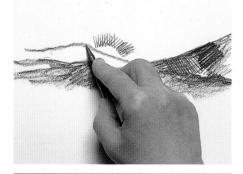

Holding the pencil with your forefinger over the shaft allows firmer pressure.

under State and the State of States

Another underhand grip, which confines the movement of the pencil tip so that the whole hand must be used to make marks.

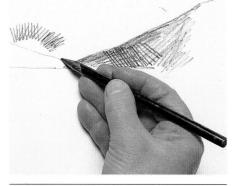

In this underhand grip, the pencil is held between the thumb and two forefingers.

Holding pencils

Because writing and drawing are allied activities, most of us find it natural to hold the pencil in the same way as we do a pen, gripping it near the lead and holding it firmly between the thumb and the first two fingers. This grip gives the maximum degree of control, and is ideal for detailed work and precise hatching and crosshatching, but can lead to tight and rather inexpressive drawings.

It is worth experimenting with different methods for both graphite and coloured-pencil work. For example, holding the pencil loosely near the end enables you to make more gestural marks. This is most successful when you are standing at an easel and drawing more or less at arm's length. To produce dense shading or a strong line, try placing your forefinger over the shaft and pushing the lead down onto the paper. Another variation, which is useful for both shading and heavy line, is the underhand grip, where the pencil is held in the palm of the hand and you press down with your thumb and make small movements with the whole hand.

⇒BASIC TECHNIQUES: DRAWING METHODS 8

⇒COLOURED PENCILS: BUILDING UP 62

PENCILS AND GRAPHITE Combining grades

Graphite pencils vary from very hard to very soft, and you can build up a range of tones in a drawing by exploiting these physical differences. A range of tones can be achieved by using one pencil – for example a 2B or 3B, but this involves altering the pressure as you work from light to dark, and there is always a danger of making the lights darker than they should be, and failing to achieve solid blacks or near-blacks in the darkest areas.

This method is mainly used for finished pencil drawings rather than for quick studies or underdrawings, but it is also useful for making thumbnail sketches to plan the tonal structure of a painting or coloured drawing. It is important to establish the main balance of tones from the outset, and to decide whether some areas are to be left white. You can amend tones as you work, erasing in the light areas and overworking with a softer pencil in the darker ones, but beware of too much erasing, as this may compromise the quality of the line and blur important edges.

The range of pencils you choose will depend on the subject and how you wish to interpret it, but, in general, you should start with a fairly hard pencil such as an HB, working up gradually to a 6B or even 9B. It is advisable to start at the top and work downwards, to avoid smudging.

HELPFUL ADVICE

If you need to make alterations to the top of the drawing after the bottom has been worked, rest your hand on a piece of clean paper – soft pencil smudges very easily.

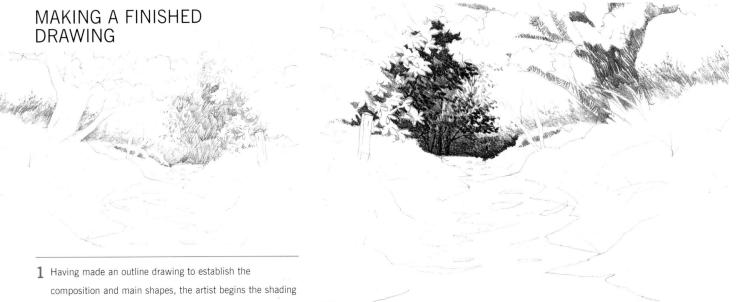

- Having made an outline drawing to establish the composition and main shapes, the artist begins the shading with an HB pencil, making directional strokes to describe the foliage and grasses. To avoid smudging, she works from left to right (reverse this if you are left-handed). The tree on the right is to be left mainly white, so she draws only the outlines of the leaves and shades around them.
- 2 She now switches to a 3B pencil and lightly shades the large tree trunk, leaving the foliage clumps white. The dark tones in the background are built up with a 4B pencil and slightly heavier pressure, with small, squiggly marks used to describe the foliage.

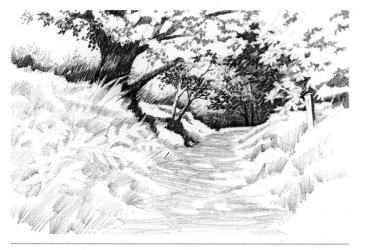

3 The first tone on the foreground is laid with the HB pencil, shading around the fern shapes, foliage clumps and puddles in the lane. The background trees are then darkened with pencils ranging from 5B to 9B.

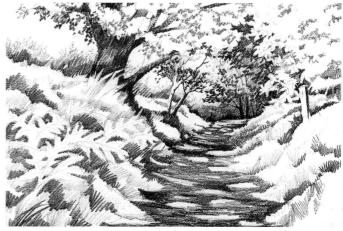

4 The tones now need to be balanced by bringing some more darks into the foreground. A 3B pencil is used to strengthen the shadows across the lane and the mid-toned areas around the ferns and foliage clumps.

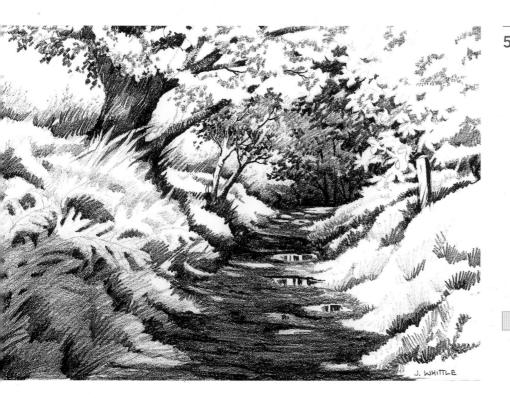

5 In the final stages, the 9B pencil is used to make some tonal adjustments, notably darkening the area at the end of the lane, strengthening the main shadow, and taking it up the right bank to link both sides of the lane. To create the puddles, small linear reflections are drawn in a few of the white patches on the right of the lane, and the others are worked over to avoid a jumpy effect.

FURTHER INFORMATION

⇒PENCILS AND GRAPHITE: HOLDING PENCILS 17 ⇒COLOURED PENCILS: PENCIL CHOICES 60

CHARCOAL Linear drawing

Charcoal, which is simply charred wood, is one of the oldest of all the drawing media, and has retained its popularity throughout the centuries. It is usually made of willow, but sometimes of vine, and is sold as sticks in various thicknesses and degrees of softness. It is a very 'forgiving' medium, as its soft, smudgy nature makes it easy to erase mistakes just by dusting down the paper. It is often recommended to beginners in life-drawing classes. Nowadays, it is probably most often used for tonal drawings, or combinations of line and tone, but it is equally suitable for more linear approaches. Drawings can be built up in the same way as pencil drawings by methods such as hatching, crosshatching and open shading – in the past, this was the usual way of working. For this type of drawing, thin sticks of willow charcoal are the best choice, or you can try charcoal pencils, which are thin sticks of compressed charcoal encased in wood. These are harder than the normal sticks, and have the advantage of keeping your hands – and the paper – clean as you work. One disadvantage of using a charcoal pencil is that it is less easy to dust off, as it is made from powdered charcoal with a binding medium.

Smooth papers are best for compressed charcoal, but for the willow sticks, a textured surface is a better choice. Pastel paper, for example, has sufficient 'bite' to retain the powdery substance while still making erasure possible, and the grain of the paper breaks up the strokes slightly to give extra interest to your drawing.

Stick charcoal

Compressed charcoal sticks

Hatching with thin charcoal stick

Crosshatching with thin charcoal stick

Side strokes with charcoal stick

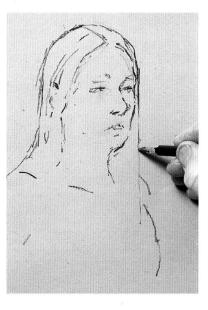

USING CHARCOAL PENCILS

1 The artist has begun by sketching in the head and features, and now draws a strong vertical to indicate the fall of the heavy, straight hair. He is working on coloured and textured paper, which holds the charcoal firmly and also allows him to add white highlights in the final stages.

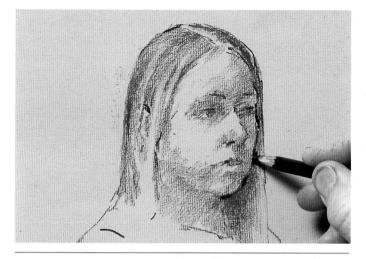

2 Tones are built up by light shading, using directional strokes that follow the forms. Notice that the paper creates its own linear pattern, adding extra interest to the drawing.

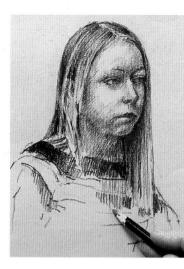

4 After drawing the hair more strongly, and darkening the shadow beside the face, the pattern on the clothing is delineated with a combination of vertical and diagonal strokes.

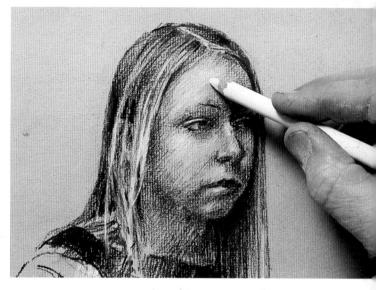

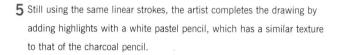

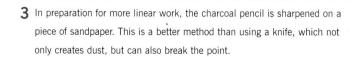

FURTHER INFORMATION

⇒ BASIC TECHNIQUES: CHOOSING THE RIGHT PAPER 12

⇒ PASTELS: PAPER TEXTURE 48

CHARCOAL Tonal drawing

When we look at any subject, we tend to define it in terms of outline rather than form, but although the outline is an important means of establishing the shape, the areas of light and shade play the major role in explaining the three-dimensional quality. Charcoal is the perfect medium for drawing in tone, as sticks can be broken and used on their sides to cover large areas, and soft blends can be created simply by rubbing with a finger. Thick sticks of compressed charcoal are the best choice for tonal drawing, as the thin willow sticks tend to break under the pressure required to build up dark tones. When the charcoal has been built up heavily, it becomes difficult and messy - to brush off, but unwanted areas of tone can be removed or lightened by using a kneadable eraser.

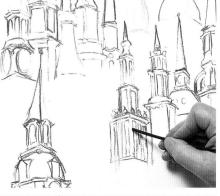

BUILDING DEPTH OF TONE

1 As the subject is a fairly complex one, the artist begins with an outline drawing, using a thin stick of willow charcoal.

2 He then switches to a thick stick and blocks in the mid-toned areas, using a variety of different strokes.

3 Rubbing with a finger works the charcoal into the paper to achieve a range of greys which can be darkened by the addition of more charcoal.

4 The tones and details were gradually built up with both thick and thin charcoal sticks. Care was taken to keep the highlights white or nearwhite, as the impact of the drawing stems from the strong contrasts.

Using a torchon to blend

Lifting out

The type of eraser mentioned on the opposite page is an essential piece of equipment of charcoal work, and not only for erasing. By pulling it to a point you can produce an implement that enables you to draw white lines into a dark area. This is very useful for creating or restating highlights, but you can also work a whole drawing light into dark, using a well-known charcoal technique known as lifting out.

To do this, first cover the whole of the

paper with a layer of charcoal, using the side of a thick stick, and aiming for a dark grey rather than solid black. Work on good-quality, smooth paper, and don't use compressed charcoal, as this is more difficult to remove.

Make an outline of the subject with a thinner stick, and then begin to 'draw' into the grey with the putty eraser, looking for the way the light is falling and picking out the main highlights with the eraser. You will find that you can make quite fine lines, as the point can be used almost as precisely as a pencil. For larger areas of mid-tone, use the flat of the eraser and less pressure. If you make a mistake or wish to darken an area, simply add more charcoal. This method is not only enjoyable, but is also a useful discipline, as it teaches you to analyse tone and see how it defines the forms.

Kneadable eraser

PULLING OUT THE HIGHLIGHTS

1 Having covered the whole of the paper with a large stick of charcoal, the artist begins to establish the placing of the ground line and the two trees. Using a chamois leather as an alternative to a kneadable eraser, he lifts out some of the charcoal between and around the trees.

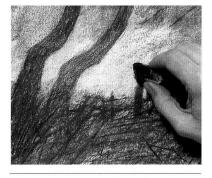

3 To provide a stronger tonal contrast, a kneadable eraser is used to remove more of the charcoal from the sky area behind the trees.

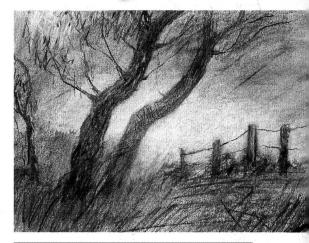

4 After adding further linear detail to the foreground and trees, the finished drawing was masked with tape to define the edges, thus giving it additional impact.

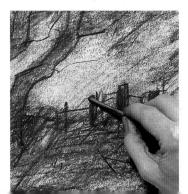

2 More detail is added with a smaller stick of charcoal, held near the end to give a loose line.

FURTHER INFORMATION

⇒BASIC TECHNIQUES: CHOOSING THE RIGHT PAPER 12 ⇒PASTELS: PAPER TEXTURE 48

CONTE Crayons and pencils

Conté crayons and pencils take their name from Nicolas-Jacques Conté, a French scientist who developed them in the eighteenth century (he was also involved in the manufacture of graphite pencils in France). Conté crayons are made from a mixture of graphite and clay held together with a binder, and the clay produces the traditional colours of brown, sanguine (redbrown), black and white. Conté sticks are square-sectioned, as are many pastels nowadays, which gives rise to some confusion between the two media. However, the crayons, which are slightly harder than soft pastels, are still sold under the original name and in the same range of four colours. There is also a pencil version, with a thinner stick of the clay and graphite encased in wood.

Conté is an attractive and versatile medium, allowing for both line and tone work. The pencils are ideal for outlines or linear shading methods such as hatching and crosshatching. You can also achieve fine lines with the sticks, either by drawing with the corner or by sharpening the stick on a piece of sandpaper. Broad areas of tone can be laid on with the side of the stick, which can be broken into shorter lengths if desired.

Like charcoal, conté crayons and pencils pick up the surface grain of the paper. Artists often choose pastel or watercolour paper to exploit the texture, but they can be used equally well on smooth paper. The only disadvantage of conté crayons and pencils is that they are less easy to erase than charcoal or graphite pencils, but it is possible to correct errors to some extent with a kneadable eraser.

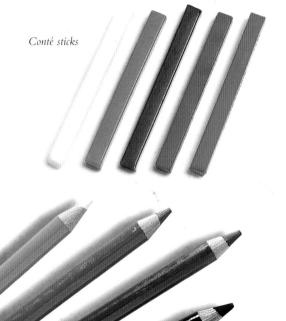

Conté pencils

Scribbling and hatching with a sharpened conté stick

Varying line strokes with a sharpened conté stick

Marks made with an unsharpened conté stick

Side strokes on smooth paper

Side strokes on textured paper

BUILDING UP TONES

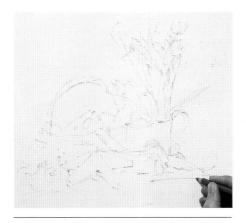

 Using a sanguine conté pencil, the artist begins with an outline drawing to establish the main shapes. He keeps the lines very light, as conté is not easy to erase.

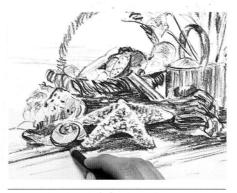

3 To give more depth of tone, he now switches to a brown pencil, using loose hatching and crosshatching strokes. Notice how the hatching lines on the basket and watering can go around the forms, a method sometimes called 'bracelet shading'.

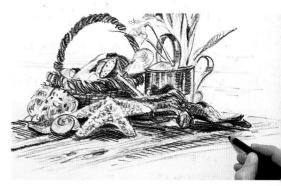

4 The shadows are now brought out with black conté pencil, using a heavier pressure.

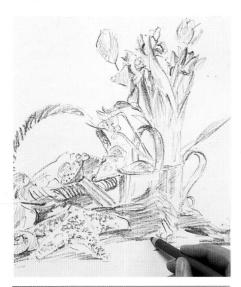

2 With the same pencil, he draws the first tone, taking care not to draw over areas that are to remain light.

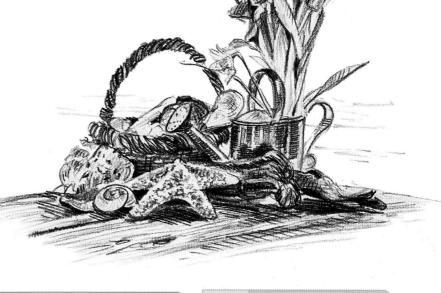

5 After some final adjustments – notably strengthening the shadows between the leaves and beneath the starfish and snail shell – the drawing is complete.

FURTHER INFORMATION

⇒CHARCOAL: LIFTING OUT 23

⇒ BASIC TECHNIQUES: CHOOSING THE RIGHT PAPER 12

⇒ PASTELS: PAPER COLOUR 44

CONTE Working on toned paper

A traditional way of working with conté crayons or pencils is to draw on coloured paper with white and sanguine conté. The paper stands as the middle tone, so that you are effectively working with three colours. This technique, known as 'à trois couleurs' (with three colours) is an excellent means of modelling form, and was frequently used by the Old Masters for nude studies.

For white and sanguine conté drawings, a cream or beige paper is the usual choice, but

the method can be adapted to different colours. You might, for example, use black and white crayon on a grey or mid-blue paper, or decide to use all four of the conté colours.

The advantage of using toned paper is that you can physically draw the highlights rather than reserving them as white, as in a normal monochrome drawing. In the Old Master drawings, the highlights were usually picked out last in white, but you can start with white if the subject presents dominant highlights or light areas, working gradually down to the dark tones, and leaving the paper uncovered for the middle tones. Any shading methods can be used, but be careful not to cover the paper too densely in the early stages or it will become clogged and unworkable.

HELPFUL ADVICE

Remember that using two or more conté colours is essentially a monochrome technique; the colours are used for their tonal value rather than to represent actual colours.

MAKING AN OLD MASTER DRAWING

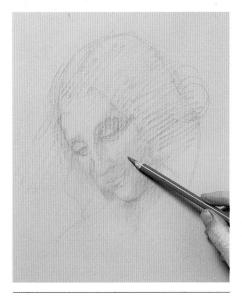

1 Working on a mid-toned, warm-coloured paper, the artist uses a sanguine conté pencil, first to make the initial sketch and then to block in the first tone with light hatching strokes.

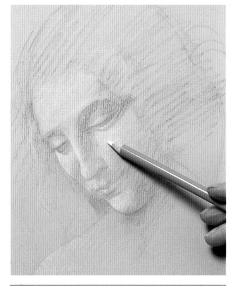

2 To build up the forms of the head, white conté is used to establish the main highlights. The strokes are kept light at this stage, with the pencil held near the end.

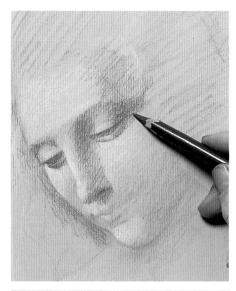

3 To define the facial features, a well-sharpened black conté pencil is chosen. Tighter control is required at this stage, so the pencil is held closer to the point.

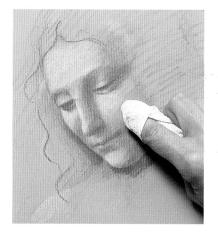

4 The artist has based his drawing on similar studies by Leonardo da Vinci. In order to achieve the soft effect for which the Master was famous, he blends the highlights and mid-tones on the cheeks with a soft cloth wrapped around his finger.

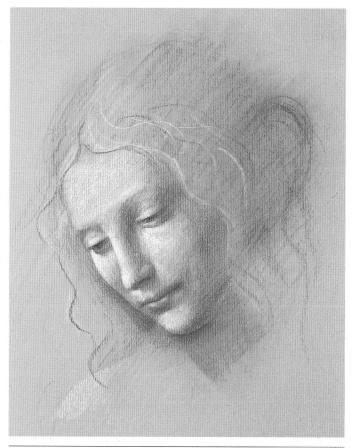

5 To complete the drawing the features were defined more strongly, the shadow at the side of the face strengthened, and touches of detail added on the hair. Notice the soft blending at the sides of the mouth and below the lower lip.

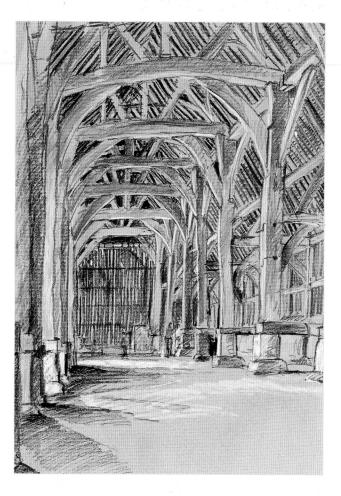

Roger Hutchins \diamond The Old Barn

The same technique has been used for this evocative study of the interior of an old barn, but in this case, the artist has not employed blending methods, as the subject demands clear, crisp lines. To help to draw the eye into the picture, he has used touches of red for the two small figures at the back of the barn.

> FURTHER INFORMATION ⇒ PASTELS: PAPER COLOUR 44

PEN AND INK Drawing implements

Pen and ink is one of the oldest of all the drawing media, as both the implements and the inks can be made from a variety of substances and materials. A sharpened piece of wood, reed, bamboo or the quill of a feather can become an effective tool for drawing. In spite of the wide range of drawing pens available today, some artists still prefer to make their own.

You will only discover which type of pen suits you best by trying them out. There are also various practical considerations related to the subject matter of the drawing and the effect you want to achieve. Fine fibre-tipped pens, which deliver the ink to the nib at a standard rate, allow you to draw quickly and are useful for outdoor work as you don't have to carry ink with you. They do produce a slightly mechanical line, but this does not matter too much for sketching, or for methods such as hatching and crosshatching. The traditional pens with a wooden handle and interchangeable nibs give a more sensitive and variable line, and are ideal

for line drawing, but the drawing process is slower as you have to keep recharging the nib. A broad-pointed nib uses more ink than a fine one, thus limiting the length of the line that can be achieved with one stroke.

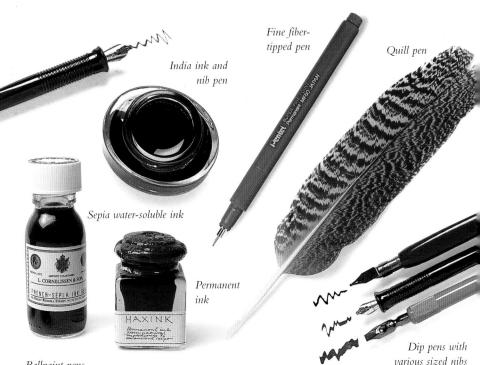

Ballpoint pens

HELPFUL ADVICE

The most common type of drawing ink is shellac-based India ink, but you can also use acrylic ink or any of the inks sold for writing pens. The latter are water-based, and you can dilute them for pen-and-wash drawings.

DEPICTING MOVEMENT

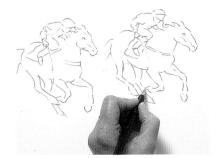

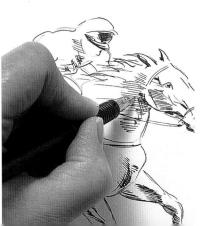

2 She now begins to build up the drawing with decisive hatching lines that model the forms as well as suggesting the forward thrust of the horse's movement.

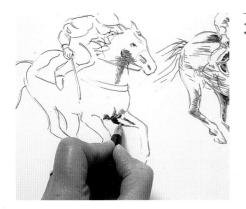

3 The shadow beneath the leg of the rear horse is drawn as a small area of solid black. This helps to throw the leg forward, enhancing the sense of speed and physical effort.

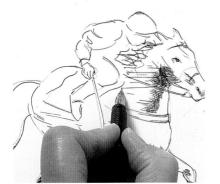

4 More 'speed lines' are drawn on the neck and body of the rear horse, but these are kept light so that they do not interfere with the strong modelling of the animal's neck.

CHARLOTTE STEWART STANDING NUDE An ordinary ballpoint pen has been used for this ten-minute drawing, with lines laid over one another to make alterations, re-establish shapes and suggest form. Because ballpoint is more familiar to us than many of the implements designed for drawing, it is ideal for rapid studies and quick sketches.

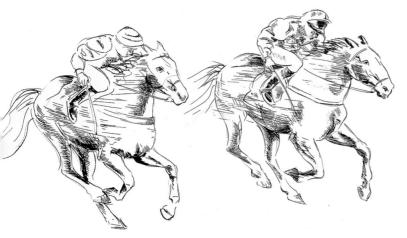

5 The completed drawing conveys a real sense of excitement, and we can almost feel how the rear horse is straining every muscle in its effort to catch up with the leader.

Crosshatching with a dip pen

Hatching with a quill

Marks made with a ballpoint pen

⇒PEN AND INK: LINE AND TONE 30

PEN AND INK Line and tone

As we have seen on the previous pages, tones can be built up through the use of line alone, but pen drawing can also be combined with washes of diluted ink or grey watercolour. Most drawing or writing inks can be diluted with water, so you can mix as many shades of grey as required. Another type of ink often used for line-and-wash drawing is Chinese ink, which comes in the form of sticks, and is made into liquid by rubbing with water. This is usually only available from specialist suppliers, but is well worth seeking out if you find you enjoy this technique.

Whether you begin with the line or the tone is a matter of personal choice, but try to avoid making a hard, mechanical-looking outline and then filling it in with tone. Aim at a sensitive, expressive line, varying the thickness so that some edges are 'lost' and others 'found'. Quill pens or bamboo pens are ideal for this kind of work, or you could use a water-soluble fibertipped pen, which will run slightly when the washes are applied – you can then strengthen the lines where needed when the washes have dried.

You can work on ordinary drawing paper, but watercolour paper may be a better choice: it won't buckle so easily, and the texture will break up the pen lines slightly to give a softer feel.

Bamboo pen

Medium rounded paint brush

Chinese block ink

Water-soluble dip pen, washed over with a brush

Water-soluble fibre-tipped pen, washed over with water

Mixing Chinese ink

WASHES OVER PEN LINES

1 Using a dip pen and India ink, and working on watercolour paper, the artist begins with a careful outline drawing to place the important elements. He uses a light, slightly broken line, as the pen work is to play a less important part in the drawing than the washes.

2 A first tone is laid over the building and parts of the trees with diluted ink, followed by a darker one on the roof.

HELPFUL ADVICE

If you intend to lay very wet washes, you should stretch the paper first, as shown on page 13.

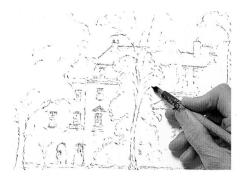

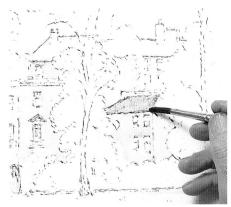

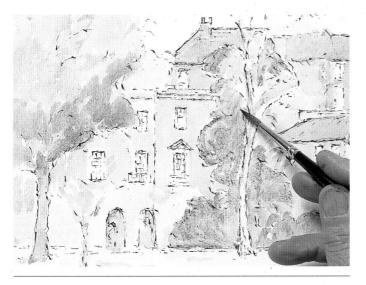

3 The washes are built up more strongly all over the drawing. The ink gives a slightly granular texture that imitates that of the foliage itself.

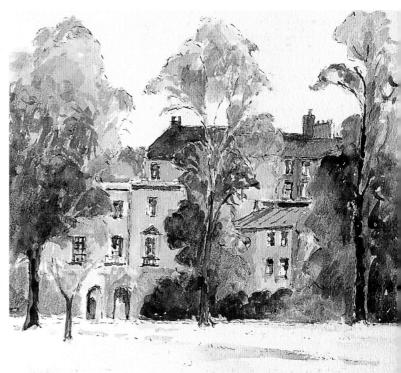

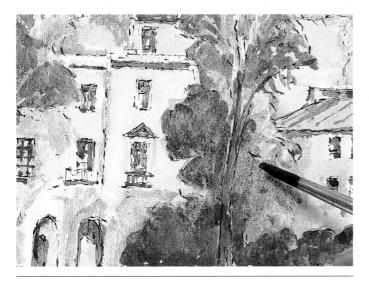

4 Small, dark washes have been applied to the windows to bring the building into sharper focus, with highlights reserved as white paper, and the foreground trees and shrubs given further dark washes. Notice that the right side of the tree is lighter in tone, as it catches the light.

5 Although the washes have obscured most of the pen lines, they are still visible in places, giving the finished work an attractive crispness.

FURTHER INFORMATION

⇔COLOURED INKS: INKS AND MARKERS 76

⇒BASIC TECHNIQUES: CHOOSING THE RIGHT PAPER 12

BRUSH AND INK Drawing with a brush

If you have only worked with the point media – pencils and pens – drawing by dipping a brush into ink and letting it glide across the paper gives a wonderful sense of freedom. It takes a good deal of practice to become expert at brush drawing; the Chinese and Japanese artists who perfected this technique and took it to great artistic heights often spent decades studying under established masters before they were considered to be among the top rank. But artists in the Western world are less bound by the strict conventions that govern Eastern art, and can enjoy brush drawing simply as an exciting and expressive technique.

The best implements for brush drawing are either a good-quality watercolour brush that comes to a fine point, or a Chinese brush. The latter are expressly designed to exploit brushmarks, but, surprisingly, are considerably less expensive than watercolour brushes. You will find you can make a wide variety of different marks with either type of brush, from fine and sensitive lines to broad blobs and shapes of various kinds. A lot depends on the pressure

HELPFUL ADVICE

Brush drawing is not specifically a monochrome method; you can also use coloured inks, or watercolour, to create more elaborate effects.

applied and how much ink is used. For example, if you begin a brushstroke by pressing the body of the brush down on the paper and then gradually lifting your hand so that you are using the point, you will achieve a leaf- or petalshaped mark. If you start a long, linear stroke with the point of a well-loaded brush and draw it out, the brush will become progressively starved of paint so that the stroke is paler at the end. It is essential to practise making marks with the brush before embarking on a drawing proper, because you can't make corrections. The essence of the method is controlled spontaneity.

Marks made with Chinese brush and ink

CHARLOTTE STEWART ↔ TURNING FIGURE

This exciting brush drawing, capturing the model in midmovement, was done in exactly ten seconds. The artist has used acrylic paint applied with a bristle brush, which has produced attractively broken strokes.

Chinese ink brushes

Different shaped

brushes

VARYING THE BRUSHES

 The artist begins with the hair, using a large brush and slightly diluted ink, letting it pool at the bottom of the stroke.

2 After blocking in the head and upper body with the large brush, she now uses a smaller one to draw the outlines of the white pants. To give maximum control, she holds the brush close to the point.

3 The texture of the chair is suggested with a fine, pointed brush and a variety of short, linear strokes. The chair plays an important part in the composition, as its busy texture contrasts with the broadly stated figure.

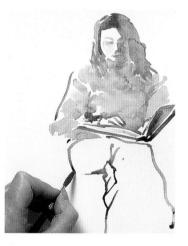

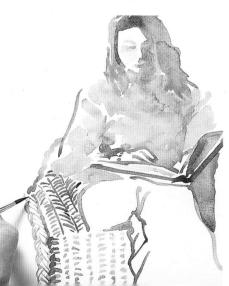

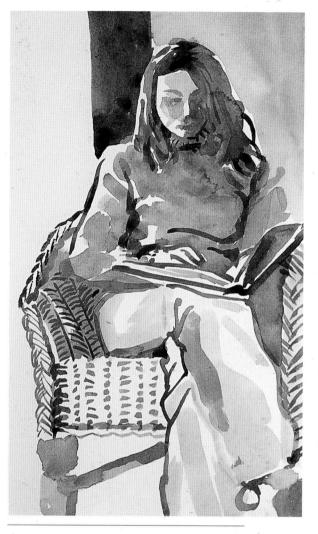

4 To complete the drawing, a strong, dark vertical was brought in behind the figure, the shadows on the hair and face were strengthened, and the forms of the legs built up with broad brushstrokes of diluted ink.

FURTHER INFORMATION

⇔COLOURED INKS: INKS AND MARKERS 76

BRUSH AND INK Blot drawing

This method of drawing was pioneered by the British landscape painter Alexander Cozens in the late eighteenth century, prompted by the writings of Leonardo da Vinci. In a book published in 1786, Cozens attempted to show how artists could utilise ink-blots to aid the imagination and free themselves of a formulaic approach to painting, which was more common in those days than it is today.

The idea was to exploit accidental shapes rather than working to a preconceived conception of a landscape, figure drawing, or whatever. Cozens suggested that a group of more or less random blots could produce an assemblage of shapes from which a drawing might be made, and demonstrated his method in a number of highly effective brush-and-ink drawings. His book, *A New Method for Assisting the Invention in Drawing Original Compositions for Landscape*, is still influential today, and continues to provide inspiration to both experienced artists and beginners.

The idea of exploiting accidental effects will be familiar to most watercolour painters, who quickly learn how to make a virtue of blotches and backruns. Exploiting shapes makes more demands on the imagination, as you need to see your way through a series of unrelated marks and find a way of making them into a cohesive pattern.

This can be an abstract or representational composition – there are no rights and wrongs in this technique, which is what makes it so exciting. Simply put down a series of blots, and let your mind roam around the visual possibilities. You may come up with something quite unexpected and surprise yourself.

DEVELOPING THE DRAWING

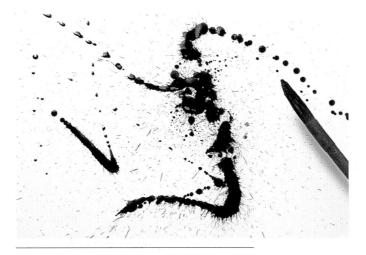

 The artist begins by spattering ink randomly, flicking it onto the paper with a well-loaded brush.

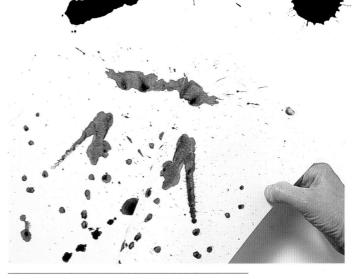

2 He then removes some of the excess ink by blotting it with another sheet of drawing paper.

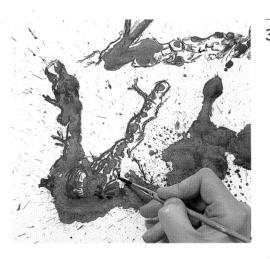

3 The ink spatter has begun to suggest a subject, so he uses pen and ink first, and then a small brush to define background trees and a foreground tree stump.

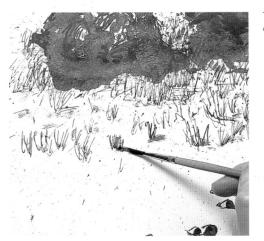

4 To provide texture and interest in the foreground, clumps of grass have been drawn with a fine pen, and a line of stones added with a brush. The dry-brush method (very little ink on the brush) is now used to add shadows beneath the grasses.

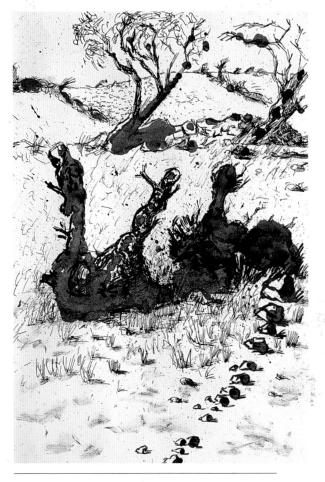

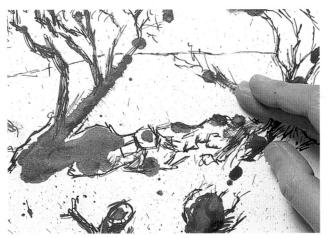

- 5 For additional texture on the background trees, wet ink lines are rubbed with a finger.
- 6 The completed drawing shows how the original ink-blots have provided a basis for an interesting composition. Notice also the attractive texture produced on the foreground tree stumps by blotting in the first stages.

FURTHER INFORMATION ⇒COLOURED INKS: INKS AND

MARKERS 76

WHITE ON BLACK Scraperboard

We are so naturally accustomed to drawing with black pens or pencils on white paper that it comes as a surprise—and often an exciting one—to work in the opposite way. Scraperboard gives you the opportunity to make white lines on a black surface, which can be a liberating experience as it reverses the normal drawing process and helps you to view your subject matter in a new way.

Scraperboard is a soft, white board coated with black ink that enables you to scratch white

Marks made on scraperboard.

lines with a pointed implement. It is exactly the same as drawing with a pen, except that in this case, you are working in "negative," and any of the same techniques can be used. Special tools are available to make the white lines, but you can personalize your work by improvising your own tools or using what you have on hand. For example, you might make fine lines with the point of a craft or kitchen knife, or blunter ones with the point of a knitting needle. By dragging a metal comb or a serrated kitchen knife across

TEXTURE THROUGH LINE

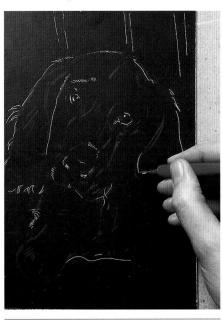

 After making some light pencil lines on the board as a guide to placing the dog's head, the artist begins with an outline drawing. the board, you can produce a series of parallel lines or hatched and crosshatched areas of shading. Any implement that allows you to scratch into the surface is worth trying out.

Scraperboard has in the past been mainly associated with book and magazine illustrations, but is becoming more popular in the realm of fine art.

HELPFUL ADVICE

It is possible to make your own boards by laying successive layers of ink onto board, which allows you to vary the base color, but this is a rather laborious process, and is best reserved for those who become addicted to the technique.

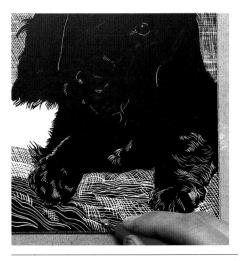

2 The next stage is to begin building up tones. Fine, close lines of hatching provide a middle tone in the background, and now wavy lines are used to suggest the texture of the foreground cloth.

Scraperboard tools

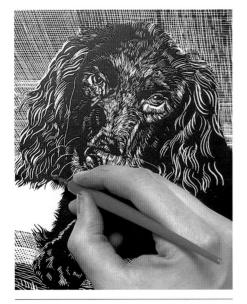

3 The dog's face and body are gradually built up with a variety of lines following the direction of the hair. The lines on the muzzle give a clear impression of the bone beneath. Larger wavy lines are used for the ears, where the hair is longer than on the head.

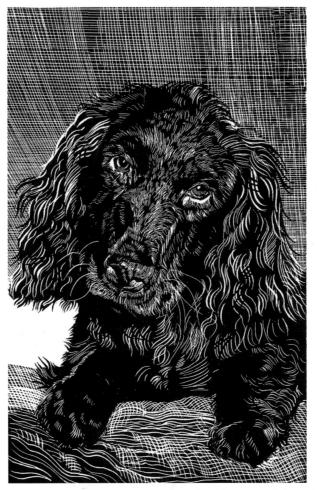

4 In the final stages, black ink was used to fill in one or two incorrect lines, and a little detail was added on the paws. No attempt has been made to fill in the whole of the body, as the areas of black give impact to the drawing.

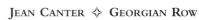

White rather than black scraperboard was used for this drawing, allowing the artist to achieve very fine dark lines. The black and near-black areas were built up slowly, with great care taken to keep the verticals and horizontals straight and true.

> FURTHER INFORMATION ⇒OIL PASTELS: SGRAFFITO 58

COLOUR MEDIA

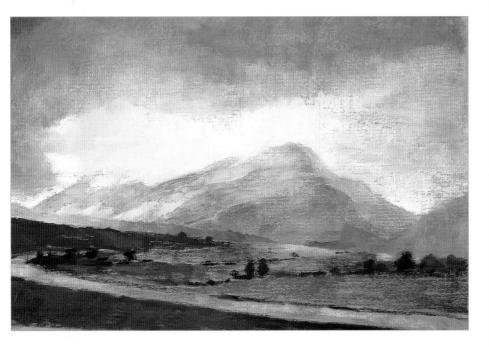

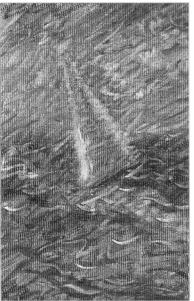

CHAPTER 2

The ranges of colour drawing media have increased dramatically over the past decades, giving the artist everwider choices of approach. Through a series of photographs and step-by-step demonstrations, this section provides ideas for getting the best out of each of the media, from coloured pencils to inks and markers. All the traditional techniques are illustrated and explained, along with several more innovative and experimental methods.

INCLUDES

⇔PASTELS:	Drawing with pastels 40 Blending and colour mixing 42 Paper colour 44 Vignetting 46 Paper texture 48 Making corrections 50 Wet brushing 52
⇔OIL PASTELS:	Using oil pastels 54 Blending with spirit 56 Sgraffito 58
⇒COLOURED PENCILS	Pencil choices 60 Building up colours and tones 62 Paper choices 64 Transparent surfaces 65 Blending 66 Burnishing 67 Scratching back 68 Squaring up 69 Frottage 70 Impressing 72 Water-soluble pencils 74 Line and wash 75
⇔COLOURED INKS:	Inks and markers 76 Overlaying colours 78

PASTELS Drawing with pastels

Pastels are rapidly increasing in popularity, and to meet the demand, manufacturers are constantly bringing out new ranges. This can lead to some confusion when buying for the first time. There are two main categories of pastel – hard and soft. In the past, the former were sold as square-sectioned sticks (like conté crayons) and the latter as round-sectioned sticks of varying thickness. Nowadays, some soft pastels are also made in square sections, but these will be clearly labelled as 'soft' on the boxes. Pastel is both a drawing and a painting medium, and soft pastels are best for broad, painterly effects made with the side of the stick. However, fine lines and marks can be achieved by using the point rather than the side of the stick, allowing you to exploit both line and soft colour areas.

All pastels are made from ground pigment bulked out with a filler and held together with a binder. Very little binder is used for soft pastels, which are almost pure pigment, but hard pastels have a higher proportion of additives, making them less prone to breaking and easier to handle. These are ideal for drawing, as you can use the side of the stick for areas of tone and the point or corner of the stick for fine line. Pastel pencils, which are simply thin sticks of medium-soft pastel encased in wood, are especially suited to linear work, but are soft enough to produce areas of tone and overlaid colours by rubbing with a finger.

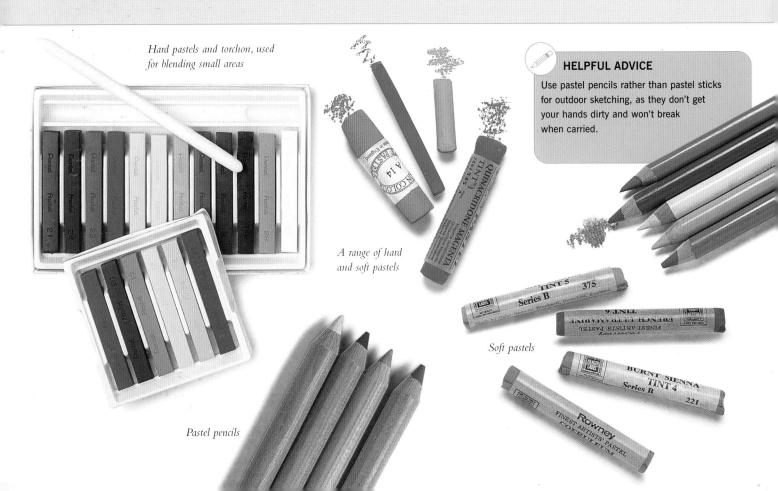

Sides strokes using hard pastel

End strokes using hard pastel

Fine line using a corner of a hard pastel stick

Side strokes using a broken stick of soft pastel

Dense and open hatching strokes using soft pastel

Fine and broad lines using side of soft pastel

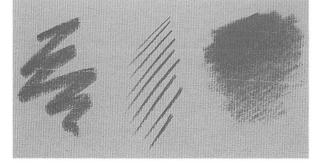

The marks here are made with pastel pencil. From left: side strokes, point strokes, shading.

Crosshatching with pastel pencil

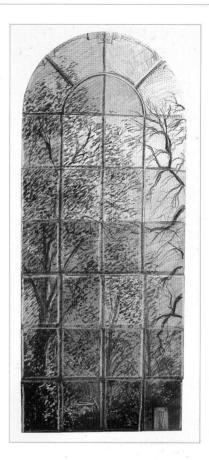

ROGER HUTCHINS \diamondsuit THE WINDOW, EVENING

In this inventive drawing, the artist has combined pastel pencil with collage. Each pane of the window is made up from a different colour or texture of paper.

FURTHER INFORMATION

⇔PASTELS: BLENDING AND COLOUR MIXING 42

PASTELS Blending and colour mixing

One of the delights of pastel is that it is so quick to use. With a medium such as coloured pencil (which is dealt with later in the chapter), areas of colour have to be built up gradually through linear shading methods. With pastel, you can simply use the side of the stick to make a broad stroke and then rub it into the paper with your hand. You can also mix colours by the blending method, making sidestrokes of two or more different hues and rubbing them together – either completely or partially.

But although blending is useful for large areas, beware of overdoing it, as it can make a drawing look somewhat woolly and amorphous. Usually, the best results are obtained by contrasting soft blends with linear detail. In a portrait, for example, you might blend the background and parts of the face and then bring in detail on the face and hair with the point or edge of a pastel stick. Or you could use a pastel pencil for the linear work, as all the pastel types can be combined.

Blending is not the only method of surface mixing, however, and it can be more effective to overlay colours without blending. If you work fairly lightly, each new layer of colour will leave some of the earlier layers showing through to produce a lively shimmer. Colours can also be mixed through line alone, as they are with coloured pencils, using the points of pastel sticks or pastel pencils and variations on the hatching and crosshatching methods.

HELPFUL ADVICE

Pastels will get your hands dirty very quickly, especially when you use your fingers for blending. Keep a packet of wet wipes handy to clean them, or you will sully the colours.

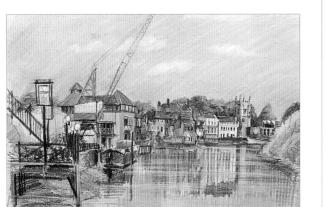

Roger Hutchins \diamondsuit Old Isleworth

Blending has been kept to a minimum in this pastel pencil drawing, as the artist wanted to give extra interest to the area of water by exploiting energetic linear effects. He has worked on pale blue paper, leaving areas uncovered in the foreground.

Blending with a finger

Blending two colours together with a finger

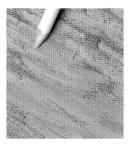

Blending with a torchon

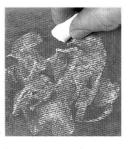

Applying a loose overlay of white over red

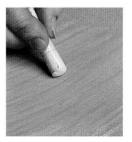

Laying a pale colour over mid-tones

Laying yellow over blue to produce green

CONTRASTING EDGE QUALITIES

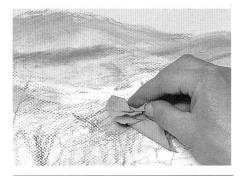

1 The sky was laid on as a flat colour and rubbed into the paper, and the colours of the hills blended to produce a soft effect. Having sketched in the middle-ground foliage with point strokes, the artist softens the lines in places with a rag.

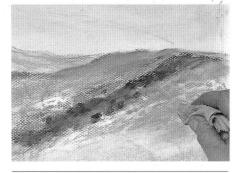

2 She continues the process of building up and blending colours, working gradually towards the front of the picture.

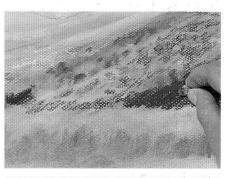

3 Stronger colours are now brought in and only partially blended, as this area needs to come forward in space.

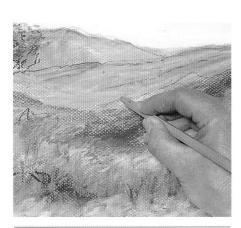

4 To contrast with the soft blends in the background, strong, dark strokes have been used for the foreground foliage and tree. A pastel pencil is now used to add some delicate lines on the middle-ground hills.

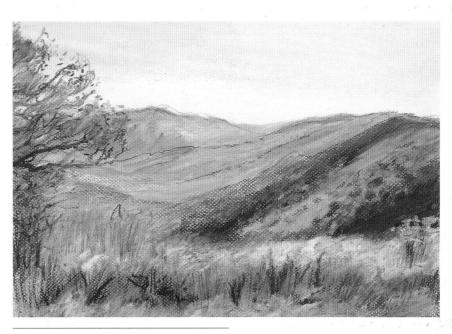

5 More detail was built up in the foreground in the final stages, with the colours mixed optically rather than blended together. To create a link between the foreground and middle distance, a few fine, dark lines were added on the hills to echo the linear quality of the grasses and tree.

FURTHER INFORMATION

⇒BASIC TECHNIQUES: BUILDING UP COLOUR 10

⇒PASTELS: PAPER COLOUR 44

PASTELS Paper colour

Pastel drawings are usually worked on a coloured surface, and manufacturers produce a wide choice of tinted papers for this purpose. There are several reasons for using a precoloured ground rather than white paper. First, it is more or less impossible to cover the surface completely because pastel paper needs to have a texture to hold the pigment, and the colour catches on the raised grain to leave flecks and patches of the paper showing. Spots of white can create a disturbing, jumpy effect, which tends to devalue the applied colours. White paper also makes it difficult to assess the first colours. Almost any hue looks very dark against white, so you could find you are setting a false key for the drawing by starting with colours that are too pale. Most importantly, tinted paper can be used as a colour in its own right, with areas deliberately left uncovered.

The choice of paper colour depends on how large a role it is to play in the finished drawing. It can either provide a contrast to the dominant colours or blend in with them. In a landscape or seascape drawing, blues or blue-greys could be left uncovered for areas of sky or sea, but exciting results can also be obtained by exploiting a complementary contrast between the paper and the dominant colour of the drawing. For a life study or portrait in which the main colours are warm, you could choose a cool blue or green, leaving patches of the paper for the shadows.

HELPFUL ADVICE

In portrait drawings, the paper colour is often used as the background, and left unworked or only lightly worked.

Yellow object on blue paper – complementary contrast

Mid-toned colour appears darker on light paper

The same colour appears lighter on a dark background

ESTABLISHING THE DOMINANT COLOUR

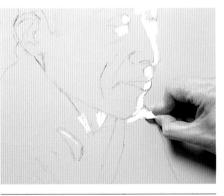

 For this portrait drawing, the artist has chosen a paper that will stand as the basic flesh tone.
 Having made an outline drawing with a black pastel pencil, he begins with the white highlights on the side of the face.

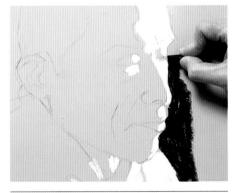

2 Next he adds a black background, taking the pastel carefully around the face. Black is used again for the clothing to achieve a balance between foreground and background. Once the main light and dark areas are in place, he can begin to consider the mid-tones.

DOUG DAWSON THE STEEPLE LIGHT

For this dusk landscape, a piece of masonite board was primed with a textured ground of warm pink. Notice how the ground colour enlivens the blue of the sky and creates a halo effect around the trees, suggesting light coming through from behind.

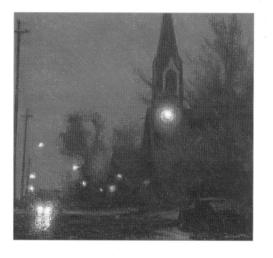

- 3 To model the face, he chooses a hard pastel of a similar colour but slightly darker in tone than the paper. Light side strokes are followed by strong lines made with the corner of the stick.

4 Black is used again to strengthen the drawing of the face, especially the deeply etched lines around the mouth.

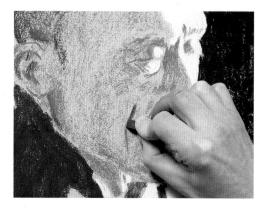

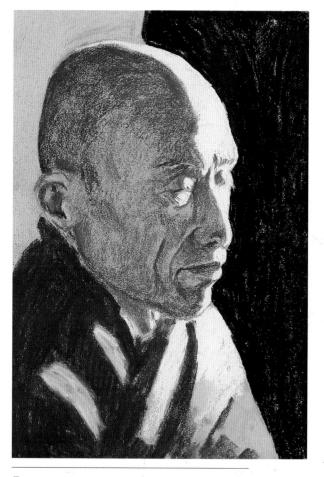

5 In the final stages, white was added to the clothing to provide a strong foreground pattern. The use of a limited colour palette with strong tonal contrasts gives the drawing considerable power.

FURTHER INFORMATION

⇒BASIC TECHNIQUES: CHOOSING THE RIGHT PAPER 12 ⇒PASTELS: PAPER TEXTURE 48

PASTELS Vignetting

Vignetting is a traditional pastel technique, most often used for portraits. The dictionary definition of a vignette is 'a picture or motif without a border', which in the case of pastel drawing means without a background. But of course there is a background in visual terms - it is provided by the paper itself - and if the colour is chosen with care, the method can be very effective. The early pastellists would often draw on beige or creamy-coloured paper, leaving the background unworked and concentrating all the applied colour on the face, but any paper colour that suits the subject can be chosen. A portrait of a black person might be given additional drama by working on a red or vivid yellow paper, and a study of a child softened with a blue or pinkish background.

If you use a strong paper colour for the background, you will need to find ways of linking it to the drawing or it will look too much like a cutout. You could do this by letting the paper colour show through in parts of the drawing, or by bringing in a touch of the background colour on clothing or features – bright lipstick, for example, to make a colour link with a red background.

Although the technique is most often associated with portraits, there is no reason why it should not be used for other subjects, such as still life or flower studies.

CHOOSING THE RIGHT COLOUR

- 1 The choice of paper colour is all-important for this method, as it plays such a vital role in the finished image. The artist has chosen a warm brown that almost matches the colour of the sitter's eyes. He starts with a charcoal drawing and then dusts it down lightly to avoid it mixing into the pastel colours.
- 2 Using a hard pastel stick, he begins to establish the light masses, making a series of faint white lines following different directions.

3 A medium-soft pastel was used to build up the areas of shadow on the side of the face, and the artist now switches to pastel pencil to define the facial features. He builds up the colour in the eyes more heavily than elsewhere, as the eyes are the focal point in a portrait.

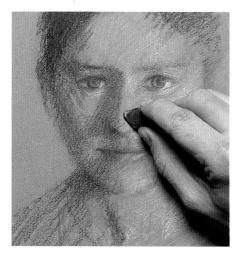

4 Although he is working very lightly, there is always a tendency for pastels to smudge, and from time to time he uses a kneadable eraser to reclaim the paper colour, which is the mid-tone in the drawing.

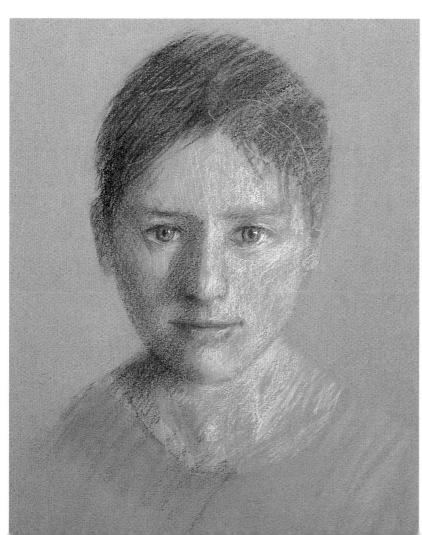

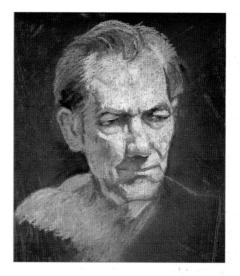

GARY MICHAEL Bob MULDOON Black would not be a wise choice of colour for a portrait of a young woman or child, but it works wonderfully well in this dramatic study. The artist has emphasised the drama by using the light shape of the shoulder as a device to lead the viewer's eye into the face.

5 In the final stages, subtle touches of pink were added to the cheeks, and the eyes and lips were more precisely defined. But care has been taken not to cover the paper completely, as it must stand as a colour in its own right.

FURTHER INFORMATION

 ⇒BASIC TECHNIQUES: BUILDING UP COLOUR 10
 ⇒PASTELS: PAPER COLOUR 44

PASTELS Paper texture

As explained in the Basic Techniques section at the beginning of the book, pastels require a textured surface to hold the pigment; if worked on smooth drawing paper, the particles of colour will simply slide off. The two standard pastel papers have a mechanical grain that some artists find unsympathetic, but you can also work on the 'wrong' side, which still has sufficient texture to hold the pigment. There are three further types of paper made for pastel work: sandpaper (a specially made artist's version sold in large sheets); pastel board (made from tiny particles of cork); and velour paper, which has a velvety surface and softens the pastel strokes. These three papers all grip the pastel very firmly, which makes it more or less impossible to erase, but they have the great advantage of allowing you to build up colours thickly with the minimum use of fixative.

If you like a pronounced texture, you can also work on watercolour paper, but since coloured surfaces are best for pastel work, you may want to tint it first. You can do this by laying a wash of watercolour, wet-brushed pastel, diluted ink or thinned acrylic paint. Some pastel painters prepare their own textured surfaces with pumice powder mixed with acrylic medium or glue size, but this very abrasive surface is more suitable for pastel paintings than drawings.

Line and side strokes of soft pastel on Ingres pastel paper

Line and side strokes of soft pastel on artist's sandpaper

Line and side strokes of soft pastel on Mi-teintes pastel paper

Line and side strokes of soft pastel on velour paper

Line and side strokes of soft pastel on textured watercolour paper

HELPFUL ADVICE

Both tea and coffee can be used to stain white paper. For an irregular effect, try dabbing with a damp tea bag. For a more even tint, paint on cold coffee with a watercolour brush.

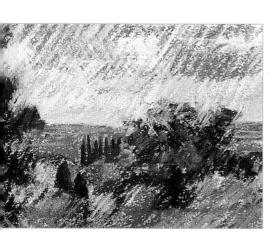

ELINOR K. STEWART 🗇 FROM TREVEREAUX HILL

Watercolour paper has been used very effectively in this soft-pastel drawing. The artist chose this surface deliberately because its roughness seemed to echo the squally weather.

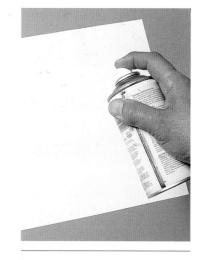

Drawings on light paper such as Ingres can be fixed from the back.

As can be seen here, fixing always tends to darken the colour, knocking back the particles into the paper.

HELPFUL ADVICE

Some people are adversely affected by the fumes from aerosol sprays, so always open a window, and if you are working in a group, take your drawing outside to fix it.

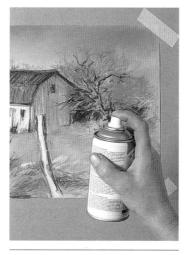

Fixative can also be used during the course of a drawing, if the build-up of pastel prevents you from laying on further strokes, or if you need to make corrections. Make sure to wait until the paper is dry before adding more colour.

Fixing

Some artists avoid fixing their work altogether, as they regard the fragility of the pastel and the brilliance of colour as all-important. It is undeniable that using fixative does to some extent degrade the surface qualities, and it also darkens the colours. This is especially noticeable when working on dark or mid-toned papers, as any light pastel colours are 'knocked back' into the paper.

But pastel drawings are notoriously prone to smudging, and fixative does offer a valuable means of protecting your work. Linear drawings that are not built up in layers can be fixed from the back, which barely affects the surface qualities, but this method can only be used on light papers. When fixing from the front, use the spray as sparingly as possible to avoid over-

wetting the paper, as this can cause colours to bleed into one another. Two or three light sprays are safer than one heavy one. Colourless Fixative Spray-can, bottle ALER-ROWNEY and mouth-spray 150 ml e 210

FURTHER INFORMATION

Perfix

⇒ PASTELS: BLENDING AND COLOUR MIXING 42

⇒ PASTELS: WET BRUSHING 52

PASTELS Making corrections

Pastel is less easy to erase than pencil or charcoal, but it is possible to make corrections in the early stages of a drawing, before the grain of the paper is fully filled. Use a bristle brush to flick off as much colour as possible, and then pick off the remainder with the point of a kneadable eraser or a small piece of bread – the latter is recommended by many pastellists. You can also brush off colour in any area where the build-up of pigment has become too heavy.

To make corrections in the later stages of a drawing – altering or modifying a colour, for example – the only method is to overwork. As before, brush off the excess colour from the area you want to change, taking great care not to sully other parts of the drawing with pastel particles, and then simply lay on further strokes of colour. You may find it helpful to spray the area with fixative (see previous page) after the brushing down so that the new application of colour does not sink into the previous ones. Pastel board, velour paper and fine artist's sandpaper

HELPFUL ADVICE

If you are working on sandpaper, pastel board or velour paper, you won't be able to use the eraser or bread method, as these papers grip the pastel too firmly, but they do allow for a surprising degree of overworking.

Kneadable_eraser

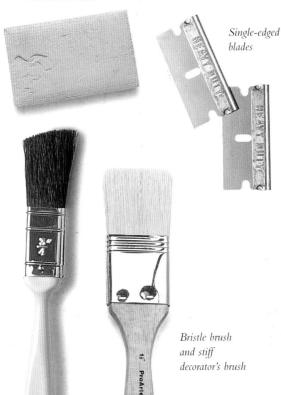

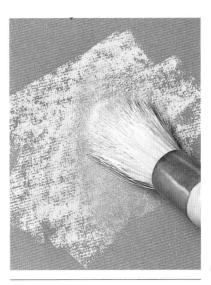

When brushing off pastel, hold the board upright so that the dust falls onto the floor rather than being pushed into the paper.

Razor blades (single-edged ones are safest) can be used to scrape off unwanted pastel marks, but don't try this on light paper, as you could damage it.

A kneadable eraser will remove a light application of pastel. If you need to lift off a large area, clean the eraser between strokes.

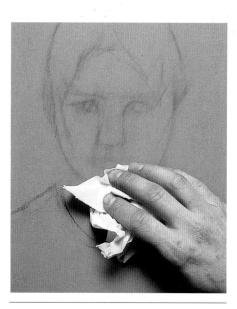

 To correct outlines in the early stages of a drawing, use a soft cloth or kitchen towel to rub down the pastel marks.

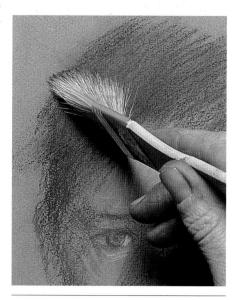

- 2 As the drawing develops, you may need to make changes by overlaying colours. This is easier if you first brush down the incorrect area with a stiff brush.
- **4** The area can then be reworked with a further application of pastel. If you try to overlay colours without brushing down first, the new layer may be sullied by the underlying colour.

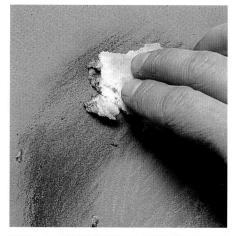

3 To clear away smudged or dusty areas, or remove further pastel after using the brush, a piece of bread will absorb the dust effectively.

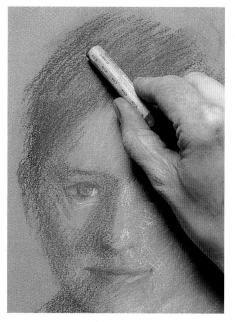

FURTHER INFORMATION ⇒ PASTELS: PAPER TEXTURE 48

PASTELS Wet brushing

If you make a mark with pastel – either a line or a sidestroke – and then brush over it with water, the colour spreads out to form a grainy wash. Wet brushing is a technique that has a number of uses. You can create line-and-wash drawings in the same way as you can with a water-soluble pencil; you can use the method to pre-colour a paper to any shade you choose; and you can make an 'underpainting' for a work that is to be built up in layers. Wet-brushed pastel does not require fixing, so you can work over it quite freely, with either further wet layers or dry pastel. This method saves a lot of time, as the water pushes the pastel into the paper grain without clogging it, allowing you to cover the surface rapidly. A whole drawing can be built up by wet brushing, producing a painterly effect. However, this does to some extent sacrifice the character of the pastel marks and textures, so it is more common to combine wet and dry. Soft pastels spread the most readily, but the method can also be used for hard pastels and pastel pencils – the latter are ideal for line-andwash effects. If you intend to use a lot of water, you may need to stretch the paper first, as shown on page 13, or it will buckle. Alternatively, you can use a heavy watercolour paper, but this will make spreading the colour a slower process, and may also provide more surface texture than you want.

HELPFUL ADVICE

When wet brushing two or more different colours that you don't want to mix, wash the brush well between applications.

5

Brushing water into a single colour

Line and side strokes on watercolour paper, brushed over with water.

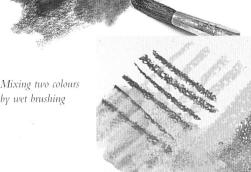

Yellow and blue strokes brushed over with water to produce green

PAINTERLY EFFECTS WITH PASTEL

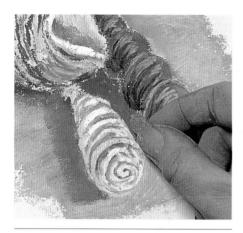

 A thick layer of soft pastel has been laid on stretched watercolour paper and then lightly sprayed with water. More pastel is now worked into the damp paper.

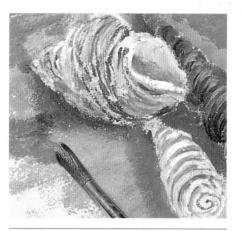

2 The background colour is spread with a wet watercolour brush. Bristle brushes can be used if you wish to exploit brushmarks.

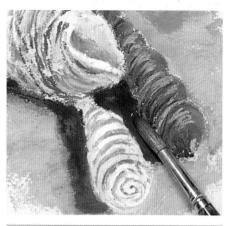

3 The shadow is given more solidity by applying a further layer of pastel and then wet brushing again.

4 The finished effect gives more the impression of a painting than a drawing. But the artist has not sacrificed the pastel-like qualities, and because the wet brushing was done lightly, the grain of the paper shows through as little specks of white in places, enhancing the textures of the shells and giving an overall sparkle to the image.

FURTHER INFORMATION

⇒OIL PASTELS: BLENDING WITH SPIRIT 56 ⇒COLOURED PENCILS: WATER-SOLUBLE PENCILS 74

OIL PASTELS Using oil pastels

Oil pastels are quite unlike the dry pastels dealt with on the previous pages, and can't be used in combination with them. As the name implies, the pigment is bound with oil rather than gum, giving a dense and greasy texture. In comparison with soft pastels, the choice of colours is slightly restricted, with fewer gradations of colour. However, the medium is becoming more and more popular, and manufacturers are gradually beginning to respond to demand by increasing their colour ranges.

One of the great advantages of oil pastels is that they don't require fixing, which makes finished drawings easier to store without damage. Because the pastels smudge less easily than soft ones, they are useful for outdoor work. However, they do tend to melt if exposed to heat, which makes them difficult to handle – rather like drawing with butter – so it is best to work in the shade.

As with soft pastels, strokes can be made either with the tip or the side of the stick, though you will have to remove the paper covering for sidestrokes. You can use oil pastel on any of the standard pastel papers, or the surfaces sold for oil painting, such as canvas boards and oil- or acrylic-sketching paper – oil pastel is sometimes combined with these painting media.

HELPFUL ADVICE

For outdoor work, include a bottle of white spirit and a rag or paper towel in your sketching kit. If the pastels become soft, you will need to clean your hands regularly.

Oil pastel on pastel paper

Oil pastel on oil sketching paper

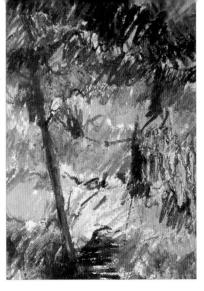

ROY SPARKES \Leftrightarrow **FOLIAGE** The colours here have mainly been mixed optically by building up a network of linear marks. To create a vibrant effect in the foliage, the white of the paper has been allowed to show through around and between strokes.

MIXING COLOURS ON THE PAPER

- 1 A firm outline is drawn with yellow oil pastel. The artist has chosen a cool blue-grey paper to provide a contrast to the rich oranges and yellows.
- 2 After making some light diagonal hatching strokes with orange, the yellow is taken over both of the fruit. The strokes are kept open so that more colours can be added without clogging the paper.

Overlaying colours

Layers of colour can be built up with oil pastel in the same way as for soft pastels and coloured pencils, but because of their greasy texture, they tend to clog the grain of the paper more quickly, so make sure you work lightly at the outset.

The best way to layer colours is by using the point of the stick, which rapidly becomes

blunted to give broad rather than fine lines. Hold the stick lightly near the end so that you don't apply too much pressure, and aim at a network of lines that can be gradually built up to areas of more solid colour. Oil pastels can't be erased in the normal way, but they can be washed off. If you make a mistake or wish to change a part of

HELPFUL ADVICE

You can't blend oil pastel colours by rubbing with a finger, but blended effects can be achieved by working one colour over and into another with a fairly heavy pressure. the drawing, dip a rag into turpentine or white spirit, and gently wipe off the colour, leaving the paper to dry before adding further pastel strokes. Turpentine or spirit can play an important role in oil pastel work, as demonstrated on the following pages.

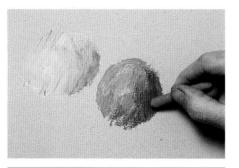

3 Now that the basic colours have been established, more contrast can be brought in, and the complementary colour, blue, is used for the shadows on the orange.

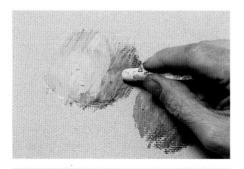

4 On both pieces of fruit, the main colour is blended into the shadows to neutralise them.

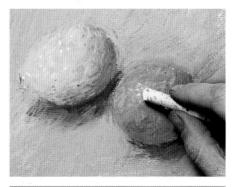

5 To heighten the complementary contrast, a grey slightly darker in tone than the paper has been taken around the fruit, and the artist now builds up the form by adding highlights and cast shadows.

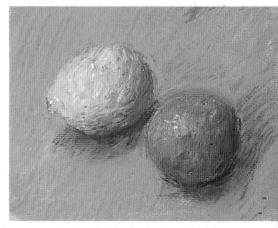

6 The colours have been skilfully blended to give both solidity and texture to the fruit. Light touches of the orange's main colour have been added beneath and behind the fruit to link it to the background.

	FURTHER INFORMATION
	⇒PASTELS: PAPER COLOUR 44
	⇒PASTELS: PAPER TEXTURE 48
	⇔OIL PASTELS: BLENDING WITH SPIRITS 56
	⇒RESIST TECHNIQUES: OIL PASTEL

AND INK 94

OIL PASTELS Blending with spirit

This technique is very similar to wet-brushing dry pastel, but in this case the pastel is 'melted' by brushing over it with turpentine or white spirit so that it virtually turns into a painting medium. You can fill the paper with colour very quickly in this way, but without clogging the grain, and you can blend one colour into another to achieve subtle effects.

The method can be used throughout the whole of the image-making process, but this does sacrifice the linear aspect that differentiates a drawing from a painting, so it is usually more effective to combine wet washes with a variety of point strokes. Although pastels are normally worked on coloured paper, white can be a better choice in some cases, as it will reflect through the layers of colour to give the luminous effect sought by watercolour painters. You can work on white matting board, but if a texture is required, the best surfaces are either canvas board or the sketching paper shown on the previous pages. All these allow you to make corrections by wiping off the colour with a rag and spirit.

The degree to which you take the blending depends on your intentions towards the drawing. You can use the method simply to soften lines here and there, or to lightly merge a network of White spirit and turpentine

different-coloured lines while still leaving the

marks visible – this can create an attractive watercolour-pencil effect. In this case, a watercolour brush is the best implement, but for more painterly effects where brushwork plays a major role, an oil painter's bristle brush is ideal.

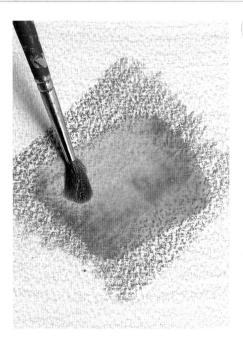

Blending two colours with a brush and spirit on watercolour paper

HELPFUL ADVICE

Normal pastel paper can be used for this technique, but there is a slight risk of deterioration over time if you use white spirit – turpentine is a safer choice.

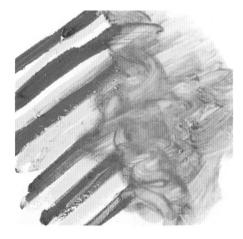

Blue and yellow mixed to produce green

Line stroke softened and spread out with a brush and spirit

PAINTING WEATHER EFFECTS

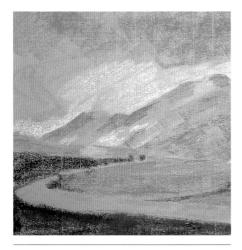

 Working on blue-grey Ingres paper, the artist has blocked in the main shapes using side strokes and loose shading.

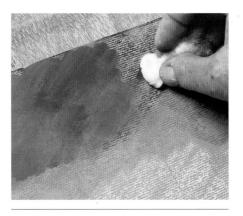

2 She then dips a piece of cotton wool into turpentine and spreads the colour in the sky area.

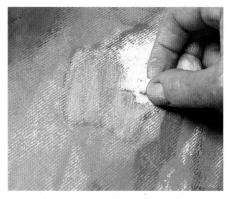

3 More white is added to the sky, using the pastel stick on its side.

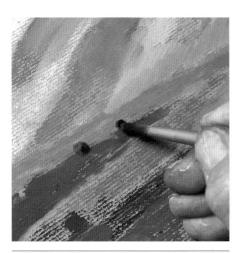

4 She then works on the middle-ground, bringing in mid-toned greens and near-blacks. The small trees are painted directly, by rubbing the tip of the brush over an oil-pastel stick and transferring the colour to the paper.

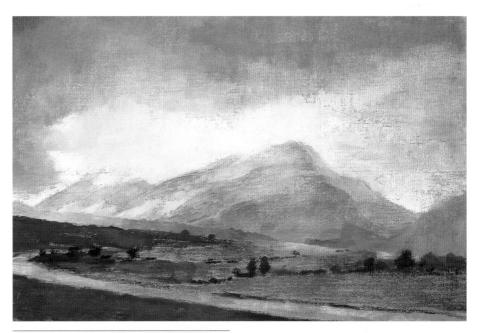

5 The artist finds this method ideal for painting fleeting weather effects such as this, as the paper can be covered very quickly and it is easy to make alterations if required.

FURTHER INFORMATION

⇒PASTELS: WET BRUSHING 52 ⇔COLOURED PENCILS: WATER-SOLUBLE PENCILS 74

OIL PASTELS Sgraffito

This method involves scratching away one colour to reveal another one below – the name comes from the Italian word meaning scratched. It is a little like scraperboard, except that this can only produce white lines on black, whereas oil pastel allows for a variety of different colour effects.

The technique is one of many borrowed from oil painting: Rembrandt often scratched into wet paint with a brush handle to describe the texture of facial hair, or details of lace on a collar. Although it can be used for other media, notably coloured pencils, it is particularly well suited to oil pastel, which can be built up thickly and remains moist enough to be removed with a sharp implement.

Sgraffito drawings need to be worked out in advance. It is not an improvisatory method, and it is essential to keep the finished effect in mind so that you can plan the sequence of the layers. The first step is to cover the paper with a solid application of colour, pushing it well into the surface (you could use watercolour, ink or acrylic for the first layer, if preferred). The second layer should be laid somewhat more lightly so that you can remove it easily with a sharp implement such as the point of a craft knife – for blunter lines, try a paintbrush handle.

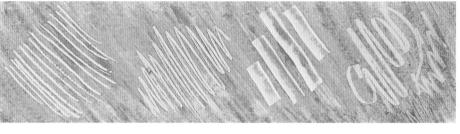

Marks with scalpel blade Marks with blunt end of paintbrush Marks with side of craft knife blade Marks with oilpainting knife

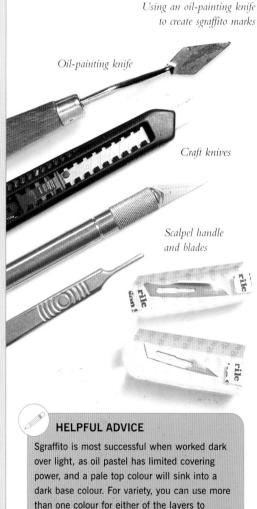

achieve different colour combinations.

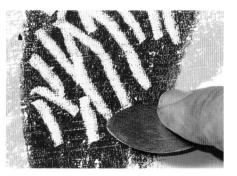

SCRATCHED HIGHLIGHTS AND TEXTURE

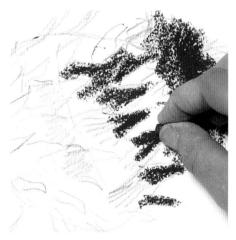

 Working on watercolour paper, which is strong enough to stand up to sgraffito methods, the artist lays a first layer of colour.

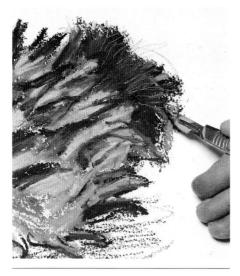

2 Having now added several more colours, pushing them well into the paper, she scratches fine lines with the point of a scalpel.

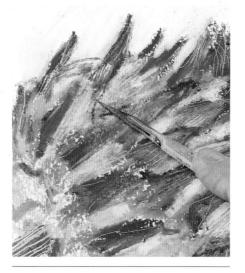

3 She continues the process, alternately laying on and scratching into colours to build up the texture of the flower head.

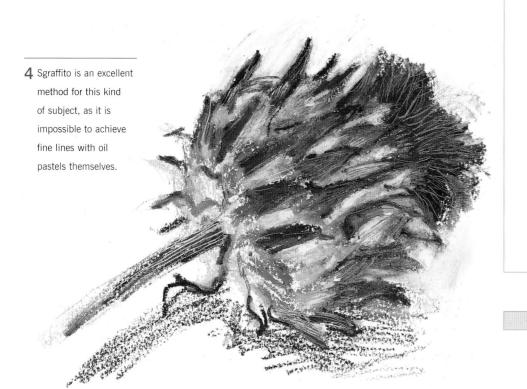

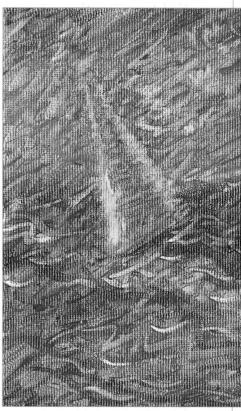

MATTHEW EVANS 💠 SAILING

In this drawing, the oil pastel has been blended with spirit, with the waves and movement of the sky suggested by lifting out squiggly marks and shapes with a brush handle. The variety of marks emphasise the movement of the boat, and the texture of the paper contributes to the overall effect.

FURTHER INFORMATION

⇒COLOURED PENCILS: SCRATCHING BACK 68

COLOURED PENCILS Pencil choices

There are many different brands of coloured pencil, and the colours and textures vary considerably from one to another. Some are hard and semi-transparent, some soft and opaque, somewhat similar to pastel pencils, and others waxy in consistency. If you are new to this medium, don't plunge in until you have done some research – ask friends and colleagues who use coloured pencils, and look through catalogues. If you are still not sure which kind of pencil suits you, buy from an art store if possible rather than by mail order.

You may decide to use more than one brand, as all the types can be combined – except for watersoluble pencil, which is dealt with later in the chapter. There can be advantages in building up a stock of pencils, as this allows you to exploit the special qualities of each one in the same drawing. For example, you could block in broad areas of colour with soft, chalky pencil, sharpening up the image with waxy pencils, which create harder, more positive lines. But this is not necessary for early experiments – you can build up a collection gradually when you become accustomed to coloured-pencil work.

HELPFUL ADVICE

It's a good idea to go to an art store to try out different kinds of pencils – stores that sell loose pencils usually supply pads of paper for scribbling on. Coloured pencils are produced in a wide range of hues and tones.

Crosshatching with coloured pencils

Shading with coloured pencil

Using spirits to blend coloured pencil

USING HARD AND SOFT PENCILS

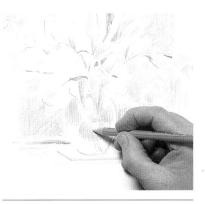

 The first layer of tone is laid with soft pencils, using light pressure and a variety of hatching and crosshatching strokes.

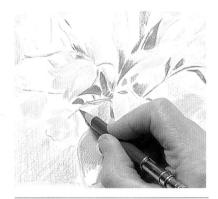

2 Harder pencils are used for the dark leaves. Close hatching strokes are used to build up the colour more solidly in these areas.

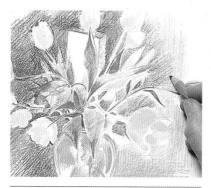

3 The artist now returns to the soft pencils to lay a second tone on the background. She varies the direction of the strokes to provide additional interest.

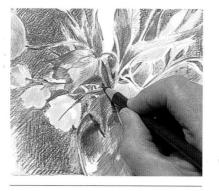

4 With a hard, black pencil, sharpened to a good point, she overlays the original dark green of the leaves. These darks are important, as they stand out against both the background and the flower colours.

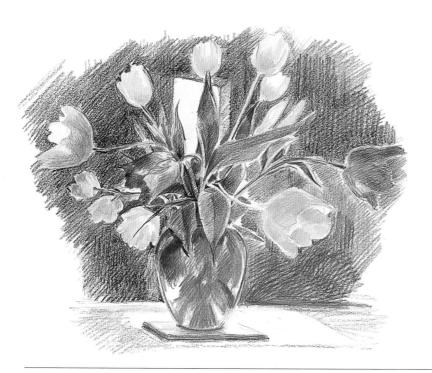

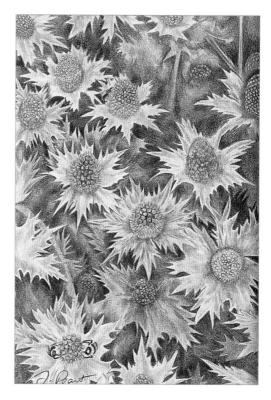

JANE PEART \diamond Thistles

The colour scheme has been deliberately muted in order to make the most of the flowers, which stand out as pale, spiky shapes against the mid-toned background. The artist has made extensive use of blending and burnishing methods to create soft effects, especially in the background, where a few of the leaves and stems have been picked out while others are suggested through subtle variations of colour and tone.

5 In the final stages, some of the yellow tulips were blended by working over them with a hard yellow pencil, and darker tones were brought in on the vase and background to give the drawing more impact. Notice that the artist has deliberately left small, white areas on the vase, stems and around the leaves to balance the white shape of the window.

FURTHER INFORMATION

⇒PENCILS AND GRAPHITE: COMBINING GRADES 18

⇒COLOURED PENCILS: BLENDING 66

⇒COLOURED PENCILS: BURNISHING 67

COLOURED PENCILS Building up colours and tones

Although coloured pencil is basically a line medium, you can achieve areas of solid colour and

considerable depth of tone by overlaying linear marks, using traditional hatching, crosshatching and shading methods. Colours can be mixed on the paper surface in the same way – this is usually necessary to some extent, as however large your range of colours, you will find you never have exactly the right hue or tone. Surface mixing also gives a more lively effect than pre-mixed colour: a green produced by laying reds, browns, yellows and blues over one another provides more visual interest than an area built up with one or two ready-made greens.

It is possible to some extent to work light over dark with coloured pencils, but although you can amend a colour in this way, you will not be able to completely obscure an underlying dark hue, so it is always best to work from light to dark. For the first layers of colour, keep the strokes relatively light to avoid clogging the grain of the paper, as this will limit the number of new layers you can apply on top.

HELPFUL ADVICE

Any type of drawing paper can be used, and smooth paper is the most popular choice, but some artists like to exploit a surface texture such as that provided by watercolour or pastel paper.

PLANNING THE COLOURS

- 1 The artist has begun by making an outline drawing in grey coloured pencil, and now lays on loose diagonal strokes of lemon yellow followed by crimson in the foliage areas and dark blue and black on the grass. Although using relatively strong colours, he takes care to work lightly so that he can lay more colours on top without clogging the paper.
- 2 He puts in a mid-blue behind the tree and builds up the colours on the trunks and branches, strengthening some of the latter with black. More foliage colours are then added, and burnt sienna is pencilled loosely over the yellow of the grass to provide a second tone.

3 Having now established most of the colours, he can begin to build up the darker areas and bring more colours into the foliage. To make a link with the grass, he brings in burnt sienna among the blues and blue-greens, which also provides additional warmth to the foliage. He continues to avoid too heavy a build-up of colours, and leaves some of the original yellow showing to reinforce the impression of sunlight.

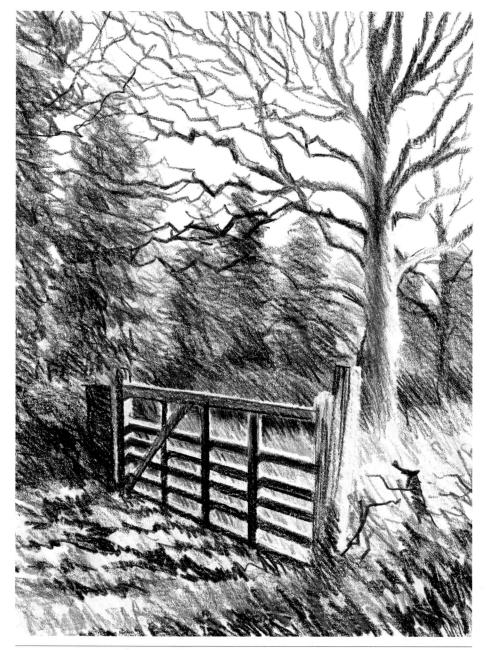

4 The gate now requires further definition, as it plays a vital role in the composition. For this, he uses indigo and brown pencils, kept well-sharpened, and takes care to preserve the white highlights. The tones on the main tree are strengthened in the same way, and then a blunted pencil is used to blend the blue-greens on the trees behind. To balance the composition, another tree is lightly sketched in on the far right, and the tones in the foreground are built up more solidly, with a blunted black pencil used for the areas of shadow.

SARA HAYWARD *A vigorous use of light, sketchy linear marks and solid areas of hatching ensure interest all over the painting. Notice the shadows, where several colours have been laid over one another to give an attractive shimmering effect.*

FURTHER INFORMATION

⇒COLOURED PENCILS: PENCIL CHOICES 60 ⇒COLOURED PENCILS: BLENDING 66

COLOURED PENCILS Paper choices

For quick sketches, linear work or light colour overlays, ordinary drawing paper provides an excellent surface, but if you want to build up several layers of colour, you will need a surface with more 'tooth'. On very smooth paper, the overlaid strokes will produce a compacted, slippery surface that can become unworkable.

The best papers to choose are those made for pastel work. You can also use watercolour paper, but this is only suitable for soft or waxy pencils, as the texture is too heavy to cover easily with harder pencils, resulting in white specks where the paper shows through the strokes. Pastel paper is easier to cover, and the regular, meshlike texture can add an extra dimension of surface interest to the drawing.

The paper colour can also play a significant role in the finished effect. Pale and neutral tints can be used for any coloured-pencil work, but strong colours are best suited to a linear approach or loose hatching methods, where the paper is deliberately allowed to show around and between strokes. Smooth drawing paper is sold in a wide range of both vivid and dark colours, which can be effective for certain approaches, or you can use coloured pastel paper if you prefer some texture to break up the strokes.

HELPFUL ADVICE

Experimenting with different surfaces will enable you to discover how both texture and colour influences the applied colours.

Coloured pencil on different tones of drawing paper

Coloured pencil on textured pastel paper

LETTING THE PAPER SHOW

1 For this drawing, the artist has chosen a smooth drawing paper in a warm, mid-toned, orange-brown. She starts with an outline drawing in black and then begins to build up the patterned clothing with a range of reds, browns and blacks, using wellspaced hatching and crosshatching strokes.

3 In the later stages of the drawing, highlights are added with a white coloured pencil. The whites on the central stick and on the shoes of the left-hand figure have been drawn more solidly, as here it was essential to cover the paper, but elsewhere, the ground colour shows through around and between the strokes to give a warm glow to the drawing.

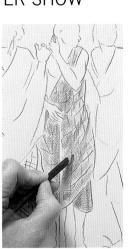

Coloured pencil on smooth, medium, and rough watercolour papers

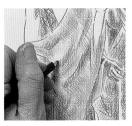

2 To achieve the shadows in the folds of the fabric, she lays one colour over another, but leaves enough space between strokes for the paper colour to show through.

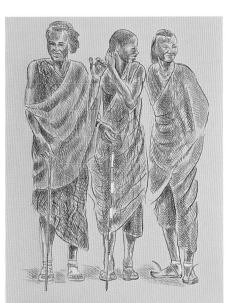

Transparent surfaces

Professional illustrators who work with coloured pencil sometimes draw on a transparent or semitransparent surface such as drafting film or good-quality tracing paper. This allows colour to be applied to both the back and the front, "thus increasing the range and depth of colours that can be achieved. Drafting film, which is highly translucent, although it has a slight blue or grey tint, is the choice of most professionals, but is expensive and usually has to be obtained from specialist suppliers.

The method is especially useful for subjects that feature intricate shapes set against a

background. In a flower study, for example, or a drawing of branches and twigs against a sky, the main shapes can be drawn on the front of the paper, and the background blocked in on the back. This lets you work more freely, as you don't have to laboriously shade around the important shapes.

DELICATE EFFECTS WITH PALE COLOURS

1 The artist is working on tracing paper, and begins by laying the first two tones on the front. The main shapes need to be established before the paper is turned over.

- 2 She now works on the back of the paper, building up the darker tones of the leaves.
- 3 After building up further detail to the stalks on the front of the paper, it is turned again and the background blue is added on the back of the paper.

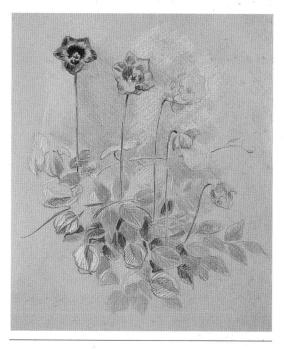

4 To complete the work, more tone and detail was added to both the front and the back of the paper, and the drawing was placed on coloured paper to bring out the brilliance of the pale hues.

FURTHER INFORMATION

 ⇒BASIC TECHNIQUES: CHOOSING THE RIGHT PAPER 12
 ⇒PASTELS: PAPER COLOUR 44
 ⇒PASTELS: PAPER TEXTURE 48

COLOURED PENCILS Blending

Blending simply means achieving soft gradations of colour rather than a series of overlaid lines that remain distinct. Chalky pencils can be blended in the same way as pastels and pastel pencils, by starting with a series of lines or solid areas of shading and rubbing the colours together, either with your finger or with a special implement called a torchon (a rolled-paper stump). Waxy and hard-textured pencils spread less easily, but colours can still be blended by laying one over another, keeping the strokes close together and following the same direction.

Partial blends, which give the impression of a solid area of colour while still retaining the character of drawn marks, can be achieved by the traditional techniques of hatching and crosshatching. For either of these methods, choose colours that are related to each other and close together in tone – working with contrasting colours will create a jumpy effect, which is the opposite of what you want.

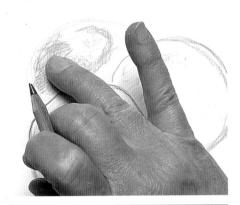

The chalkier types of coloured pencil can be blended with a finger, just like graphite pencils or pastels.

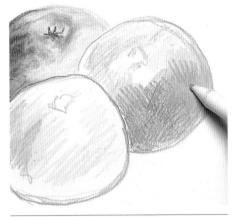

You can also use a torchon to soften the transition between colours.

Close shading lines graduating from blue to red

Solid colours blended together by overlaying

Crosshatched lines in related shades of pencil

HELPFUL ADVICE

If you are buying coloured pencils for the first time, avoid mail order purchases if possible, as you need to try out one or two pencils to check how easily they can be blended. Most good art stores provide a 'scribble pad' for this purpose.

Burnishing

This method takes blending a step further. The pencil marks are pushed into the paper, producing a glazed, light-reflecting surface that increases the brilliance of the colours. Burnishing is usually done in the final stages of a drawing, and the traditional method is to shade closely and firmly over existing colours with a white or pale grey pencil. If you wish to modify one or more of the underlying colours, a contrasting hue could be chosen, but it must be light in tone. Waxy pencils can be burnished with a plastic eraser or torchon, and can also be used to burnish over a previous layer of chalky pencil, whose texture does not easily produce an impacted, glossy surface. Depending on the subject and the effect you want to achieve, you can burnish the whole of the drawing or restrict the method to selected areas. For example, in a flower study, you might imitate the smooth, reflective surface of a vase or polished table by White pencil

Torchon

burnishing, contrasting these smooth areas with looser, more textured marks elsewhere in the drawing.

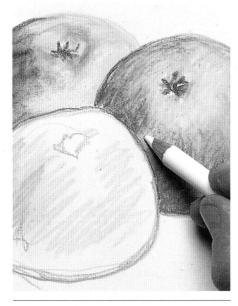

White pencil is commonly used for burnishing, but bear in mind that it naturally lightens the colour a little. Firm pressure is needed to compress the underlying pigment.

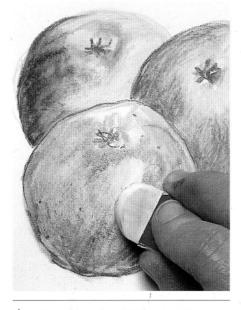

A plastic eraser is most suitable for burnishing highlight areas, because it will remove some of the pigment.

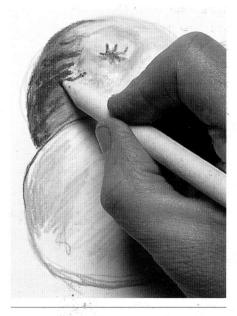

Torchons are especially made for coloured-pencil and pastel work, and are very useful for burnishing as they don't change or remove the colour.

FURTHER INFORMATION

⇒ PASTELS: BLENDING AND COLOUR MIXING 42

COLOURED PENCILS Scratching back

One of the disadvantages of colouredpencil work is that it is difficult to make corrections; erasing is only possible to a limited extent. Light lines made with a chalky pencil are sometimes possible to remove with a kneadable eraser or a piece of bread pulled to a point, but the erased line may still leave a colour stain on the paper. Using a plastic eraser on waxy pencils tends to spread the colour and push it into the paper surface – this type of eraser is more useful for burnishing than for making corrections.

However, you can remove a layer of pencil by scratching back with the side of a blade, a method commonly used for highlighting, reclaiming lost highlights, and removing a too-heavy build-up of colour. It works best on smooth drawing paper, as the knife would simply scuff the top grain of textured paper, leaving colour in the 'troughs'. Use the flat of the blade: the point should be reserved for drawings in which there is an intentionally heavy buildup of colours, as in the sgraffito technique, which is equally well-suited to waxy coloured pencils.

SCRATCHED TEXTURE

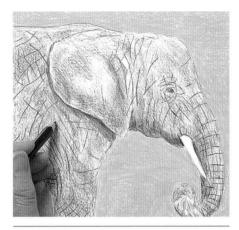

1 The background and elephant's head have been brought to semi-completion, with diagonal hatching lines of grey and white beginning to suggest the texture. The artist now uses black lines to draw the pattern of wrinkles on the hide.

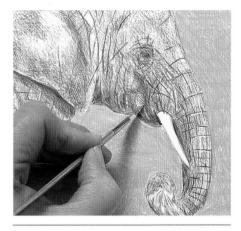

2 For the highlights, where the wrinkles catch the light, she scratches into the pencil work with the point of a sharp knife.

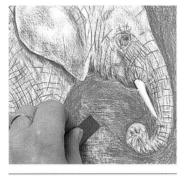

3 Having darkened the background to make the head stand out better, she scratches into this second colour with a razor blade to reveal some of the paler underlying colour.

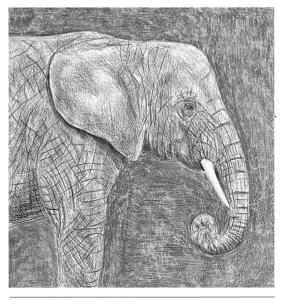

HELPFUL ADVICE

When scratching back, care must be taken to use the flat of the blade, keeping it level with the paper surface to avoid making gouge marks.

4 The finished drawing gives an excellent impression of the leathery hide, which is enhanced by the subtle background texture.

Squaring up

Because of the difficulties of correcting colouredpencil work, it is important to make the preliminary drawing as accurate as possible. For any complex subject, it is best to begin with a light drawing in graphite pencil, which can be erased easily. If you are working from a photograph, you can ensure accuracy by using the squaring up method.

Working from photographs usually involves enlarging the image, and although this can be done freehand, it is difficult to change the scale of objects without making mistakes. Squaring up involves drawing a grid over the photograph, and another, proportionately larger, grid (with the same number of squares) on the drawing paper. For example, if you use a 1-in (2.5-cm) grid on the photograph and want to double the size, the grid on the paper must be 2 in (5 cm).

The grid on the photograph helps you to identify the position of each object, and you can then transfer the information onto the paper, working square by square and taking note of where each line intersects one of the grid lines.

Grid drawn onto tracing paper overlaying photograph

TRANSFERRING IMAGES

For a relatively simple subject like this one, the drawing could be made freehand, but using the squaring-up method ensures that the perspective is correct. The artist has protected the photograph with tracing paper before drawing the grid, and has marked the larger grid lightly on the drawing paper. Having copied the main lines, she now begins to fill in the shapes.

HELPFUL ADVICE

Although squaring up is a rather slow method, it is worthwhile, and also enables you to adjust the composition if desired, making one object larger or smaller or changing shapes slightly.

COLOURED PENCILS Frottage

The name of this technique comes from a French word meaning 'rubbing', and it will be familiar to anyone who has made rubbings of church brasses. A piece of paper is placed over a flat, textured surface and shaded with coloured pencil so that the underlying texture comes through. The potential of the method was more or less accidentally discovered by the German Surrealist painter Max Ernst, who found that taking rubbings from rough wooden floorboards and other surfaces evoked all sorts of images, rather like seeing pictures in a fire.

The method is perhaps best suited to abstract or semi-abstract approaches, but it could also be used in a representational drawing to supply elements of texture in certain areas. For

HELPFUL ADVICE

This technique is best used on smooth paper, as textured paper would conflict with the texture to be rubbed, thus confusing the image. example, in a still life, you might take a rubbing of actual wood grain for the table top, or bring in a background texture by making a rubbing of a piece of coarse fabric. It is an enjoyable technique to experiment with, and almost any textured surface can produce results, from wood grain, tree barks and rough walls to manmade materials such as fabric, wallpaper, or cork or raffia table mats. Frottage is not restricted to coloured pencil; the shading can be done with any dry medium, such as pencil and graphite, pastels and oil pastels.

A look around your home will reveal many textured objects suitable for the frottage method, but take care with curved metallic surfaces such as this grater, as they could tear the paper.

Lace fabric

Textured stone

Wood grain

EXPLOITING READY-MADE TEXTURES

 The artist began by sketching out the composition. He then took rubbings by placing the paper over textured surfaces, using bamboo matting for the bow and a piece of rough wood for the table top.

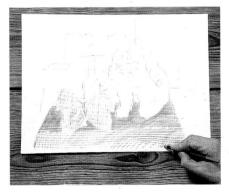

2 Having added shadows to the frottaged table base, he now builds up colour on the bow, using vertical and diagonal hatching lines.

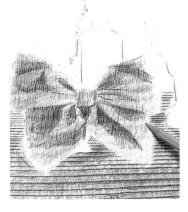

3 For the background areas, he takes rubbings from two different sides of a metal sheet, using orange and red-brown coloured pencils.

4 The texture of the rectangle behind the bottle was achieved by rubbing purple coloured pencil over metal mesh, and various colours are now rubbed over the sole of a shoe for the Chinese dog.

5 The textures are complete, and the drawing is built up with coloured pencil to add detail and tone. To give unity to the composition, the turquoise on the bottle is repeated on the bow.

6 The artist has created a lively and unusual composition in which the focal point is the untextured, brilliantly-coloured bottle, contrasting with the mechanical patterns provided by the frottage.

FURTHER INFORMATION

⇒PENCILS AND GRAPHITE: COMBINING GRADES 18

⇒ PASTELS: DRAWING WITH PASTELS 40

COLOURED PENCILS Impressing

If you make an indentation in the paper by pressing into it with a paintbrush handle or similar blunt instrument, and then shade over it, you will see a white line where the indentation has been made. The applied colour will catch on the top grain of the paper, but will not sink into the 'trough' made by the drawing implement. Once you have made the initial lines, you can shade over them with any colours you choose, and the applied colours will glide over the paper surface, leaving the impressed lines intact.

This method, also known as 'white line drawing', can be very effective in coloured-pencil work, and is a valuable technique in its own right, as it is more or less impossible to achieve strong white lines by any other means. It is an excellent method for drawing leaf or petal veins in a floral study, for creating white patterns or intricate detail against a coloured background, or for rendering various textures. The line does not, of course, have to be white – you can work on tinted paper, overlaying a pale line with darkertoned or contrasting colours.

The only difficulty with the method is that it involves drawing 'blind', as you won't be able to see the lines you are making. However, you can give yourself a guide by making a light pencil outline. Or alternatively, make a drawing on tracing paper first, lay it over the drawing surface, and impress the lines just as though you were making a tracing of the subject.

Classic white-line effect

Dark-line effect on toned paper

Red-green complementary contrast

Marks made with graphite pencil

Almost any pointed implement can be used to make an impression on the paper, from burnishing tools to paintbrush ends.

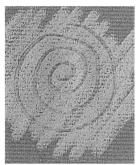

Marks made with end of paintbrush

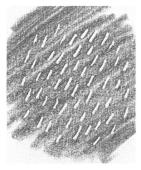

Short stipple marks made with a ballpoint pen

HELPFUL ADVICE

To obtain the best results, work on a smooth but strong surface that won't easily tear, such as a good-quality drawing paper or pastel paper, rested on a plastic mat or folded sheets of inexpensive paper such as newsprint.

WHITE LINE PATTERN

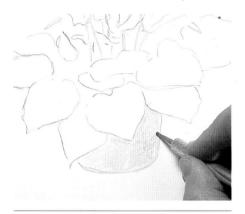

1 The artist has made an outline drawing of the subject and laid some light colour on the plant pot. She now uses a special tool designed for burnishing and embossing to draw an impressed pattern.

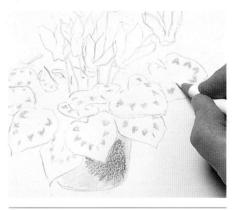

2 The pattern on the leaves is to remain white, so the impressing is done before any colour is laid, using a well-sharpened, hard, white pencil.

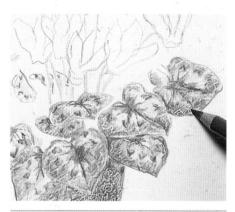

3 Colour is now laid on the leaves, and a second tone added to the plant pot. The coloured pencil adheres only to the flat surface of the paper, leaving the impressed lines white on the leaves, and very pale brown on the pot.

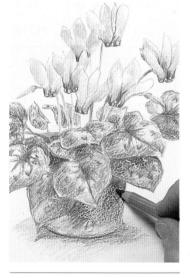

4 The form of the plant pot is built up with darker tones, and shadows are added beneath the leaves to bring them forward in space. **5** The drawing was completed by adding darker tones in places to give solidity to the forms and make the impressed lines stand out more strongly.

FURTHER INFORMATION

⇒ PASTELS: PAPER COLOUR 44

 ⇒ OIL PASTELS: SGRAFFITO 58

 ⇒ COLOURED PENCILS: BURNISHING 67

COLOURED PENCILS Water-soluble pencils

Several manufacturers produce ranges of 'watercolour' pencils and pastels (the latter are sometimes called crayons) that can be used both as a drawing and a painting medium. When dry, they behave in much the same way as coloured pencils or pastels – though the crayons are of a different consistency to chalk pastels – but colour can be spread across the paper with a wet brush to achieve watercolourlike washes. These are very useful for outdoor sketching, as they allow you to lay broad areas of colour more quickly than by shading methods. They are less suited to painterly approaches, as the capacity to overlay or mix wet colours is rather limited. The pigments don't have the translucency of true watercolours, and quickly become chalky or muddy, so the best approach is to restrict the washes to a single colour and give equal importance to the line. A linear mark will still retain its identity if you wash over it quickly with a damp brush – you will need to experiment to discover how much water to use. You could also use shading or hatching methods with the dry pencils, washing lightly over them to partially merge the colours.

Hatched lines brushed with water

Crosshatched lines brushed with water to create a wash effect

Albondia 🛶 🖂 🗤

GERANUMROT HELL, PA

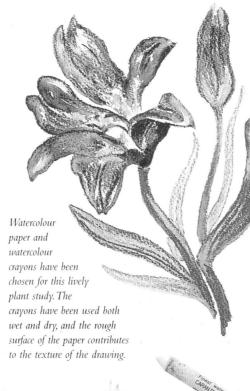

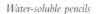

Water-soluble crayons are waxier than pencils

ALL MEDCOLOR II * 7500 TOT

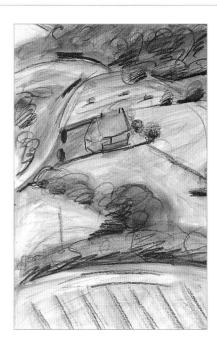

SARA HAYWARD ♦ SUMMER LANDSCAPE

The artist has achieved a nice balance between line and wash, exploiting both brushmarks and varied linear effects. Water has been used sparingly so that the lines are still visible beneath the washes.

Line and wash

The traditional line-and-wash technique involves drawing with a pen and black ink and adding colour and tone with watercolour or diluted ink. This can present a problem in fully integrating the drawing, as the black lines stand out against pale washes. With watercolour pencils the lines can be made in any colour you choose, with the washes a lighter tone of the same colour, so there is an obvious relationship between the two. This method is most suitable for subjects with a strong linear structure, such as a figure drawing or a stylised portrait or flower study. The line is established first, using the pencil quite heavily to ensure that there is sufficient pigment on the paper to allow it to be spread into a wash. When the washes have dried, lines can be reinforced and new ones added if necessary. Or you can work into a damp wash with a dry pencil, which will soften the line to produce a 'lost edge' effect.

SUBTLE WASH EFFECTS

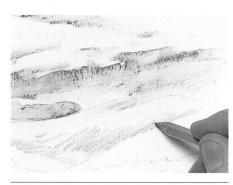

1 The artist began by drawing the sky with blue and grey pencils, and then washed over the marks, using enough water to make the washes run slightly. She now draws the middle-distance hills.

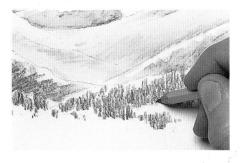

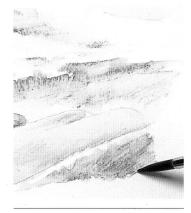

- 2 The raw sienna for the hills was in turn washed over, leaving a hard edge where the wash dried, and a stronger colour is now used for the area just behind the foreground. Less water is used to wash over this colour, leaving the lines visible.
- **3** The foreground is drawn with burnt umber and grey pencils, using firm, vertical strokes that contrast with the diagonals in the area behind.

Water-soluble crayons brushed with water

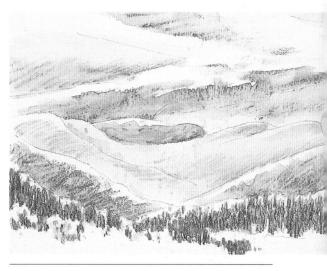

4 The dry pencil marks in the foreground bring it forward in space as well as echoing the jagged edges formed where the wet washes have spread and dried.

FURTHER INFORMATION

⇒LINE AND WASH: PEN AND WASH 82

⇒LINE AND WASH: PENCIL AND WATERCOLOUR 84

⇒LINE AND WASH: WATERCOLOUR AND COLOURED PENCILS 86

COLOURED **INKS** Inks and markers

Drawing with coloured inks and marker pens used to be mainly the province of professional illustrators, as most inks were not fully lightfast, and faded badly over time. This did not matter when work was done for an immediate presentation, and original drawings were usually copied by laser printing or similar methods, but for the fine artist it presented a serious problem.

Nowadays, however, there is little need to worry about fading, as ink-making technology is rapidly improving, and several manufacturers produce ranges of permanent inks in pure and brilliant colours. Most of these are acrylic-based, which means that they are soluble in water, but form an impermeable surface once dry. Bottle inks can be applied with a pen or a brush, or you can use coloured-ink pens (markers), which combine the colour with the drawing implement to allow a rapid application.

The best-known type of marker pen has a broad, wedge-shaped tip, which is ideal for covering large areas, but fine and medium points are also available for linear approaches and detail. The inks they contain are either water- or spirit-based, and in both cases are transparent, enabling colours to be mixed on the paper surface. The water-based ones are the best choice, as spirit-based inks tend to bleed through to the back of the paper.

Marks made with a fibre-tipped marker

Marks made with a wedgeshaped marker

inks

Continuous tone using a marker

Ink marks made using bamboo pen and medium paintbrush

Pearlescent

HELPFUL ADVICE

Take care when buying markers, as some are sold for office purposes rather than as fine-art materials, and these are unlikely to be fully lightfast. If you have a favourite artsupply shop, ask for advice. If ordering by mail, choose an established manufacturer such as Edding, and make sure you read the catalogue description.

DRAWING WITH COLOURED INKS

1 The artist begins by brushing in the larger branches, flooding in more ink in places to vary the tones. She is using a medium-sized, round watercolour brush.

2 The smaller branches are drawn with a dip pen. Although the same colour of ink is used, the marks are lighter because the pen holds less ink than the brush.

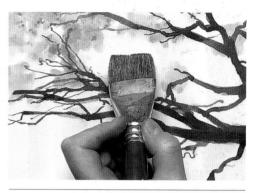

3 The drawing is allowed to dry, and a wash of diluted, pale pink ink is applied over the whole surface, using a large flat brush and vertical strokes.

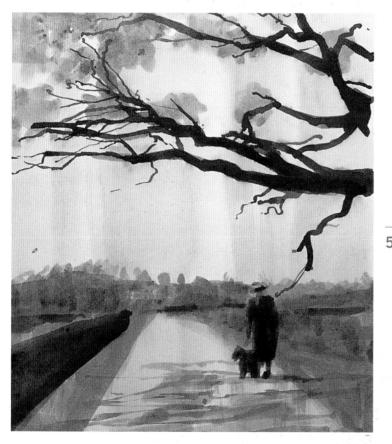

5 In the final stages, touches of detail were added with layers of diluted ink applied with the round watercolour brush. The almost monochromatic treatment creates a strong sense of atmosphere. 4 The figure is to be a lighter tone than the branches, so it is painted in slightly diluted ink. For the background, the ink is diluted even more, and touches of green are brought in.

FURTHER INFORMATION

 ⇒PEN AND INK: DRAWING IMPLEMENTS 28
 ⇒BRUSH AND INK: DRAWING WITH A BRUSH 32
 ⇒COLOURED INKS: INKS AND MARKERS 76

COLOURED INKS Overlaying colours

Because coloured inks are transparent, as are those in marker pens, colours can be mixed on the picture surface by laying one on top of another. Bottled inks can also be pre-mixed in a palette, and diluted with water to produce a range of tones. Markers don't offer the latter advantages, and are thus most suitable for bold approaches that exploit the brilliance of colour that makes the medium so exciting.

Coloured-ink drawings, like watercolours, should be worked from light to dark – although you can modify a dark colour by working a lighter one on top, you will not be able to cover it fully unless you make the ink opaque by adding white. This can spoil the translucent effect, so should be used with care, but white ink is useful for making corrections, or for introducing highlights or touches of texture in a drawing.

If you are mixing on the paper surface rather than on a palette, avoid building up too many layers of different colours, as this can cause muddying. It is a good idea to try out various colour mixes on a spare piece of paper before starting on a finished drawing, but use the same surface for both, as the texture will to some extent affect the appearance of the colours. On watercolour papers, the ink tends to sink in, while on a smooth drawing paper, it will 'sit' on top of the paper grain to produce more solid colours.

HELPFUL ADVICE

If you are using ink diluted with water for the early stages, you may need to stretch the paper, as shown on page 13.

White and pearlescent silver inks

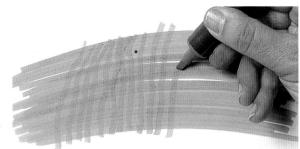

Tone built up with two layers

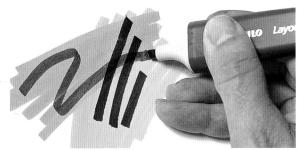

Dark marker lines overlaid onto paler flat area of colour

'Brush' markers

ACHIEVING RICH COLOUR EFFECTS

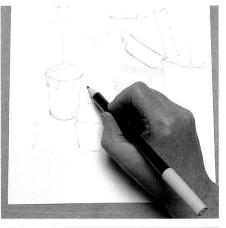

1 The artist begins with an outline drawing, using fine markers in several different colours.

2 She now lays on the first colours, building up in layers from light to dark as in watercolour painting.

3 The tones and colours are gradually strengthened with overlays of colour. The white of the paper and the first pale colours are left as highlights.

- 4 The building-up process continues, with details added and shadows strengthened. Because the inks are waterproof and transparent, several layers
- of colour can be laid over one another without disturbing those below.

5 The richness and density of colour is a characteristic of coloured inks, and would be difficult to achieve with any other medium.

FURTHER INFORMATION

⇒COLOURED INKS: INKS AND MARKERS 76

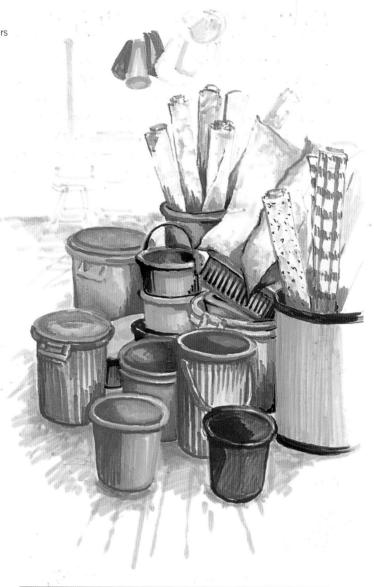

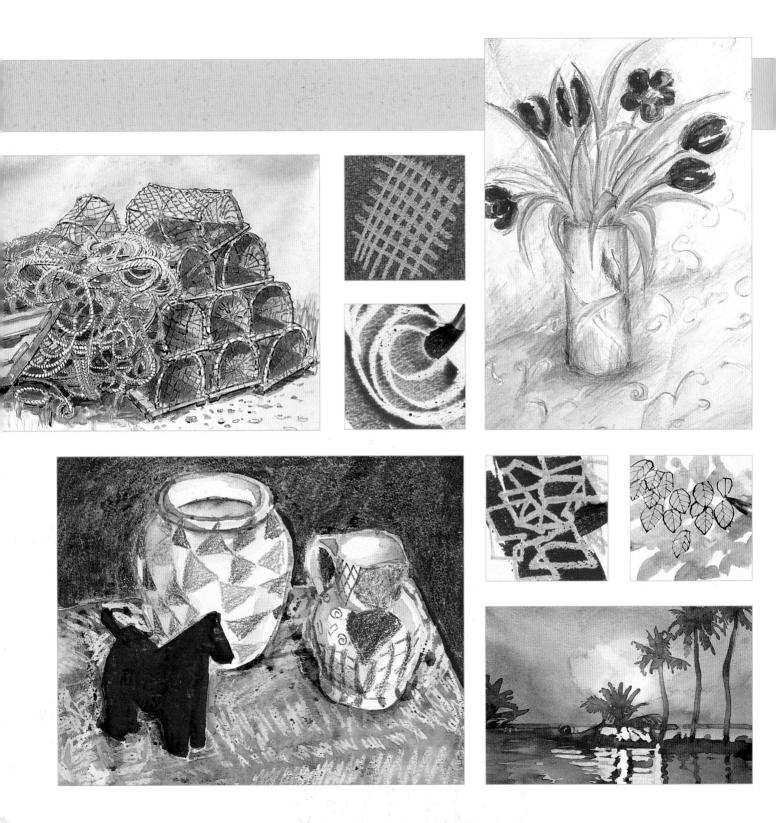

MIXED MEDIA

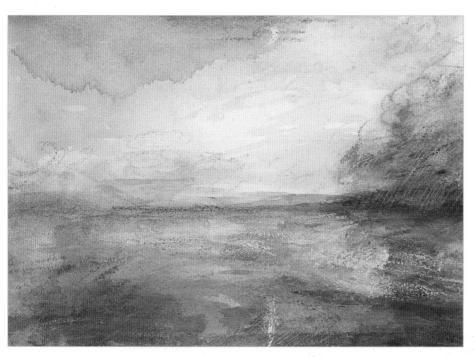

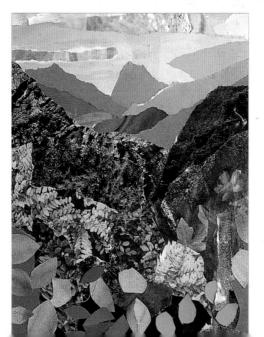

CHAPTER 3

Mixed-media drawings were at one time mainly restricted to traditional techniques such as pen and wash, but as artists continue to experiment and push out the boundaries, new and exciting possibilities have begun to emerge. If you try out some of the methods shown on the following pages, you may discover interesting variations of your own – mixed-media drawings invite a personal and individualistic approach.

INCLUDES

⇔LINE AND WASH:	Pen and wash 82 Pencil and watercolour 84 Watercolour and coloured pencil 86 Watercolour and pastel 88
⇒RESIST TECHNIQU	JES:
	Masking fluid 90
	Masking tape 91
	Wax/oil resist 92
	Oil pastel and ink 94
⇒UNUSUAL TECHN	IQUES:
	Wash-off 96
at a start	Ink and bleach 98
	Conté and oil bar 99
⇔COLLAGE:	Drawing over paper shapes 100 Drawing with torn paper 102
⇒HOME PRINTMAK	ING:
	Handmade monoprints 104
A. C.	Colour monoprints 106

LINE AND WASH Pen and wash

Pen and wash – using a fine pen in combination with pale, flat, watercolour washes – is one of the oldest of all mixed-media techniques. Before watercolour became fully recognised as a medium in its own right in the eighteenth century, it was largely used for tinting what were essentially line drawings, thus playing a secondary role in the finished work. This is still an effective method for subjects in which line is more important than the colour, but most artists now prefer to exploit interactions of linear marks with loose, multicoloured washes and brushstrokes of watercolour to build up more dynamic effects. There are many different approaches to penand-wash drawings. The traditional method was to make the complete drawing first, but it is often more effective to develop line and colour simultaneously, laying washes over a sketchy pen drawing and then working into the colour with more line. Alternatively, the watercolour can be completed first, or brought to a semi-finished stage and then given linear definition where needed. If you do this, however, take care not to concentrate the line in one area of the painting, as this will focus too much attention on one part of the picture at the expense of the rest.

You can use any kind of pen, including fibretipped pens and markers, but try not to make the marks too uniform. Vary them from thick to thin, and make small dots, dashes and blobs as the subject demands.

HELPFUL ADVICE

If you want the line to merge into the colour so that it doesn't stand out too strongly, try a water-soluble pen, or a nib pen with watersoluble ink. The wet washes will spread the ink, softening the marks while still leaving them visible.

Washes over hatched lines in permanent ink

Line over background washes

Washes create base shapes and pen lines add detail.

The marks shown here have been made over dry watercolour, with another wash added on top. The implements and inks are, from left to right: dip pen and India ink, dip pen and writing ink, dip pen and acrylic ink, water-soluble fibre-tipped pen, and permanent fibre-tipped pen.

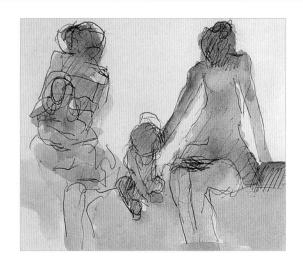

Elinor K. Stewart 💠 Fountain, Aix

A combination of ballpoint pen and watercolour was used for this delightful outdoor sketch, with the water provided by the nearby fountain. The drawing was made very quickly, with no attempt at detail, and lines drawn over one another as the figures changed position.

VARYING THE LINE

 This is an intricate subject in which the linear pattern is of major importance, so the artist begins with a careful line drawing, using a fine graphic pen.

2 He then applies a series of small, loose watercolour washes, not attempting to stay precisely within the drawn lines.

3 After further washes in various colours, a fine red drawing pen was used to reinforce the original lines, and the swirling pattern of the ropes is now emphasised with stronger black lines made with a fibre-tipped pen.

4 A paintbrush is dipped into opaque orange acrylic ink and further lines are drawn to build up the cobweb pattern of the fishing baskets.

5 To complete the drawing, the artist continued the process of alternate washes and line work, and then painted the highlights on the ropes with tiny brushstrokes of opaque white ink. Notice that the orange ink on the fronts of the baskets has acted as a resist, repelling the darker watercolour washes laid on top.

FURTHER INFORMATION

⇒PEN AND INK: DRAWING IMPLEMENTS 28

⇒PEN AND INK: LINE AND TONE 30

⇒COLOURED INKS: INKS AND MARKERS 76

LINE AND WASH Pencil and watercolour

Soft pencils, conté pencils, or even charcoal can be used in combination with watercolour in the same way as pens, giving a softer effect that some artists find more sympathetic. In a way, this is a more natural and direct approach – watercolours usually require a preliminary pencil drawing, so you will just be continuing as you started, using pencils and brushes hand-in-hand. In a normal watercolour, care must be taken not to make the underdrawing too heavy, or it will show through the lighter washes. In this method, however, the pencil is intended to play a major role in the finished drawing, so the first lines are deliberately allowed to show through, and built up further as the colour is darkened and intensified.

Those who are more expert in drawing than in watercolour painting will find this a very forgiving technique, as any mistakes or unsuccessful passages of colour can simply be drawn over with pencil shading and reinforced with pen lines if needed.

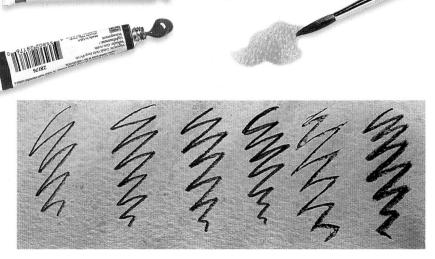

Different grades of pencil and crayon over a dry watercolour wash. From left to right: 2B, 4B, 6B, 8B pencil, conté crayon, charcoal pencil

COMBINING LINE AND COLOUR

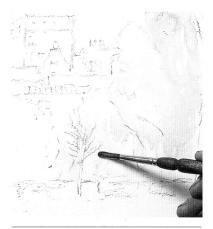

1 Working on watercolour paper, and using a soft carbon pencil, the artist has drawn out the composition and now lays on the first pale watercolour wash.

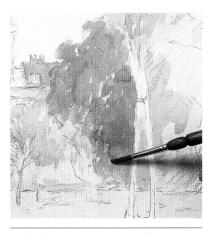

2 He continues to build up the washes, working from light to dark, and now concentrates on the large tree in the foreground. He applies the paint loosely, allowing blotches to form in places, and leaving small white patches to suggest the light coming through between clumps of foliage.

HELPFUL ADVICE

You will need a range of soft pencils for this technique, from about 2B to 6 or 8B, or you can use a conté or carbon pencil for the darker lines in the final stages of the drawing.

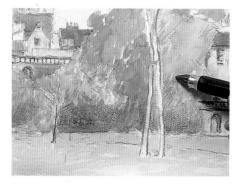

3 Once the washes have dried, a graphite stick is used, first to define the tree trunk, and then to apply shading at the bottom of the foliage.

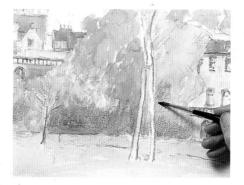

4 More watercolour is applied over the pencil shading to soften this area of foliage. The wet paint causes the pencil marks to spread slightly.

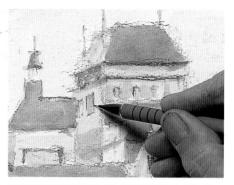

- 5 The original pencil marks are reinforced by picking out a few details on the building with a fine retractable pencil.
- 6 The combination of pencil, pen and watercolour is ideal for architectural subjects, as it is easier to draw small details such as windows, chimneys and so on than to paint them with a small brush.

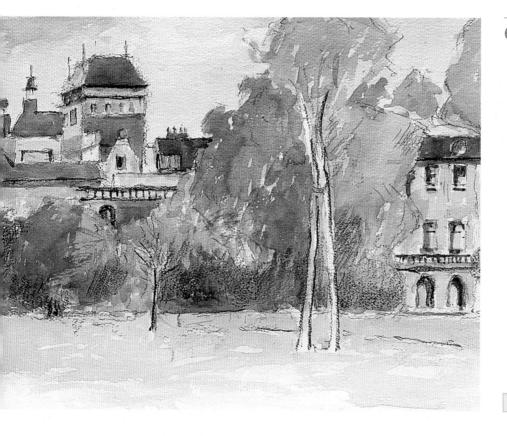

FURTHER INFORMATION

 ⇒PENCILS AND GRAPHITE: DRAWING WITH PENCILS 16
 ⇒PENCILS AND GRAPHITE: COMBINING

GRADES 18

LINE AND WASH Watercolour and coloured pencils

In most line-and-wash methods, especially pen and wash, the line element stands out from the fluid medium simply because it is monochrome and usually darker than the colour washes. By combining coloured pencils with watercolour, you can achieve softer, more integrated effects, as you are working colour into colour. Added to which, the two media are natural partners, with the clear, bright hues of the pencils complementing the translucency of watercolour. Coloured pencils can be used simply to sharpen up areas of a watercolour painting in the final stages, or the drawing can be planned from the outset as a mixed-media exercise in which linear marks are contrasted with fluid washes and brushmarks. You can start with watercolour directly, or make a coloured-pencil outline, paint into it, and then continue to build up with both media at the same time. Another use for watercolour in this context is to make an underpainting for a coloured-pencil drawing. This can save a lot of time, and also allows you to exploit colour contrasts. For example, you might work over a blue watercolour sky with mauve coloured pencils, keeping the strokes sufficiently far apart for the first colour to show through. Or you might use a red underpainting for a tree, working over it with greens and browns.

HELPFUL ADVICE

Always let the washes dry before applying more pencil, unless you are using water-soluble pencils, in which case you can work into wet watercolour. This can be very effective, as the underlying water content softens the pencil tip, giving broad marks of dense colour.

Coloured pencil marks over a contrasting-coloured watercolour wash

Coloured pencil marks over a similar-coloured watercolour wash

EMPHASISING STRUCTURE

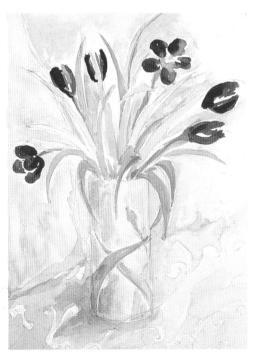

1 The combination of watercolour and coloured pencil allows you to emphasise detail and structure while still retaining the essential fragility of the watercolour medium. The artist began with a faint coloured-pencil outline and then washed in watercolour.

2 She laid on further watercolour washes to build up the colours, and when dry, worked into the stems and leaves with coloured pencils.

3 Some shading is now added with a blue pencil to darken the background and help the leaves to stand out.

- 4 The process of building up the picture continues, with alternate watercolour washes and colouredpencil work. The watercolour is allowed to dry before drawing over it with pencil.
 - 5 The shadow beside the vase had already been suggested at the initial wash stage, and is now reinforced with pencil shading.

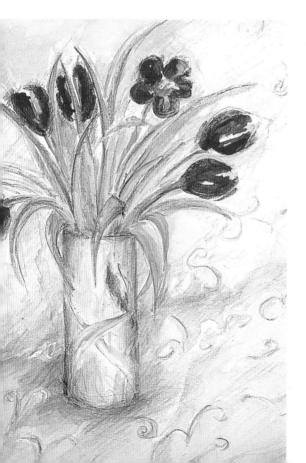

6 A little more detail was added all over the picture, and loose marks made in the foreground to suggest a patterned cloth and to make a link with the leaf and flower shapes.

FURTHER INFORMATION

⇔COLOURED PENCILS: PENCIL CHOICES 60 ⇔COLOURED PENCILS: WATER-SOLUBLE PENCILS 74

LINE AND WASH Watercolour and pastel

Chalky pastel has a very different surface quality to watercolour, so combining these media can be more problematic than coloured pencil and watercolour. However, quite a few artists do use the two together, usually beginning with loose watercolour washes and then laying pastel on top. You will need to use watercolour paper, the texture of which will break up the pastel strokes, but this can be an effective way of adding an element of texture to a drawing.

As an alternative to watercolour, you might try gouache, the opaque version of the medium. This has a similar matt surface to pastel, making the mixed-media effect more subtle. Also, pastel paper provides an excellent surface for both the gouache and the pastel, so the strokes can be laid more densely if required. The best approach is to lay down the basic shapes and colours with the gouache, allow the painted layer to dry, and then work over it with pastels or pastel pencils to build up detail, pattern and texture.

HELPFUL ADVICE

Because pastel is opaque, you can make changes or even bring in new elements as you work, so this method is well suited to those who like to let drawings develop rather than planning them in detail beforehand.

Dark blue pastel over light blue watercolour on watercolour paper

Contrasting colours of pastel and watercolour on watercolour paper

Light blue pastel over opaque dark blue gouache on smooth paper

Yellow pastel over opaque dark blue gouache on smooth paper

Gouache

GOUACHE AND SOFT PASTEL

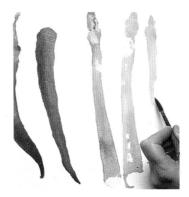

1 The artist begins with diluted gouache, which looks very similar to watercolour. The traditional method is to work up from thin to thick, but in this case the opaque colour will be provided by the pastels.

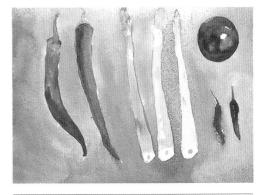

2 Still using diluted gouache, with no addition of white (which makes it opaque), she lays an orange wash all around the objects.

Watercolours

3 Blue soft pastel is now brought in, with patches of the orange allowed to show through to give a complementary contrast in the background.

4 The colour of the chilies is intensified with red pastel, using the point of the stick to give fine lines.

5 Highlights are added with thick white gouache, which blends slightly into the underlying reds to give a soft effect.

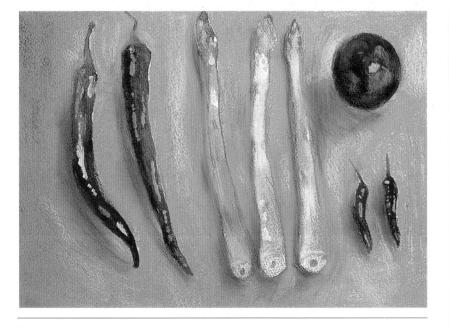

6 The smoothness of the apple and chilies contrasts with the rougher texture of the background and asparagus stalks.

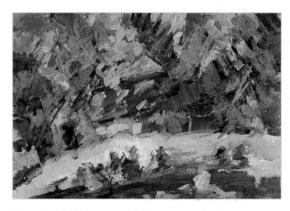

ELINOR K. STEWART Several media have been combined in this vivid landscape – charcoal, gouache, watercolour and soft pastel. The gouache has been used quite thickly on the trees, with light colours laid over dark.

FURTHER INFORMATION

⇒PASTELS: DRAWING WITH PASTELS 40

⇒MIXED MEDIA: WATERCOLOUR AND COLOURED PENCILS 86

RESIST TECHNIQUES Masking fluid

Masking fluid is a rubber latex solution, which is sold in bottles and applied with a brush. It is often used by watercolour painters to reserve highlights or any other areas of a picture that are to remain white or paler than the surrounding colours. In

this context, it provides a practical solution to the problem of painting around intricate highlights, but can be used in a more creative way, as a method of painting in 'negative'. The brushmarks you make with the fluid can be as expressive and varied as the 'positive' ones you make with the fluid, medium – watercolour, coloured inks, or fibre-tipped pens – so that you can contrast white shapes with coloured ones.

But the masked shapes and brushmarks don't have to remain white – they will often appear too glaring in contrast to the other colours, and will need to be tinted. You can also plan coloured masked effects by using a layering method, applying the masking after you have laid one wash of colour and then painting on a second darker hue. This process can be repeated several times, as the fluid can be removed at any time during the working process.

PAINTING NEGATIVE SHAPES

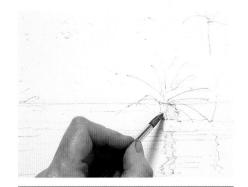

1 As in any painting in which highlights play an important part, it is vital to work out their placing at the outset. The artist makes a pencil drawing and then paints on the masking fluid.

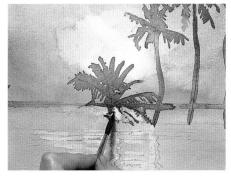

- 2 She has laid a first and second tone, using diluted coloured inks, and – when dry – has painted on more masking fluid in the foreground. She now adds detail to the central tree and reflections.
- 4 To complete the painting, the sky and water were darkened with additional washes to bring out the full effect of the setting sun reflected in the still surface.

3 The ink is allowed to dry, and both layers of masking are rubbed off. Where the masking was laid on white paper, the highlights remain white, but those laid over a previous colour retain the pale brown of the wash.

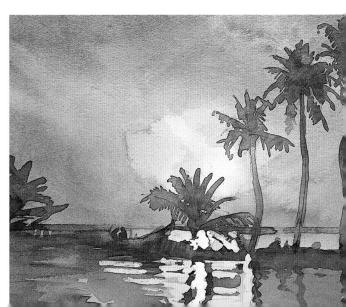

HELPFUL ADVICE

- Use an old brush for masking fluid, and wash it immediately after use. Once dry, it cannot be removed from the hairs.
- Don't use masking fluid on any highly textured paper, as removing it may tear the surface. Cold-pressed watercolour paper or drawing paper are the best choices.
- Masking tape is primarily made for painters and decorators, and can be too sticky for art purposes. To remove some of the 'tack', stick it lightly to your arm or the back of your hand and then pull it off.

A piece of masking tape, roughly torn along one edge, is stuck onto the paper and ink is applied on top.

When the ink is dry, the tape is removed.

USING MASKING TAPF

- 1 The pattern of a tablecloth is to be achieved with masking tape. The artist has sketched in the main lines of the composition and now sticks down the tape. To produce a scalloped edge where the fringe is to be, he has torn small pieces from one edge of the tape.
 - 3 The tape is removed and more coloured-pencil work is done, including drawing the fringe. The uneven edge provide by the torn tape gives a more natural impression than a straight edge would have done.

2 He now begins to fill in the shapes with coloured pencil, working lightly so that the tape does not become dislodged.

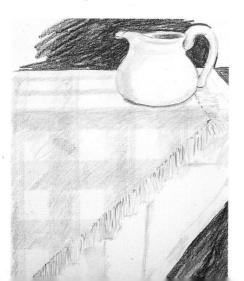

Masking tape

If you need to reserve straight lines (for example in an architectural study. where you want to lay a wash over the background while keeping the edges of the building sharp and clear, masking tape is more useful than the fluid, as it's not easy to paint straight lines. The tape should be removed as soon as the wash is dry, or the glue may spoil the paper. This method of masking is not restricted to the fluid media: you can use it with pastels, coloured pencils, or most of the monochrome media, though it is least successful with soft pastels, as the paper grain reduces the clarity of the edges. It works best on fairly smooth paper.

To introduce a pattern element into a drawing, try cutting broad strips of the tape into shapes with a sharp knife. Or alternatively, you might use the custom-made shapes – stars, crescents, and so on – that are readily available in most stationery stores. But don't stick them down too firmly or they may be difficult to remove.

FURTHER INFORMATION

⇒COLOURED PENCILS: BUILDING UP COLOURS AND TONES 62

⇔COLOURED INKS: INKS AND MARKERS 76

RESIST TECHNIQUES Wax/oil resist

On smooth paper, the resist will be more

complete, especially if you apply heavy pressure.

These cravons are thinner than normal candles,

with good points, thus enabling more precise

still-life object, several colours of wax crayon

drawing. To suggest patterns on wallpaper or a

could be used to sketch in the patterns, or just

to suggest them by means of broken lines, dots

shading in various ways with wax crayons. The

and dashes. Forms can also be built up by

Wax crayons (the kind sold for children)

provide a means of making coloured resists.

Masking fluid and masking tape, dealt with on the previous pages, form a complete block to the paint applied on top, whereas the methods shown on these pages act as a partial block. Oil and wax do not mix with water, so if you scribble lightly on paper with a candle and then lay on washes of watercolour or coloured inks, the colour will slide off the waxed areas. Worked on textured paper, this creates an attractive mottled effect that is excellent for suggesting texture, as the wax will sit on the top grain of the paper, while the wet colour will sink into the 'troughs'.

Candle wax and wash

Coloured wax crayon and wash

Turpentine and wash

sculptor Henry Moore exploited resist methods in his drawings of people sleeping in the London Underground during World War II, using methods of bracelet shading (lines going around the forms) overlaid with watercolour.

Oil bars, sometimes known as painting sticks, are an alternative to wax crayons, but are a good deal more expensive. Partial resists can also be achieved by painting with artist's turpentine before applying the fluid medium (white spirit is less suitable as it has a lower oil content). This can create exciting if somewhat unpredictable effects, which are well worth experimenting with. Oil pastel will also resist fluid colour, but this is a technique in its own right, and is explained on the following pages.

HELPFUL ADVICE

If you are using acrylic inks, you may find that you need to dilute them slightly. Acrylic paints and inks have considerable covering power, and may not slide off the wax if used at full strength.

COLOUR AND TEXTURE EFFECTS

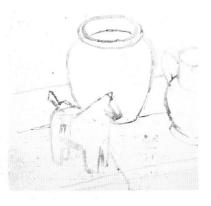

1 A brush drawing is made first, to establish the composition and provide a working guide. The artist uses a Chinese brush, dipping just the point of it into diluted ink.

2 The background has been applied with a red wax crayon, used fairly lightly to avoid over-filling the paper grain. The ink now painted on top forms runs and blotches where it slides off the wax.

3 In the foreground, stronger, more positive strokes were made with the yellow wax crayon to bring in a pattern element. These are now overlaid with green ink.

4 Having drawn in the pattern on the pots with different colours of wax crayon, the artist continues the layering process for the background, applying more wax and then more ink.

5 The foreground is treated in a similar way, again by layering wax and ink. Excess ink is mopped up with a cloth.

6 To build up the form of the horse figure, two layers of ink are used, the second being applied after the first had dried.

7 Light washes are applied with heavily diluted ink to build up the forms of the vases.

8 The completed picture is rich in both colour and texture. Notice especially how the successive layers of colour in the background create an attractive shimmering effect.

FURTHER INFORMATION

 ⇒OIL PASTELS: USING OIL PASTELS 54
 ⇒COLOURED INKS: INKS AND MARKERS 76
 ⇒RESIST TECHNIQUES: OIL PASTELS AND INK 94

RESIST TECHNIQUES Oil pastel and ink

Oil pastels can be used in conjunction with inks or watercolours as a simple resist method, but this combination offers more possibilities for a fully integrated, mixedmedia approach. Drawings can be built up in layers in whatever way you choose. You can begin with a watercolour or coloured ink underpainting – which can be simply a series of loose washes – and then work over it with oil pastels, or you can start with the pastels, laying washes of fluid colour on top. You can continue to build up the drawing by alternating them, applying ink or watercolour over pastel and vice versa, until you are satisfied with the result.

When working pastel over an ink layer, you might also exploit the sgraffito method explained in the Colour Media section. For example, in a drawing of trees, you could begin with a yellow ink layer, overlay it with darker oil pastel colours, and scratch back to the yellow for highlights and touches of detail. You can spread the oil-pastel colour with turpentine if required, or remove it partially to allow an underlayer of ink or watercolour to show through. This technique provides many options, so it is wise to experiment with it before trying it out on a finished drawing.

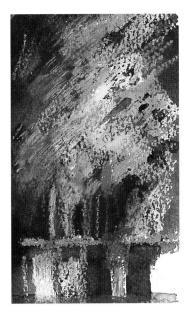

Multiple layers of ink and oil pastel on watercolour paper

Yellow ink over blue oil pastel

Acrylic inks

USING DILUTED INKS

 Full-strength inks would obviously be inappropriate for this delicate subject, so the artist dilutes them well with water before applying the first washes.

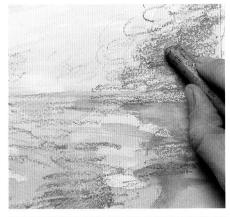

2 He begins to establish the darks with oil pastel, using light scribbling marks.

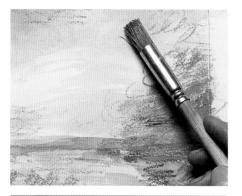

3 Further washes of diluted ink are laid over the darker areas, and more oil pastel is brought into the foreground.

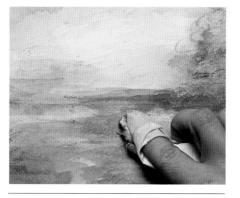

4 Another ink wash was laid at the top of the sky, drying with jagged edges suggestive of clouds (see below), and some of the oil-pastel colour is now blended with a rag dipped in turpentine.

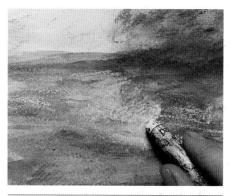

5 The process of building up with alternate layers of ink and oil pastel continues, with white oil pastel worked in to restore texture to the blended area.

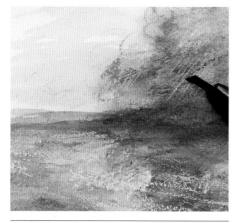

6 After adding the moon and its reflection with the white pastel, the artist uses a knife blade to scratch into the foliage.

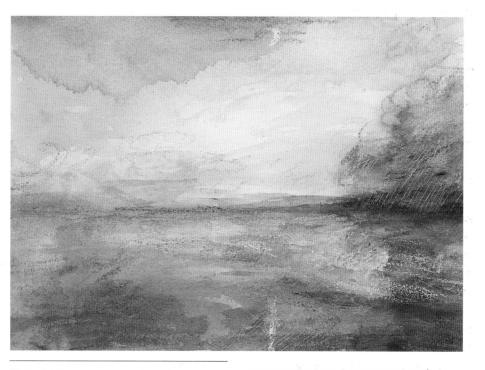

7 The finished picture demonstrates the subtle effects that can be achieved with this combination of media.

FURTHER INFORMATION

⇒OIL PASTELS: USING OIL PASTELS 54
 ⇒OIL PASTELS: BLENDING WITH SPIRIT 56
 ⇒OIL PASTELS: SGRAFFITO 58
 ⇒COLOURED INKS: OVERLAYING COLOURS 78

UNUSUAL TECHNIQUES Wash-off

This interesting technique provides a method of producing a negative image, which can then be coloured with washes of ink or watercolour, or left as white on black. It takes a bit more time than a normal drawing, and requires patience and a methodical approach, but the results are well worth the effort. The method itself is simple: a design is painted in white gouache, which is water-soluble, black waterproof ink is laid on top, and the whole thing is held under running water, removing only the ink that lies on top of the paint. Make a light pencil drawing first, and then lay a pale wash of watercolour over the whole of the paper so that you can see where you are placing the gouache. When the latter is fully dry, use a large, soft, flat watercolour brush to lay on the ink in a series of broad strips, working from top to bottom. Take care not to go over an area you have already worked, as this could lift the gouache away and cause it to mix with the ink. Leave the ink to dry, place the board in a bath or large, deep tray, and pour water over it (don't use a shower head, as this degree of water pressure could break up the ink to make grey rather than black areas).

When the method was first pioneered, black India ink was used, producing a woodcut effect, but the method can be adapted to take advantage of the greater range of materials now available. For example, you might make a multicoloured background with acrylic inks (also waterproof), and bring in more ink colours, or more gouache, on the negative areas. It's an enjoyable method to play around with, and you may discover your own recipes.

HELPFUL ADVICE

It is essential to use watercolour paper or a heavy drawing paper for this technique, as thinner papers could tear when wet. The paper will need to be stretched in advance to prevent buckling.

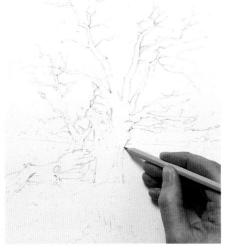

 The artist makes a careful pencil drawing to establish which areas are to be left white.

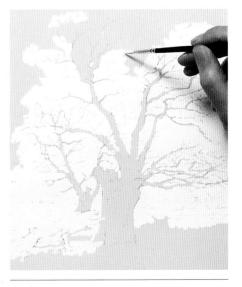

2 After covering the paper with a wash of Naples yellow watercolour, he uses gouache paint to fill in the areas to be left white.

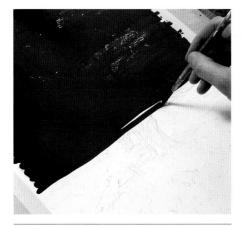

3 The gouache is left to dry and then Indian ink is taken over the whole area of the design. This must be done slowly and carefully, strip by strip.

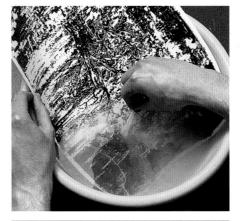

4 The paper is held in a bowl of water and the ink is removed gradually, with the aid of cotton buds.

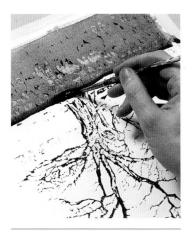

5 When dry, more white gouache is added to reinforce some of the white areas, and the artist lays a brown ink wash, turning the board upside down to provide easier access to this foreground area.

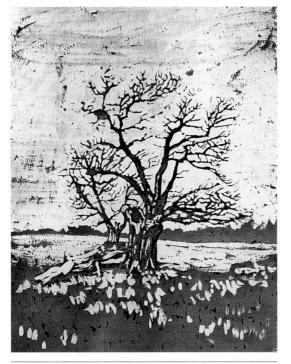

6 The wash-off method is seldom entirely predictable, and in this case, the first layer of yellow has broken up the black ink slightly, but the effect is nevertheless attractive.

Hazel Harrison \Leftrightarrow Rhododendrons

A photograph formed the basis for this composition, which was carefully drawn before the gouache and ink were applied. The blackand-white drawing was tinted with a mixture of watercolour and gouache.

FURTHER INFORMATION

⇒COLOURED INKS: INKS AND MARKERS 76

UNUSUAL TECHNIQUES Ink and bleach

This is an unpredictable but exciting technique that involves drawing with brushes and household bleach into black or coloured inks to lift out the colour. It is a little like making 'negative' brushmarks with masking fluid, but is a more direct method.

Start by covering the area you want to work on with water-soluble ink. When dry, dip a brush into diluted or full-strength bleach and paint into the ink. Effects can be varied according to the brushes used and the marks you make, but the paper surface and type of ink also play a part. For example, you may find that even diluted bleach removes more of the ink than intended (you can seldom achieve subtle tonal gradations), and some inks will leave one or more of the constituent colours behind, giving yellow or green brushmarks rather than white.

Any writing inks are suitable, even those marked 'permanent', but most artist's drawing inks are either acrylic- or shellac-based, and can't be removed with bleach. This limitation can be turned to advantage, as it gives you an opportunity to experiment with layers of colour. You could try starting with a multicoloured layer of acrylic ink, lay water-soluble ink on top, and lift out to the previous layer. You can make more brushmarks on top of the lifting-out layer, provided that it is not black, or even bring in an opaque medium such as pastel.

HELPFUL ADVICE

Ink applied on smooth paper or board will have a blotchy, uneven appearance, which could be exploited as an ingredient of the drawing, but if you want it to go on smoothly, watercolour paper is the best choice.

VARYING THE EFFECTS

1 The entire paper has been covered with black ink, and areas are now lifted out with bleach, using first a brush and then a bamboo pen, which produces fine white lines.

2 After drawing some details with black permanent ink, and adding more white lines with the pen and bleach, the artist lays another wash of blue ink.

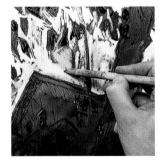

- 3 Areas of the blue ink have been removed with a brush dipped into bleach, and the bamboo pen is used again to draw into the wet ink and bleach.
- 4 In the final stages, the building was given definition with further white bleach-lines, using both the brush and the pen to vary the marks. The drawing has something of the quality of a linocut, but the artist has created a strong sense of drama by exploiting the tendency of bleach to produce yellow rather than white.

Conté and oil bar

Oil bars, sometimes known as painting sticks, are a form of condensed oil paint, with a consistency resembling a very soft oil pastel. They are made in a range of colours, and painters often use them in conjunction with oil paints, but for this technique you only need the transparent, colourless bar, which is used for blending.

Scribbling over the paper surface with the oil bar and then applying conté crayon produces a soft paste, which can be moved around the surface with a palette knife, a piece of thin cardboard, or an old credit card (an ideal implement). Drawings can be built up in layers, applying more oil bar, then more conté, and so on. As in pastel work, soft effects can be created by blending with a finger. Crisp lines are produced by drawing into the paste with a graphite or conté pencil, or by scratching white lines with the handle of a paintbrush, as in the oil-pastel sgraffito technique. More than one colour of conté can be used if desired, or you might try the method with hard pastels for a full-colour approach.

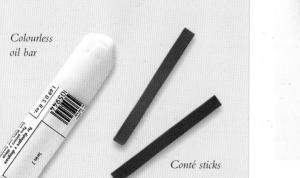

CREATING A PAINTERLY EFFECT

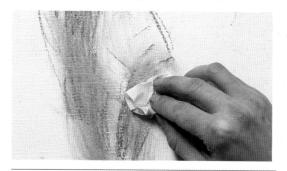

1 Oil-sketching paper has been chosen for this drawing, as it does not absorb the oil and is also tough enough to withstand scraping and scratching. The artist begins by covering the surface with colourless oil bar, and then makes a light drawing with a conté stick. To produce a paintlike consistency, the conté is rubbed into the oil bar with a cloth.

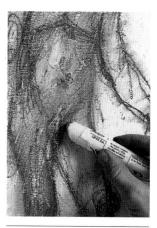

2 After adding more line and tone, the oil bar is used again over the conté. Notice that this picks up some of the colour, and is thus useful for highlights.

3 Another layer of conté and oil bar was applied and the tonal intensity was then reduced by scraping back to the paper with a palette knife. The drawing was completed by rubbing with a finger to clarify the highlights, and adding touches of dark line with a black conté pencil.

FURTHER INFORMATION

⇒BRUSH AND INK: DRAWING WITH A BRUSH 32

⇒OIL PASTELS: SGRAFFITO 58

⇒COLOURED INKS: INKS AND MARKERS 76

COLLAGE Drawing over paper shapes

Collage, which simply means sticking coloured paper or flat objects onto a paper surface, has always been popular as a play activity for young children. Since the early years of the twentieth century, it has also become a fine-art technique. It was, possibly, exploited most notably by Henri Matisse in his wonderful series of abstract and figurative works made towards the end of his life, using cutout paper shapes in brilliant colours.

In these, the paper shapes themselves constitute the whole of the drawing, but nowadays, it is more usual to combine cut or torn paper with other media so that they form one ingredient in a mixed-media image. There are no real rules about collage techniques, and almost anything can be used that can be stuck down, from pre-coloured papers, hand-coloured tissue paper and pieces torn from newspapers and magazines to dried leaves and pieces of grass. Here, we concentrate on one of the simpler forms of the method – drawing over paper shapes. This is most suitable for a subject containing strong, simple shapes and forms, such as a still life or architectural subject.

You may find it helpful to make a light preliminary drawing to act as a guide for cutting the papers, but even so, don't stick down the collage elements until you are sure of the best arrangement. When they are in place (and the adhesive is dry) you can work over them with more or less any of the drawing media – coloured pencils, pastels, pastel pencils or coloured inks – to refine the detail and build up the forms. If necessary, you can add more collage as the work progresses.

HELPFUL ADVICE

Try contrasting cut and torn edges to add extra surface interest. If you use pieces taken from newspapers, stick them on upside down so that they don't attract too much attention.

Tearing freehand

Tearing against a straight edge

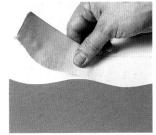

Tearing against a curved template

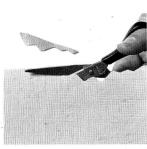

Cutting shapes with scissors

Paper glue, spreader and glue brush

Using a cutting mat to achieve squares and striaght lines

Cutting curvy lines using sharp craft knife on a cutting mat

VARYING AND OVERLAPPING SHAPES

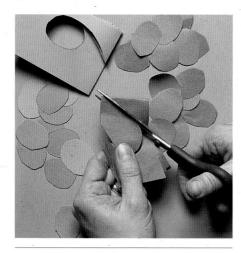

 The artist begins by cutting round shapes for the grapes, using several different colours of paper.
 He takes care not to make the shapes too regular and mechanical looking.

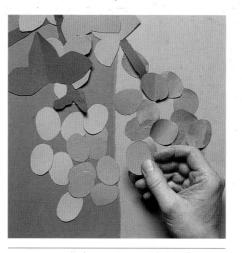

2 Having cut out some leaf and stems shapes, he places them on the paper, moving them around and overlapping some until he is happy with the composition.

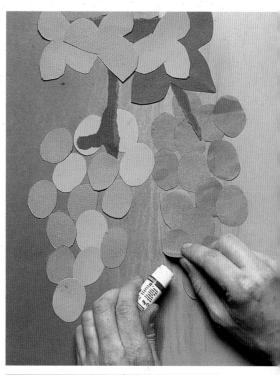

3 Each shape is run over a glue stick and lightly pressed onto the paper. It is still possible to make alterations at this stage.

4 When the glue has dried, soft pastel is worked over the top to add details to the leaves and shadows, and highlights on the grapes.

FURTHER INFORMATION

⇒PASTELS: DRAWING WITH PASTELS 40 ⇒COLLAGE: DRAWING WITH TORN PAPER 102

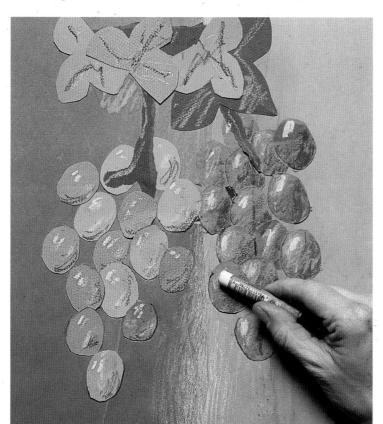

COLLAGE Drawing with torn paper

This form of collage not only produces a lively and unusual image, but also sharpens your observational skills. For this reason, it is often set as an exercise for students. The idea is to build up the drawing, a bit like a mosaic, using small pieces of coloured or toned paper torn into shapes. Tearing the paper rather than cutting it enables you to work faster, and the torn edges also contribute to the overall effect.

You can work in monochrome or in colour, using either pre-coloured or hand-coloured papers, but don't bring in too wide a variety of tones or colours or the image will become confused. As you work, pay careful attention to the way the fall of light models the forms, look for broad areas of tone and colour, and try to analyse the shapes made by shadows and highlights.

An interesting way of working in monochrome is to use tracing paper as the collage medium, shading pieces in advance with different grades of pencil to produce a range of tones. This is especially well suited to life studies and portraits, and creates a more subtle effect than using mechanically toned papers.

HELPFUL ADVICE

Unlike the collage on the previous pages, the torn paper shapes don't have to be precise, as you can amend them simply by sticking further pieces on top.

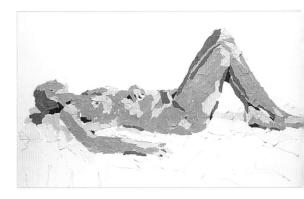

Chloe Alexander \Leftrightarrow Reclining nude

The colours of the paper for this drawing were carefully chosen so that the mid-tones, although slightly different in hue, are all close in tone. The torn edges of the paper break up the solid masses by casting numerous tiny lines of shadow that give an extra sparkle to the image.

Collection of coloured papers, various scraps torn from magazines and pieces of hand-painted papers

CONTRASTING DIFFERENT PAPERS

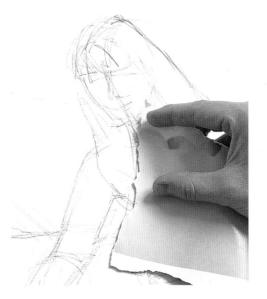

1 This collage technique is becoming very popular, and artists who specialise in it build up large collections of toned and coloured paper. But it is easy enough to colour your own paper, and here the artist is using a combination of bought and hand-coloured paper. He begins by making a drawing and then finds a suitable base colour for the skin.

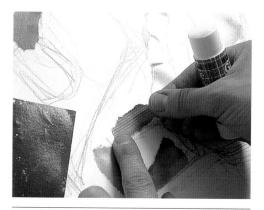

2 Small pieces of skin colour have been torn and stuck down, and he now begins to lay on the dark tones. It is easier to decide on the colours of the mid-tones once the main lights and darks are established.

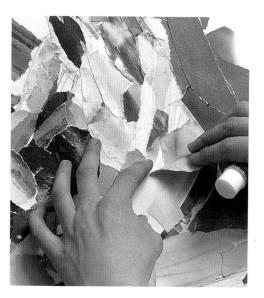

3 The picture has now reached the midway stage, and adding the mid-tones will pull it all together. The process of tearing, sticking and overlapping paper continues. It can be helpful to stand back from the work at this stage, as a close view presents a confusing jigsaw effect.

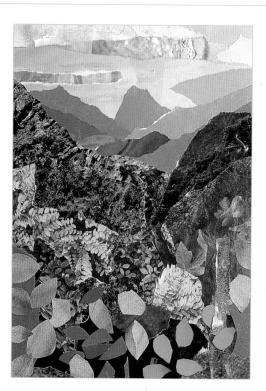

Brian Gorst ↔ Mediterranean Landscape

Different materials and methods have been combined in this attractive image. The mountains are composed of torn machinemade paper, cut-out shapes have been used for the immediate foreground, and images from magazines were used for the lightcoloured foliage.

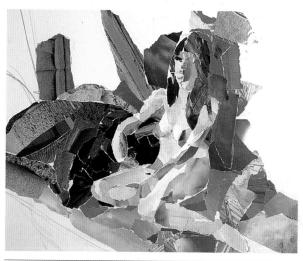

4 By paying careful attention to the shapes of shadows and highlights as well as contrasting warm and cool colours, the artist has achieved a portrayal of the human form that is both convincing and exciting.

FURTHER INFORMATION

⇔PENCILS AND GRAPHITE: COMBINING GRADES 18

⇒COLLAGE: DRAWING OVER PAPER SHAPES 100

HOME PRINTMAKING Handmade monoprints

Monoprinting is a fascinating technique that combines elements of drawing and painting with those of printmaking. Unlike other printing methods, whose purpose is to produce multiple versions of an image, monoprint is a one-off method, as the name implies. Also unlike other printing methods, monoprints can be done at home without the need for a printing press, and require little special equipment – all you need is printing inks or oil paints, a roller and a sheet of glass or other non-absorbent surface.

There are two basic methods, and many variations of both. The first involves painting a design on the printing surface, laying paper over it, and then rubbing gently with a clean

> roller or your hand to cause the ink to adhere to the underside of the paper. A variation of this method is to ink up the whole of the surface

and draw into the ink with a brush handle or similar implement to produce white lines. White shapes can be achieved by placing pieces of cut paper on the inked surface to hold the ink away from the printing paper.

In the second method, the printing surface is inked up evenly all over, a piece of paper is laid on top, and a drawing is made with a pencil. The pressure of the pencil picks up the ink, and when the paper is removed, you will see a printed version of the drawn lines. Areas of tone can be produced simply by rubbing lightly with a finger, and a wide variety of textured effects can be achieved by using implements such as combs or household cleaning brushes. You can use an existing drawing or sketch as a basis for the monoprint by placing it on top of the printing paper and 'tracing' the lines, but bear in mind that the image will be reversed.

HELPFUL ADVICE

If you intend to work on top of the print, choose a paper suitable for the medium – lightweight pastel paper is a good choice for any of the dry media, and is thin enough to pick up the ink. Either water-soluble or oil-based printing ink can be used, but the former is less messy and makes the cleaning-up process much easier.

DRAWING INTO THE INK

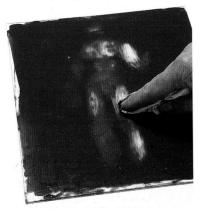

 The slab is inked up all over and the artist draws into it, using a rag wrapped around his finger.

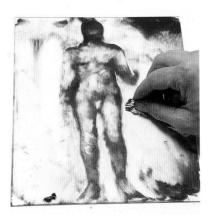

2 He continues the process, wiping out the ink all around the figure. For this method, it is best to use oil-based inks or oil paint, as watercolour inks may begin to dry before the print is taken.

DRAWING ONTO PAPER

 In this monoprint method, the slab is inked up evenly with a roller, and the paper is placed carefully on top.

2 The design is drawn with a pencil so that the pressure picks up the ink beneath. The artist now rubs with a finger to produce areas of tone.

3 The printing paper is then removed by holding one corner and peeling it off gently.

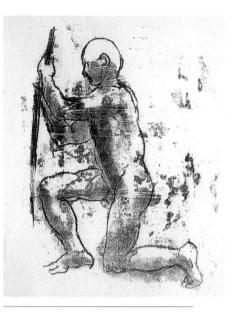

4 The paper often picks up ink in other places simply through contact, producing the attractive, mottled texture that is typical of hand monoprints.

WHITE LINE DRAWING

1 This is similar to the drawing shown opposite, except that the artist is not concerned with tone, and thus uses a pencil to produce fine lines.

2 The paper is placed over the inked slab and rubbed with the hands – alternatively, you could use a clean roller.

3 The white lines print clearly, and the mottled ink provides an interesting background. The effects can be varied by using different paper textures.

HOME PRINTMAKING Colour monoprints

Colour monoprints are made in the same way as monochrome ones, using the method of painting directly onto the printing surface. In this case, glass is better than an opaque surface, as it allows you to place a working drawing underneath as a guide. This is helpful if the subject is complex, but you may find it more challenging to work directly from a still life setup or a photograph.

As before, you can use either printing inks or oil paints (or even acrylics as long as you add retarder to slow the drying time). The colours can either be mixed on a palette or on the glass itself, but avoid building up thick layers of colours, as only the top one will print. The colours can be thinned with water (or white spirit in the case of oil-based media).

Prints can be made in several stages to build up colours, or you can print in colour over an existing monochrome print. You will need a system of registration so that the paper goes back in the same place each time. The simplest method is to stick the paper down at the top with a piece of masking tape, flip it back after the first print, and replace it when you have cleaned the surface and reworked the image.

Those who are not dedicated printmakers tend to favour the more direct method of taking Water-soluble block printing inks

a single impression and building up detail and depth of colour with pastel or oil pastel – hand monoprints are usually seen as a basis for a coloured drawing rather than as a complete entity. But try not to work over the whole of the surface or you will sacrifice the qualities of the print; instead, think about how you can contrast the pastel work with the areas of soft, granular texture.

HELPFUL ADVICE

Diluting the ink or paint can yield interesting results, clearly showing the marks of the brush, and is ideal for areas of broad texture.

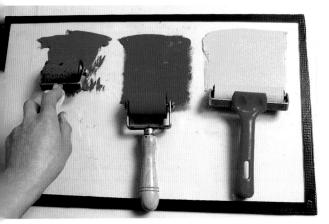

Different widths of rollers are available. The small ones are sold mainly for linocutting, which is basically a small-scale activity. The larger ones, designed for printmakers, are considerably more expensive.

DIANA CONSTANCE ⇒ STANDING NUDE This artist works mainly in pastel, and has used the monoprint method as a form of underpainting. The light application of pastel combines with the texture of the print to produce an attractive and highly individual work.

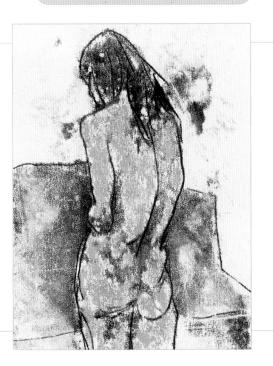

WORKING WITH OIL PAINTS

1 Oil paints provide an excellent substitute for printing inks, as they are slow to dry and much easier to pre-mix. The artist uses slightly diluted oil colours, and paints the design onto the glass surface, keeping the areas of colour separate.

2 He then places a piece of thin drawing paper over the printing surface and rubs it with his fingers to encourage the paint to adhere.

3 The paper is held by one corner, removed carefully, and then left to dry.

4 Because oil paint has been used for the print, oil pastels are the obvious choice for overworking. The black lines are kept free and suggestive, in keeping with the earlier brushstrokes.

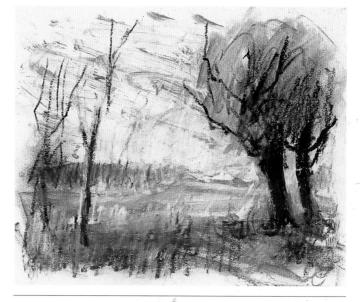

- 5 Blue, green, black and white oil pastels have been brought into the foreground and sky areas, and more black is used to strengthen the tree.
- 6 The artist has been careful not to add too much oil pastel, so that the finished drawing retains its printlike quality.

FURTHER INFORMATION

⇒HOME PRINTMAKING: HANDMADE MONOPRINTS 104

DIGITAL DRAWING

CHAPTER 4

The computer has revolutionized the art of commercial drawing, but it is increasingly being taken up by fine artists as well as by many amateurs. This section gives advice on suitable software and demonstrates some of the exciting effects you can achieve, either by drawing directly on-screen or by working in line or colour over a photograph, using a variety of digital brushes and special effects.

INCLUDES

⇒THE BASICS: Tools and materials 110 Drawing and painting media 126

⇒ BEYOND THE BASICS:

Filters and effects 114 Layers and selections 116 Working with photographs 118

THE BASICS Tools and materials

Most PC operating systems include a programme that allows you to draw, paint and edit photographs. Microsoft Paint, for example, is part of Windows. Although slightly primitive, it's a good place to start experimenting with digital drawing. You can draw freehand and create geometric shapes, pick colours from a palette or create new 'custom' colours, and combine visual images with type. Scanners also include a basic

> photo-editing and drawing package, or a cut-down version of one of the more professional packages.

MICROSOFT PAINT TOOL BAR AND COLOUR PALETTE

To... 🖾

As you begin to discover the possibilities of drawing on-screen you will probably want to upgrade to more sophisticated software. There is a wide choice available, although some programmes, that are primarily aimed at professionals, can be very expensive. However, as these are continually being revised and improved, it is often possible to pick up older versions quite cheaply. One of these is Painter Classic 1, which is easier to use than the more complex later versions, and offers a wide range of drawing implements. Another is Photoshop Elements which, although basically a photoediting programme, also allows for the production of original drawn and painted images. The other vital piece of equipment is a stylus and drawing tablet. Drawing with a mouse can be awkward and clumsy as it is held quite differently from a pencil or pen, whereas a stylus replicates the natural drawing movement. Tablets come in a range of sizes, with commensurate differences in price, but smaller ones are well within the budget of most artists.

Graphic tablet and pen

Bitmap or raster image If you scan a

Vector image at 100% and 400%

BITMAP AND VECTOR IMAGES

If you scan a photograph, or a drawing of your own and then zoom in on an area, you will see the mosaic of colours, called pixels, that make up the image. Images made up from pixels are known as bitmap, or raster images to give them their technical term, and are the most common type for colour work as they can create very subtle gradations of tone and hue. However, they do have one disadvantage: because each image contains a set number of pixels, they are what is known as resolution-dependent, which means that they will lose detail and appear ragged (pixelated) if they are enlarged too much or printed at a low resolution.

Bézier curves use points and handles to adjust the shape of vector images. Vector images, on the other hand, are resolution-independent, and can be enlarged as much as you like with no loss of definition. This is because they are made from curves, lines or shapes that are defined by mathematical equations. Illustrator is a vector-based drawing programme. The shapes in Photoshop's shape menu, which allows you to incorporate lines, circles, rectangles and so on into an image, are vector-based, as are the many variations of type, and any clip-art images you might like to import. Most software applications designed for painting and image-editing use bitmap images, but some of the graphics programmes – usually titled Draw rather than Paint – support vector graphics.

TYPICAL COLOUR TOOLS

Shape Dy Scattering M Texture Dual Brush Color Dynam Wet Edge State Barris

Рнотознор

There are three ways to select colours in Photoshop: selecting from a standard or personalised grid (1), mixing colours using sliders (2), or picking from a rainbow colour bar (3). It is also very easy to match a colour in your work by clicking on the picker tool (4) then on the colour you wish to match. The foreground and background boxes in the tool bar (5) used with the large colour picker (6) give you control over areas of colour. There is a range of standard brushes and drawing tools, and options for customising them (7). The tool bar also has the usual digital equipment including selection, drawing and cloning (8).

2

3

4

6

Illustrator offers colour options for linear work and solid areas. Colours can be selected in three ways: by picking off a colour grid (1), using sliders of the constituent colours (2), or selecting from a rainbow colour bar (3). There are also options to specify the weight and fill of the line (4). The usual range of standard or customised brushes is available (5), as is digital equipment such as selection, drawing, distortion and cloning (6).

Colour options in Painter are more sophisticated than those in Illustrator and Photoshop. The colour selector (1) allows you to choose tone with the central triangle, and control the hue with the outer colour wheel. Colour can also be chosen with sliding bars (2), and tested in a sample window (3). You can match colours with the picker tool (4). Various drop-down menus (5,6,7) give you control over surface, drawing implement and the sharpness or texture of the implement.

•	BI Brush Variant	
	Blunt Chalk 20	_
٠	Blunt Chalk 30	
٠	Dull Grainy Chalk 10	
۲	Dull Grainy Chalk 20	
	Dull Grainy Chalk 30	÷

THE BASICS Drawing and painting media

Any software designed specifically for drawing and painting will provide a range of tools, from pens, pencils, pastels and coloured pencils to various different brushes. Painter, for example, has a vast range of brushes and drawing implements grouped in categories, enabling you to work in more or less any media you choose. Photoshop Elements only gives a choice between pencil, various shapes of brush, and airbrush, but it is possible to achieve many different effects by varying the opacity and pressure, and by working one colour over another.

The way you choose colours varies according to the programme, but in most cases there is a palette or colour wheel, and all you need to do is click on the chosen colour. A useful tool in this context is the eyedropper, which allows you to precisely match an existing colour. For example, if you want to repeat a colour from one area to another, or simply increase the density of colour by working into it, select the eyedropper tool and click on the colour you want, and it will automatically become the current colour. This is also useful if you are copying a photograph and want to use the same colours to 'translate' it into a coloured drawing or painting.

When you are learning a new piece of software (which can take some time), the best course is to familiarise yourself with the brushes and other drawing implements by simply doodling. Digital drawing tools, especially those in the dry-media groups, don't always give quite the same effect as real-life ones, and you may find that you can achieve a more realistic coloured pencil or pastel effect by using a different implement. This can be frustrating, but can also lead to exciting discoveries – you will enjoy this form of picture-making more if you regard it as a whole new approach with its own characteristics rather than trying to replicate the effects achieved with conventional materials.

1 Painter Classic is a fairly basic programme, but does have a good selection of drawing and painting implements, which can be modified by choosing different sizes and opacity values. The brushes used here are, from left to right, starting at the top: coloured pencils, square chalks, waxy crayons and leaky pen. Note that all the drawing and painting implements are referred to as brushes in the programmes.

2 Adobe Photoshop is primarily a photo-editing programme, but a lot can be done with the basic brushes and pencils, and colours can be softened and blended by using the blur*and sponge tools, or the eraser set at medium opacity. The examples here were made with a variety of brushes and pens, some from the calligraphic and square selection found under the Brushes menu.

3 Painter offers a vast array of brushes divided into different categories. The three in the top row, charcoal, square chalk and sharp chalk, are all from the dry media group, while the second row, dry bristle (here used with wet eraser), runny wash camel and wet sponge, are found under the watercolour heading of the Brushes palette.

4 A further selection of Painter's dry-media brushes, from left to right, starting at the top: charcoal in two layers, square chalk, sharp chalk, scratchboard tool, flattened pencil and coloured pencil. The scratchboard tool is an excellent drawing implement, and if you are using a pen and tablet rather than a mouse, the line can be varied simply by increasing or decreasing the pressure.

5 The later versions of Painter, from 7 onwards, offer a new category of liquid ink, which produces strong, rich colours and offers an exciting array of different brush variants, of which (from left to right) graphic camel, calligraphic flat, sparse camel, dry bristle, airbrush and coarse camel are shown here. Liquid ink must be used on a layer of its own – you can see it on page 118, combined with oil pastel and pencil.

PASTEL ON COLOURED PAPER

1 The artist has used Painter for this pastel drawing, opening a separate layer for each stage of the work – see page 116 for an explanation of the layers system. The artist begins by opening a new blank document (File/New), choosing a paper colour by clicking on the paper colour square, and selecting the artist's chalk brush variant. He chooses a creamy white from the colour wheel and begins to draw the outlines of the tulip. Unwanted lines are removed with the eraser tool or by clicking on Edit/Undo.

2 When the drawing is complete, the artist opens a new layer, and loosely brushes in all the pink areas. As in traditional pastel work, the strokes are kept quite loose in the early stages. He uses the eraser to remove any colour that strays outside of the flower head, and varies the tones and colours slightly. The pastel covers up much of the underdrawing, but this doesn't matter, as it remains intact on its own layer and can be referred to if necessary.

3 A third layer is created for highlights, lowlights and definition of forms, and the highlighted tips of the petals are blocked in with very pale cream, still working quite loosely. More dark pinks are stroked over the petals. To avoid having to work around the tulip, the artist opens a separate layer for the background, and begins to block it in using large brush sizes in the soft pastel variant and two shades of green.

- 4 With the background layer highlighted, the artist begins to define the background by adding some leaves. These are worked lightly so that they blend into the original greens to give a slightly blurred, out-of-focus effect that throws the flower head forwards in space.
- 5 Finer detail is added on another layer, still using soft pastel, but in a smaller brush size. The artist uses darker pinks and purples, and directional strokes to follow the forms of the petals. For the last

stage, the paper texture is changed to coarse, using the paper palette under Art Materials. To give the background more depth, black is dabbed on with a large size of square chalk. Finally another layer is created, and diffused highlights are made on and around the flower with white soft pastel.

FURTHER INFORMATION ⇔ DIGITAL DRAWING: LAYERS AND SELECTIONS 116

BEYOND THE BASICS Filters and effects

A good way of giving a hand-drawn look to an image or to make various other adjustments is to use plug-in filters. Plug-ins, which are small programmes within the main one, are kept in separate folders, but become accessible when the programme is started, usually through a toolbar menu. They vary widely according to the software: some programmes offer a bewildering wealth of different effects, from extra brushes to image enhancement and colour correction to the application of surface texture.

Photoshop and Photoshop Elements both have extensive ranges of artistic filters, as do Adobe Illustrator and Paint Alchemy, which allow you to change a drawing or painting in one medium into something quite different. A pastel sketch, for example, can be rendered into coloured pencil by applying a crosshatch filter, and a pencil drawing dramatically altered with a charcoal filter. You can also achieve exciting effects with photographs, giving them a handpainted appearance.

Filters offer exciting possibilities, but when applied to an existing drawing rather than a photograph can be unpredictable. When you select a filter, a dialogue box with a preview window will appear, allowing you to specify such variables as stroke length, brush detail,

sharpness, contrast and so on, but the control you can exert is limited, and in some cases you may find that the effect is too strong for the chosen image. Also, filters don't always live up to their names - crosshatching looks mechanical, as the strokes are evenly spaced and all of the same weight and thickness, and few watercolour filters really resemble the real thing. However, many of them create interesting and unusual effects that couldn't be achieved by conventional means, so they are worth experimenting with - the beauty of digital art is that it eliminates any wastage of paint and paper.

Edit **Object** Type Select Filter Fffect

Filters and effects are accessed via the main menu bar. Click on it and a drop-down menu will appear (1). If some of the effects are highlighted in grey in the listing, you need to convert your files to RGB in order to make them available. Many of the categories have sub-sets (2) for extra choice. If you acquire and install a plug-in (3) it will appear at the bottom of this list, click on it to activate.

HELPFUL ADVICE

It is difficult to create the same effect twice when using filters, so get into the habit of writing down the settings and any other relevant details.

Blur

Distort

Noise

Last filter

Extract Liquefy Pattern maker

Artistic Coloured Pencil...2 Cutout... Brushstrokes Dry Brush... **Pixelate**

> trol Brush Angle Using I Image Lightness

Render Sharpen Sketch Stylize Texture Video

Digimarc Xaos Tools — 3

Other

All the filters and effect options have dialogue boxes which pop up when the effect is selected. Here sliders let you adjust the effects, such as stroke length, paper surface, thickness, pressure, density and direction of stroke, and usually see a small preview area.

Preview

Paint Alchemy by Xaos Tools is a Photoshop plug-in. It allows for a wide variety of drawn and painted effects. To overcome the mechanical nature of the strokes you can vary the angle and thickness as well as colour, tone, opacity, coverage and much more.

Paint Alchemy

PHOTOSHOP Graphic pen

Brown charcoal

Rough pastel

Coloured pencil

ILLUSTRATOR Ink outline

Sumi-e

Angled strokes

Dry brush

XAOS TOOLS Soft pencil light

Soft pencil dark

1.1

and the second second

Oil canvas blur

Pastel

BEYOND THE BASICS Layers and selections

Most drawing, painting and photo-editing programmes allow you to experiment with different effects and compositions by using layers. Layers can be visualised as pieces of transparent film stacked on top of one another. When you make a drawing, or scan in a photograph, it appears as a background layer called the canvas. If you create a new layer on top of this,you can work on it without altering the underlying image, as layers are independent of each other and, similarly, you can work on the canvas without affecting any other layers.

Layers are especially useful for collage-type compositions, in which images, shapes or

textures are superimposed over others. This type of work involves making selections, which is the digital equivalent of cutting out a shape with scissors. Suppose you want to 'paste' a drawing of an animal or flower onto a hand-painted, textured, or photographic background, you would start with the background in the canvas layer, draw around the chosen image with one of the lasso tools to select it, and put it into a new layer (usually you will find a menu command such as 'layer via selection').

Selection is one of the main elements of digital work. It is the way you isolate the area on which you want the computer to work. You can make selections in several ways, as shown below and opposite. You can combine as many selections as you like in one image, and they don't have to be drawn or photographic – you could make collages with pieces of digitally coloured or textured pieces of paper, or found objects such as leaves that can be scanned in. To try out different juxtapositions, you can change the stacking order of the layers at any time, and you can apply various different effects to individual layers as well as altering the colour and opacity.

Рнотознор

The Layers window (1) allows you to turn the visibility of each layer on or off, by clicking on the eye icon, and adjust transparency using the opacity percentage slider. There are a number of tools to select various parts of the image, all of which are found in the toolbar (2). The marquee tool (3)is useful for simple geometric shapes, the lasso tool (4) for drawing around chosen areas, the magic wand (5) for selecting areas where the colour or tone is distinct, the picker tool (6) to sample a colour which is linked to a selection dialogue box (7), which allows you to adjust the range of the selection through the fuzziness slider, and the quick mask tool (8), which allows you to paint a selected area.

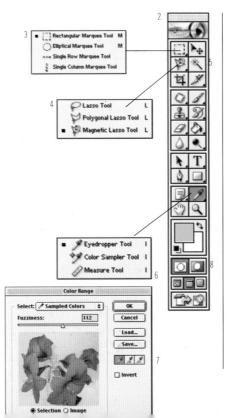

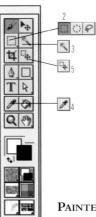

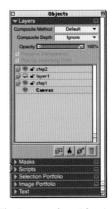

PAINTER The Layers palette (above) will help you organise your work, and if you make a mistake it is easier to rectify as you are dealing with only one layer at a time. If you are working with lots of layers make sure you name them. The selection tools contain the normal marquee tool (1), both round and circular, a lasso tool (2), a magic wand (3), a colour picker (4) for selecting items of the same colour, and a tool for resizing the selection (5).

	Layer 1	0 =	1
	→ 🙀 <group></group>	0	
B T T	7 ♥ ≪Group>	0	
8	◆Path>	0	100
8	☐ <path></path>	0	
8	♦ 🔄 «Group>	0	
B	Path>	0	
B []	♦ 🛛 «Group>	0	
6	≪ath>	0	
B	[] - Path>	0	
B	♦ 🔄 «Group>	0	
B 🗌	<path></path>	0	
B 🗆	[] - Path>	0	
B [☐ Path>	0	
B	♦ 🗍 «Group»	0	
8 0	Group>	0	
8 0	⇒ == ≪Group>	0	
8 1 1	Group>	0	
6	□ <path></path>	0	
6	□ <path></path>	0	
B [Path>	۹	
B []	Path>	۹	
	⇒ Group>	0	
6 0	⇒ 🔄 ≪āroup>	0	
B 🗌 D	⇒ 🚳 ≪Group>	0	
B [Path>	0	-
B T	<path></path>	0	-

ILLUSTRATOR The layers in Illustrator work slightly differently from other packages. Each time you draw a new element, the software creates a path as a separate item. These paths can be grouped logically, then placed in larger groups to form layers. The layers in the palette (left) show the paths and groups for the flowerhead featured in the illustration (above).

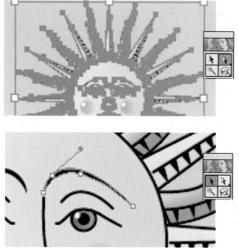

The selection tools are top left and right of the tool bar. The latter picks up a whole group of paths, the former picks up individual paths. The picker (1) and the magic wand (2) can both be used to select items of the same colour.

1	4	*	
2	5	×	2_
	5	×	2 -

BACKGROUND SELECTED

Masking techniques are accurate, infinitely changeable, and fast. Here the artist wanted to keep the image of the flower, but separate it from the dull background. Instead of drawing around the complex flower shape, he worked on the single-colour 'negative' background. If you select the magic wand (1) and click on the background, a selection will appear. Keep changing the tolerance level (2) and reselecting until you get a reasonable

MASK OF BACKGROUND

USING MASKS FOR SELECTIONS

Δ PFTALS. separation, as indicated by the 'marching ants' between the background and the flower (3). Click the quick mask button (4), and the area selected will appear as a coloured mask. You can now clean up and fine-tune the edges with the brush tools. Toggle backwards and forwards on the foreground (5) and background buttons (6) to paint in or paint out areas until you get a clean edge (7). Click off quick mask and the selection will appear.

PAINTING OUT BACKGROUND FROM

CLEAN EDGE

Remember that you have actually been working on the selection of the background area, so you need to invert your selection to keep the flower. Paste your new selection onto a separate layer over any desired background.

BEYOND THE BASICS Working with photographs

Filters can transform a photograph into something resembling a painting at the click of a mouse (see page 114), but you can also paint or draw directly on to photographs to produce different effects. The way you do this depends on the software. Painter provides a facility for tracing over a photograph by first cloning (duplicating) the image and then 'laying' tracing paper on top. You can draw or paint directly over a photograph if you prefer, but the underlying colours can make it difficult to see where you are placing the marks or brushstrokes, especially if you are working in monochrome from a colour photograph. Photoshop Elements doesn't have a tracing system, but you can do more or less the same thing by creating a new layer over the background layer (the photograph) for drawing or painting, and reducing its opacity.

If you are working in colour you may find it helpful to have the photograph open on the screen at the same time, so that you can use the eyedropper tool to select the same or similar colours. But don't try to make too faithful a copy of the photograph, as this will defeat the purpose of the exercise - experiment with different tools and media to see which ones best suit the subject and the mood you want to convey. You might use soft pastel or charcoal for a portrait of a child, for example, and try out oil-painting brushes or coloured inks for a landscape.

Using the dropper tool to select colours from the original photograph allows precise matching.

WORKING OVER A PHOTOGRAPH

A copy is made of the photograph using the Painter cloning system, and the tracing paper option is set to provide a ghost image.

1 The artist chooses the oil pastel variant from the dry-media section of the Brushes palette, opens a new layer, and begins by blocking in the sky, toggling the tracing paper on and off to check progress. The colours for the clouds are also matched with the dropper tool, and painted over the blue on the same laver.

HELPFUL ADVICE

Don't forget to save your work frequently as computers are notorious for crashing when working on something as demanding and processor-intensive as paintings.

2 A new layer is created for the foliage and blossom, with the ghost image helping to position the shapes. The artist doesn't concern himself with detail at this stage; it is best to choose one basic colour for each area and bring in variations later. He changes the brush size from time to time but doesn't allow it to become too large, as this slows down the computer, sometimes bringing it to a standstill. To achieve randomly sprayed dabs of colour for the foliage, he opens the random section in the Brush Controls palette and moves the jitter slider to the right.

3 He continues to build up the painting by spraying on different colours to achieve the rich density of the foliage, and then begins to work on the grass. For this, he uses a slightly larger brush size, and with the jitter slider set down to about 0.2, drags horizontal strokes across from left to right. To add variety, he introduces some dark green shadows under the trees and some pale green patches, taking these colours from other areas of the photograph. A slightly stronger pink, obtained by moving the little circle on the colour wheel fractionally, is chosen to spray on more blossom over the trees and up over the sky. For this, the jitter slider is moved two-thirds to the right and the brush size reduced to 13.7. The dropper was used to sample the colour of the buttercups, but this didn't give a bright enough yellow, so again the colour was amended by moving the circle in the colour wheel.

Keep toggling the trace on and off to see what you are doing. 4 The dark green foliage at the bottom left is blocked in with the darkest colour in the area, with progressively lighter greens worked into it. Although the colour was satisfactory, the brushstrokes didn't look quite right, so the artist decides to add some texture. He does this by selecting the add grain variant of the photo brush and then going to the paper section of the Art Materials palette – the paper texture chosen will be that created by this brush.

BRUSHESS: PHOTO: ADD GRAIN

5 The main colours of the wall are sampled from the photograph and blocked in broadly with the oil pastel. A new layer is then opened, a 2B pencil selected from the pencils category in the Brushes palette and the outlines of the stones drawn in. If pencil lines appear too harsh they can be blurred or diffused with one of the variants of the photo brush used previously. For further definition, the nervous pen variant was chosen from the pens category – this creates a variable fine line which was ideal for pulling the rocks together. For the trees, the graphic flat brush variant in the liquid ink category is used, with the colour directly cloned from the photograph by clicking on clone colour in the Art Materials palette and working over the ghost image.

BRUSHES: PENS: NERVOUS PEN

6 Details such as fine twigs in the sky area, the horizontal fence wire, and some blades of sunlit grass are drawn with a combination of the nervous pen and a fine liquid ink brush. Note that both watercolour and liquid ink brushes create new layers of their own, as they don't work on ordinary layers. For the final touches, more leaves and flowers were added with the oil pastel, and some grain was added here and there with the add grain variant of the photo brush.

The final image with grain added to the road, and extra texturing.

Carl Melegari \diamond Lou

This powerful composition was produced in Photoshop, using 32 different layers. The figure was hand-drawn in ink and then scanned in; textures were added from the artist's own photographic collection. Photographs and selections formed the basis for the background, with the magic wand tool and the threshold command used to fill in areas with solid colour and create strong contrasts.

THEMES

While the first part of the book has concentrated on techniques and the range of effects that can be achieved with each of the drawing media, this section shows how different artists adapt drawing methods to their subject matter and the ideas they wish to convey. The gallery of images that follows is intended to provide both inspiration and practical hints that will help you to develop your own drawing style.

INCLUDES

⇒BASIC SKILLS:	Composition 124 Keeping a sketchbook 126 Choosing the medium 128
⇔THE HUMAN FIGI	JRE: Weight and balance 130 Seated and reclining figures 132 Clothed figures 134 Portrait studies 136
⇔LANDSCAPE AND	URBAN THEMES: Composing a landscape 138 Trees 140 Landscape details 142 Buildings 144
⇔STILL LIFE AND IN	NTERIORS: Still life set-ups 146 Interiors as still life 148 Floral still life 150
⇒NATURE:	Plants and flowers 152 Animals and birds 154

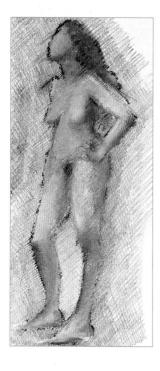

BASIC SKILLS

A large part of drawing consists of forward planning, gaining experience and gathering information for future work. The following six pages provide hints on composing the drawing, choosing the best medium for the job at hand, and making the best use of your sketchbooks to record impressions and try out ideas for finished drawings.

Composition

Drawing is a craft like any other, and learning to manipulate the 'tools of the trade' is an essential first step towards producing a drawing that stands up as a finished image. But it is only a first step; however well you handle your chosen medium, the drawing won't succeed fully unless equal attention is paid to the way it is composed.

The process of composition begins as soon as you put a mark on paper, so think about the balance of the various elements before you begin. In a portrait or figure drawing, for example, you need to consider where you will place the head or body in relation to the outer edges of the paper. In a landscape, you must think about the position of the horizon and the relationship of sky to land – it is always best to avoid splitting the picture into two equal areas, or placing a dominant feature too centrally.

To help you make these decisions, a viewfinder is a near-essential piece of equipment. It can be made by cutting a rectangular aperture in a piece of cardboard. Moving this around to frame your subject in different ways will present you with more compositional possibilities than you will see by simply looking at the subject.

Editing the subject

Bear in mind that you don't have to include everything you see; knowing what to leave out is a vital aspect of composition. You can move elements around, exaggerate angles, and so on to lead the viewer's eye into and around the picture. Try to think as much about the way the drawing is developing as you do about the subject itself – the artist's job is to interpret rather than to copy. The advantage of drawing on paper is that it allows you to change the format and composition as you work, cropping in more closely, making a horizontal into a square or vertical rectangle, and so on.

Unifying the composition

If you are working in colour, try to unify the composition by means of 'colour echoes', repeating the same or similar colours from one area to another. In a portrait, you might do this by bringing in a little of the clothing colour on the face, and in a landscape by using touches of sky blue among greens for foliage or shadows.

DOMINANT SHAPES

One way to deal with a strong, dominant shape is to echo it in another part of the picture, and another is to emphasise it by means of contrast. Bill James has chosen the second approach for his energetic pastel study, Ballerina, using the angular shapes of the arms to counterpoint the near-circle of the dancer's tutu. Notice how he has placed the upward-reaching arm slightly off-centre, and also how he has brought colour interest into the background by overlaying subtly contrasting colours.

PASTELS: blending and colour mixing 42

CHOOSING A FORMAT

The natural choice for a composition with a vertical emphasis is an upright rectangle, but in his pastel drawing, Winding Creek, Bill James has used a square format to great advantage. It has allowed him to push the three verticals into the centre of the picture and to make more of the foreground and the sweep of the river.

 PASTELS: drawing with pastels 40
 PASTELS: blending and colour mixing 42

LEADING THE EYE

Even in this rapid outdoor sketch, Ray Mutimer has not neglected composition, using the curve of the road to lead the eye from the foreground to the humpbacked bridge and over to the dip beyond. To stress the focal point, the darkest tones are concentrated in this central area. In order to build up the tones quickly, he has used a soft graphite pencil, drawing with the side of the point rather than the tip.

PENCILS AND GRAPHITE: drawing with pencils 16

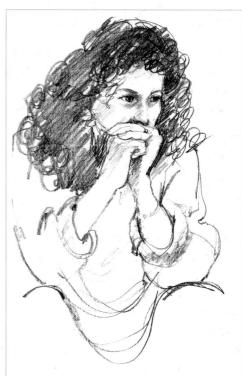

FRAMING THE SUBJECT

Always think of the edges of your sheet of paper as a frame, as this helps you to decide where to place the main elements. In Mari l'Anson's pencil sketch, the figure is placed off-centre with the arm cropped slightly on the left, which has the effect of pushing the figure forwards and giving a sense of movement.

PENCILS AND GRAPHITE: drawing with pencils 16

HELPFUL ADVICE

Composing landscape subjects, in particular, can be confusing as it is natural to pan around with the eyes, thus taking in more than will actually fit on the page. Using a viewfinder will help you to isolate a part of the view.

Keeping a sketchbook

Many artists now use a camera as a 'sketchbook', in order to record details of landscape or cityscape, or people going about their business. However, the majority combine photography with drawn sketches, and some eschew the use of the camera altogether. Photographs can undoubtedly be useful, especially for fleeting effects such as clouds or sunsets, but taking a quick snap does not involve you in the subject in the way that drawing does. Even if you only make rapid visual notes consisting of a few lines you will find yourself seeing with an artist's eye, and looking at your sketchbooks later will often help you to recapture your feelings about the subject.

Choosing a sketchbook

The choice of sketchbook depends on where you mainly intend to use it and on your chosen medium and way of working. Small handbag- or pocket-sized books are ideal for pen or pencil studies of people, allowing you to work unobtrusively without being observed, but you may find you want to draw on a larger scale for landscape or buildings. There is a wide choice available, one especially useful type being spiral-bound, allowing you to open out the pages and take a drawing over two sheets.

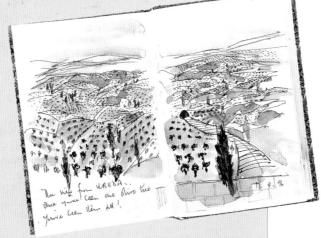

TONAL SKETCHES

When making sketches for a finished drawing or a painting in another medium, it is important to decide what information you will require. In these sketches, Alan Oliver has been mainly concerned with tone, using a 4B pencil and varying the pressure to create a range of lights and darks. Notice also how he has suggested the texture of the various surfaces by using different marks, from open hatching to loose scribbles with a blunt point.

PENCILS AND GRAPHITE: drawing with pencils 16

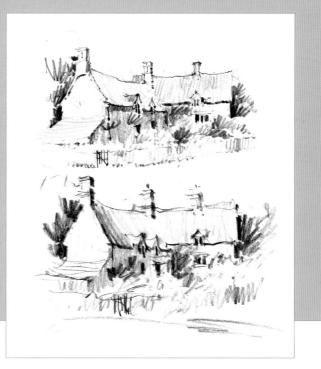

PATTERN IN LANDSCAPE

Sketching helps you to decide on your personal approach to a subject. Here Jim Woods has emphasised the lively pattern created by the shapes of the fields with their lines and dots of olive trees. He has used a water-soluble pen with light watercolour washes, and has taken the drawing over both pages of the sketchbook.

PEN AND INK: line and tone 30
LINE AND WASH: pen and wash 82

Ou fine than stop after on fine within an punthean beautiful the fearth Andthing opposite a bittle square. The left half was appeared to be 1 bright a hogen Stamps for getters we would is be porting letters in trance ! The for the BRONE

MAKING NOTES

Jim Woods often combines sketches made in watercolour, pen and pencil with written notes that serve as an additional aidé-memoire when he comes to plan the final composition. This is especially helpful if a long time is to elapse between sketch and finished work. Always give yourself as much information as possible when sketching.

LINE AND WASH: pen and wash 82
 LINE AND WASH: pencil and watercolour 84

CAPTURING POSTURES

In this delightful series of figure sketches, Alan Oliver has caught the overall shapes and postures with the most economical of means, sometimes using no more than an ink outline and in other cases blocking in a whole shape with soft pencil. He uses a spiral-bound sketchbook with pages the size of standard typing paper.

PENCILS AND GRAPHITE: drawing with pencils 16
PEN AND INK: drawing implements 28

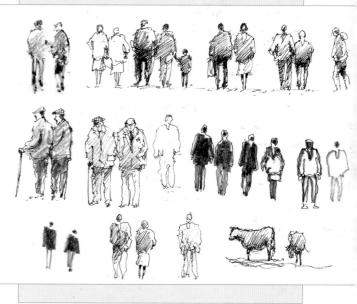

HELPFUL ADVICE

Another advantage of using a sketchbook is that it gives you the chance to practise and build up your drawing and observational skills. The more you do it, the more confident you will become.

Choosing the medium

Although there is no 'special' medium for any subject – a landscape or portrait can be as successful in pencil as it is in pen and ink, pastel or coloured pencils – you will sometimes feel that a particular medium gives you the best opportunity of expressing your ideas. The first choice is between colour and monochrome, and you must decide what it is that most excites you about the subject. Some people have an immediate response to colour, while others look for pattern, linear qualities or strength of form.

Getting the feel of the medium

The best way to decide on a medium is to try out several and discover which one 'talks back to you'. In the field of monochrome drawing, start with pencil; if you find yourself frustrated, move on to a broader medium such as charcoal or ink and wash. If you are more interested in line than tone, and the subject suits a linear approach, you might try pen and ink. By following a similar procedure with the colour media, you will quickly discover whether coloured pencils, pastels or inks best suit your style and way of working. Some artists like the speed and immediacy of pastels, while others prefer to build up detailed effects with coloured pencil, and find pastel messy and hard to control.

Practical choices

Time and location are also important factors in the choice of medium. If you are outdoors making quick sketchbook studies of moving subjects such as people or animals, pencil, pen and ink (and biro) are both ideal, as they all enable you to make visual notes rapidly. Charcoal smudges too easily to be much use for sketchbook notes (it may have rubbed off before you get home), but is perfect for rapid, larger-scale work, such as short poses in life-drawing classes. For recording colours in sketches, soft coloured pencils, pastel pencils or watercolour are all good choices, and will provide a good basis for fully worked studio drawings.

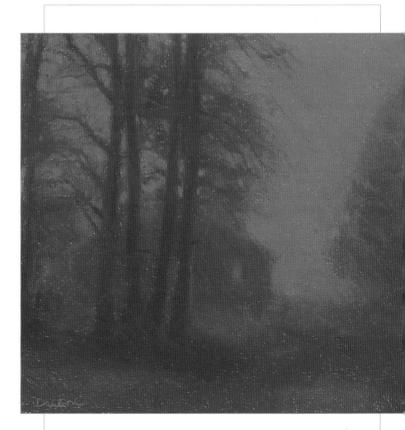

SOFT PASTEL

Pastel is ideal for a subject like this, in which colour and atmosphere are more important than fine detail. For Sodaville Fog, Doug Dawson has laid successive layers of colour to achieve subtle but glowing hues, and has worked on a warm, pink-toned paper, flecks of which can be seen showing through the pastel.

PASTELS: blending and colour mixing 42
 PASTELS: paper colour 44

COLOURED PENCIL

Coloured pencil is a versatile medium, as it can be used loosely and freely or in a more controlled manner to build up both blocks of colour and fine detail. As can be seen from this drawing, Reflections in a Shop Window, Jane Peart enjoys detailed work, and has built up the picture gradually with layers of coloured pencil and various blending methods. To emphasise the focal point, she has boosted the red in the centre of the image with an overlay of coloured ink.

COLOURED PENCILS: blending 66

DRAWING WITH BALLPOINTS

Because we write with these pens every day, they are more familiar to us than most of the fine-art media, so it makes sense to use them as drawing implements. They are ideal for quick studies like this figure sketch by Charlotte Stewart, and although they cannot be erased, any incorrect lines can simply be drawn over and reinforced by using heavier pressure.

PEN AND INK: drawing implements 28

HELPFUL ADVICE

There's no right or wrong when it comes to selecting which drawing medium is best for you: it comes down to personal choice and circumstance.

FINE DETAIL WITH PENCILS

Graphite pencils are ideal for achieving both fine detail and a range of tones. For this drawing, Bramley Apple, Jean Canter has chosen a heavyweight, smooth-surfaced drawing paper and has used B and 2B pencils, blending the tones on the apple with a cotton bud.

PENCILS AND GRAPHITE: drawing with pencils 16

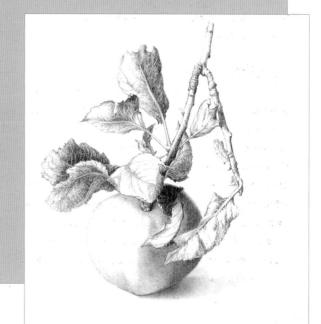

THE HUMAN FIGURE

Our fellow humans provide a uniquely accessible range of subject matter – a trip to the supermarket or a walk around a town or village will provide endless inspiration in the form of faces and figures. Drawing people, whether clothed or unclothed, is certainly challenging, but the sense of achievement that follows a successful drawing makes it well worth the effort.

Weight and balance

For several decades, life drawing – drawing from the nude – has been unfashionable in art schools, but it is now once again recognised as an important part of the discipline of drawing. It is not essential, but is extremely helpful if figures, either static or in movement, are to form part of your subject matter. Drawing clothed figures without some knowledge of the nude can present problems, as the clothing often acts as a disguise, making it difficult to 'read' the pose and understand the proportions.

Structure and movement

When you draw the nude figure, you will become familiar with the underlying skeletal structures and muscles, the proportions and the distribution of weight. To render the figure in a convincing way it is vital to grasp that any movements of its constituent parts affect the whole body. Raising the arms also raises the ribcage and shoulder blades; moving the head puts stress on the neck; resting weight on one leg alters the angle of the pelvis, and so on. The changes that take place as weight is redistributed are most clearly seen in the standing figure. If the model stands in a relaxed pose with feet apart and the weight of the body evenly divided, the pelvis and shoulders will both be level. However, if one foot is bearing most of the weight, the hip will be pushed up on this side, while the shoulders above the weight-bearing hip will tilt downwards to compensate.

HELPFUL ADVICE

When drawing a standing figure, establish the position of the shoulders and hips first by holding a pencil up in front of you and moving it to coincide with the angles. It is also vital to balance the figure so that it does not appear to be toppling over. In any standing pose, there is a theoretical 'balance line', starting from the pit of the neck for a front view, the back of the ear for a side view, and the back of the neck for a back view. This line runs down to the weight-bearing foot or, if the weight is evenly distributed, falls in the middle of the two feet. Check this line with the pencil in the same way as before and mark it in lightly to provide a guide for the placing of the feet.

ANALYSING THE POSE

If the model is to pose for more than about 20 minutes, spend a little time observing before you draw, looking for the main shapes and angles. In Natalia Palarmarchuk-Littlewood's drawing, the hips, buttocks and the position of the hand show how the weight is resting, with the upper body sloping upwards and slightly away. The weight-bearing hand itself is invisible, but the artist has stressed it by using a cast shadow. The drawing is in pastel pencil, which allows for both strong line and areas of tone.

PASTELS: drawing with pastels 40

LINEAR DRAWING

In this lovely drawing reminiscent of Henri Matisse, David Cottingham has used brush and ink to draw entirely in outline, indicating the forms and their relative positions in space by varying the strength of the lines. Notice how cleverly he has cropped the figure, including the important features such as the torso, shoulder, arm and weightbearing hand, while leaving the rest to our imagination.

BRUSH AND INK: drawing with a brush **32**

MAKING A BROAD STATEMENT

Elinor K. Stewart's drawing, Redhead, is completely convincing in terms of weight distribution and form, although there is little detail, and the facial features have been deliberately excluded. She has used an unusual technique, combining oil pastel with graphite pencil – this gives an interesting effect, as the oil 'stops' the graphite to create a dark outline.

Soll PASTELS: overlaying colours 55

HIPS AND SHOULDERS

As can be seen from Natalia Palarmarchuk-Littlewood's pastel pencil drawing, the distribution of weight can be indicated clearly even without including the lower legs and feet. The angles of the hips, buttocks and shoulders show that the weight is resting on the left foot, with the other leg relaxed and slightly outstretched.

PASTELS: drawing with pastels 40

Seated and reclining figures

Standing figures can be drawn in isolation, with nothing more than a line or two or a touch of shadow to indicate the ground. However, when the model is sitting on a chair or lying on a bed or sofa, you will have to engage with the context as well as the figure. This gives you an opportunity to experiment with composition, producing a complete image rather than just drawing to gain knowledge and experience.

Relating the figure to the setting

The bed, chair or sofa will also help you to check the angles and shapes of the figure, acting as reference points, so always try to draw both at the same time rather than adding the surroundings as an afterthought when the figure is complete. This is especially important in the case of a seated figure on a chair – the chair takes the weight of the body, just as the feet do in a standing figure, so it must be drawn accurately. Some art teachers advocate sketching in the chair before beginning on the figure, which can be helpful.

Perspective effects

Seated and reclining figures are sometimes thought to be easier than standing poses. In fact, they present problems of their own, the main one being the perspective effect known as 'foreshortening' that makes nearby objects appear larger than far-off ones. For example, if you were to draw a reclining figure from directly behind the head, the latter would appear very large in relation to the feet – actually, a foot is about the same length as a head if both are seen on the same plane. It is often hard to accept how drastic the effects of foreshortening are, so you tend to draw what you know rather than what you see. For example, if a seated figure is seen from the side, the thighs and lower legs will be much the same length; moving around to the front will foreshorten the thighs so that they may be only a quarter of their actual length, or even less.

EXPLOITING PERSPECTIVE EFFECTS

For his pencil drawing, Clive, Paul Bartlett has chosen a viewpoint directly behind the model's head, producing extreme foreshortening of the lower part of the body. This has given the figure an unusual and interesting shape, which he has made the most of by leaving the body almost white, set against the largely mid-toned background and emphasised by the very dark hair.

PENCILS AND GRAPHITE: drawing with pencils 16

HELPFUL ADVICE

To check the effects of foreshortening, it is essential to take measurements, holding a pencil up at arm's length and sliding your thumb up and down it to check one size against another. It is also vital to retain the same viewpoint as you draw, because any change in your own position alters the perspective, making the initial measurements invalid.

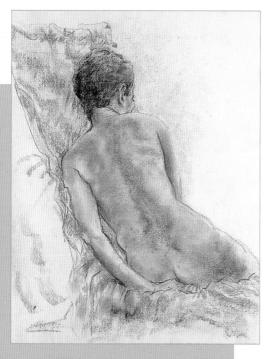

FLESH TONES

Lorna Marsh has used soft pastels to capture the glowing hues of the skin, using mainly earth colours except in the background, where she has brought in red, green and a touch of

purple. She has included enough of the setting to explain the model's pose, but has avoided cluttering the composition with unnecessary objects.

PASTELS: blending and colour mixing 42

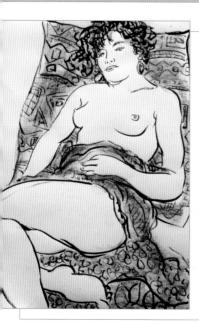

PATTERN AND CONTRAST

David Cottingham has created an attractive and decorative brush and ink drawing in which the pale shapes made by the body are contrasted with a patterned background. The curve of the drapery running across the body echoes those of the leg and forearm to give a sense of rhythm and movement.

BRUSH AND INK: drawing with a brush 32

SHADOW COLOURS

Working with watercolour and coloured pencil, Sara Hayward has exaggerated the greens often seen in the shadows of flesh to produce a lively colour study. She has also used complementary contrasts, bringing in purple drapery to enhance the yellow highlights on the body, and touches of red coloured pencil to contrast with the greens.

LINE AND WASH: pencil and watercolour 84

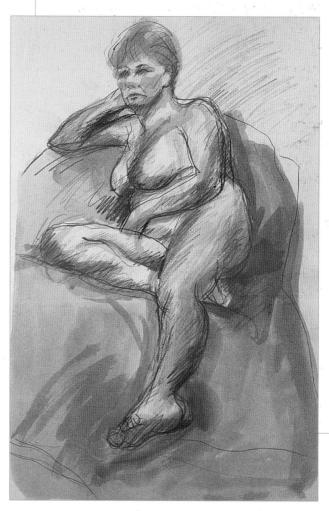

Clothed figures

Clothed figures provide a more accessible subject than nudes, and a wider range of possibilities, since clothing varies from person to person and from season to season. But they can present problems, as heavy or bulky clothing disguises forms and makes shapes and proportions hard to assess. Those who have studied the nude have an advantage, as they can make an informed guess at the body beneath its outer covering, but with careful observation you can still produce successful drawings even without this prior knowledge.

Looking for clues

Start by analysing the overall shape and then look for clues. Clothes tend to hang on certain parts of the body, so that even when partially hidden by a heavy garment, you can still judge the width and characteristic slope of the shoulders, and the size of the hips in relation to the rest of the body. Clothes also often provide useful hints in the form of contour lines. If a person is standing with the weight on one leg, the clothes may be pushed up over the weight-bearing hip, which helps you to place the legs and feet correctly. The neck of a T-shirt or sweater forms a contour line that describes the form of the neck and the angle of the head, while the edge of a sleeve helps you to see the form of the arm or wrist.

Different approaches

THUR HERE

The amount of detail you bring in on the clothing depends both on your intentions towards the drawing and the amount of time available. For quick sketches, detail will not be a priority, and a few lines will usually suffice. For a more prolonged study, you may want to pay special attention to the clothing, possibly even making it the main subject of the drawing.

PATTERNED CLOTHING

The bold spotted pattern of the dress is the main subject of John Elliot's pen-and-ink drawing, and although the head has been drawn in detail, the coat in the foreground has been treated sketchily to prevent it detracting from the focal point.

PEN AND INK: line and tone 30

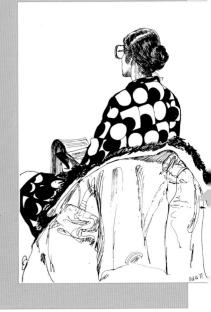

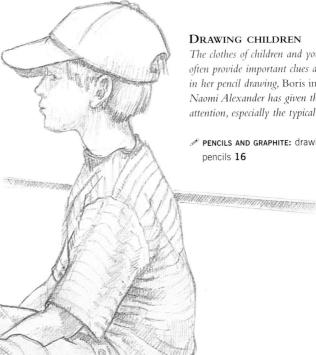

DRAWING CHILDREN

Antipantition and a subscription of the

The clothes of children and young people often provide important clues about them, and in her pencil drawing, Boris in Burgundy, Naomi Alexander has given them careful attention, especially the typical baseball cap.

PENCILS AND GRAPHITE: drawing with pencils 16

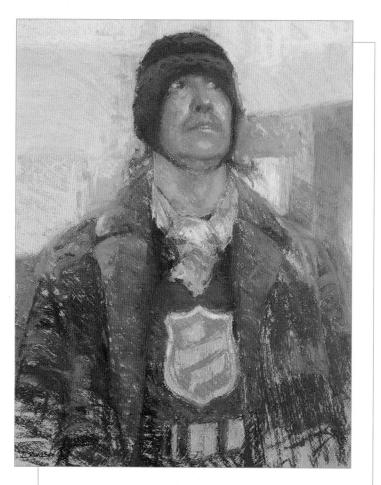

INFORMAL PORTRAITS

In this powerful study, Private in the Salvation Army, Doug Dawson has concentrated most attention on the face and the glowing badge, which seem to echo one another in conveying a message of hope. He has worked in pastel on textured paper, and the colour on the face has been worked so thickly that it almost resembles oil paint.

PASTELS: paper texture 48

PASTELS: blending and colour mixing 42

HELPFUL ADVICE

People's choice of clothes, or what they are wearing on a particular occasion, will often tell a more complete story about their interests and activities than simply a face and body, so bear this in mind when making portrait drawings.

SKETCHING FIGURES

Mari l'Anson's page of humorous sketches in pen and ink shows how a few lines can capture the essentials of both posture and clothing as well as suggesting a mood. The man in the striped T-shirt with one hand in his pocket, and the girl eating a iced lollipop, typify happy vacationers.

PEN AND INK: drawing implements 28

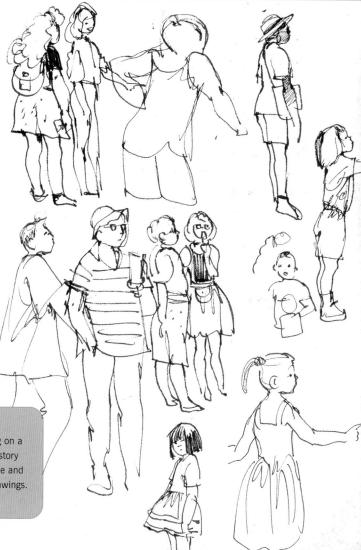

Portrait studies

The first concern of the portraitist is to capture a likeness of the sitter, but there is much more to making a successful portrait study. First, the drawing must work in pictorial terms, meeting the usual criteria of composition, balance of tone and colour, and accurate rendering of form. And second, it should tell you more about the sitter than simply the shape of the nose, eyes and mouth – it should express something of the person's character. Some of the most arresting portraits of all time were made by Titian in the fifteenth century and Rembrandt in the seventeenth. These are so convincing in terms of character and atmosphere that we almost feel we know the sitters personally.

Studying the subject

Professional portrait painters often spend time with their subjects in their own homes in order to get to know them and observe important factors such as gestures, facial mannerisms, and typical posture. You will rarely have the opportunity to do this unless you are drawing family and friends, but if possible, do take time to study your sitters and talk to them so that you can build up a rounded picture.

Individual characteristics

However, it is possible to draw convincing likenesses even if you have never met your subject, especially if you concentrate on the whole figure rather than just the head. Many people are instantly recognisable by the shape of their bodies, typical clothing, the way they walk, and so on. If you practise making quick sketches of people you encounter in daily life you may find that you can capture the essence of an individual in a few lines, with the minimum of detail.

GESTURES

In David Melling's drawing, Woman, the facial expression, with hands held over mouth to stifle laughter, forms the main subject of the drawing. Much of the face is hidden, but a likeness emerges through the eyes, hands and the shape made by the head and hair. The coloured pencil has been used almost monochromatically, with a small range of browns and redbrowns, and the directional stokes and use of a textured paper impart a distinct pattern to the shading.

COLOURED PENCILS: paper choices 64

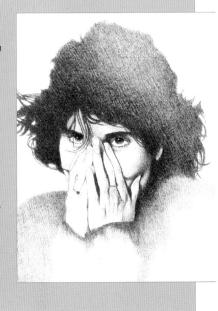

EYE POSITION

In many formal portraits, the sitter is shown gazing straight out at the viewer, creating a sense of engagement between the subject and the audience, but in this informal portrait, the gaze is more inward, suggesting that the sitter is lost in thought. Ray Mutimer has worked in watercolour, treating it more as a drawing than a painting medium, and using the marks of the brush to describe the shapes and forms.

BRUSH AND INK: drawing with a brush 32

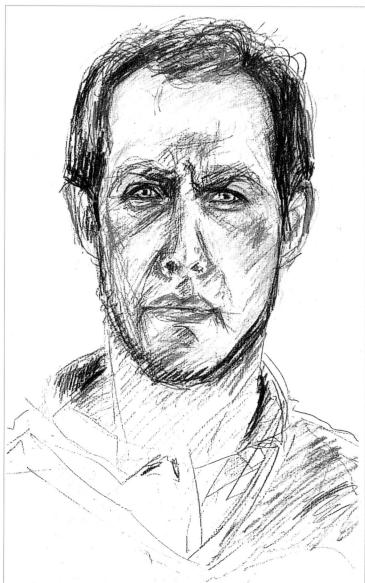

Self-portraits

If you have no model on hand, practice by drawing yourself in the mirror, as artists have done over the centuries. In his coloured pencil self-portrait, John Townend has produced a very powerful image through loose, almost scribbled marks and strong contrasts of colour, notably the complementary colours, red and green.

- COLOURED PENCILS: pencil choices 60
- COLOURED PENCILS: building up 62

PROFILES

The majority of portraits are drawn from a full frontal or three-quarter view so that all the features can be seen, but in his charcoal study Jim, Paul Bartlett has chosen a profile in order to make expressive use of the hand cupping the chin. The composition is powerful, with a strong sense of drama. Highlights have been achieved by lifting out areas of charcoal, and the details strengthened with charcoal pencil.

CHARCOAL: linear drawing 20
 CHARCOAL: lifting out 23

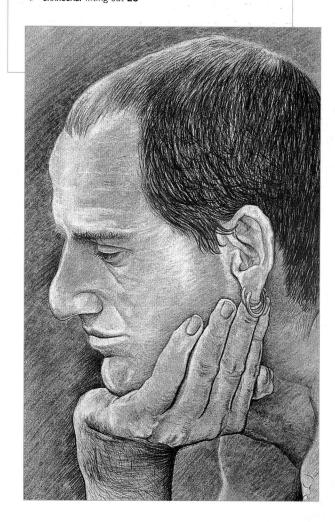

LANDSCAPE AND URBAN THEMES

Landscape subjects are often thought of in terms of colour – the Impressionist oil paintings immediately come to mind – but expressive landscape drawings can be made with any of the drawing media – even the monochrome ones.

Composing a landscape

The first basic rule in landscape drawing is to be selective, leaving out anything that does not help the composition. This is especially true when working from photographs, which often capture a wealth of unhelpful detail which you feel bound to include, but be stern with yourself and remember that drawing and painting is a process of interpretation rather than copying.

Inviting the viewer in

It is also vital to draw the viewer's eye into the picture so that they have the sense of being able to travel around in it, as in a real landscape. Try to make links between the main planes of the

picture – foreground, middle distance and far distance. A well-known compositional device is to use a curving road, path or river leading in from the foreground, but if these are not present in your subject, you can invent more subtle lead-in lines, such as a roughly diagonal line of grasses or shrubs.

Echoing colours

If you are working in colour, you can tie the different elements of the composition together through colour links – repeating the same or similar colours in different areas.

CREATING SPACE

Ray Mutimer has chosen a muted colour scheme for his pastel pencil drawing, Hedge, as befits the subject. The buildings form the focal point of the landscape, but even here the colours have been played down so that they recede in space while the dark spikes of the hedge come forward. He has worked on a mid-toned grey paper, which allowed him to draw directly with white, leaving the paper showing in the shadow areas.

PASTELS: drawing with pastels 40PASTELS: paper colour 44

LEADING THE EYE

In his conté drawing, In the Côtes du Rhone, Anthony Atkinson has used the common compositional device of a road leading in from the foreground to the middleground. Firmer drawing and deeper tones around the gateposts stress the focal point.

conte: crayons and pencils 24

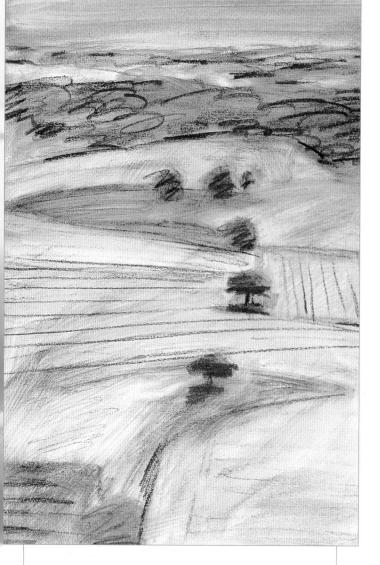

REPEATING COLOURS

Sara Hayward has employed a limited palette of vivid hues for her watercolour-pencil drawing, repeating similar colours from foreground to distance. Although the tones and colours are dark towards the back of the picture, she has not sacrificed the feeling of space because she has used a series of strong lead-in lines that form a zigzag pattern that the viewer's eye naturally follows.

COLOURED PENCILS: line and wash 75

PLACING THE HORIZON

The horizon line is most commonly placed about one-third of the way up or down the paper, depending on the role the sky is to play, but in Weathered Cottages Bridget Dowty has chosen a very low horizon in order to exploit the wonderful downwards sweep of the clouds. The small slice of landscape is given stability by the solid, static shapes of the two houses, and the eye is led towards them by the dark path. She has used a combination of media – pastel, watercolour, fine fibre-tipped pen and masking fluid.

COLORED INKS: inks and markers 76
 LINE AND WASH: watercolour and pastel 88

HELPFUL ADVICE

When repeating colours from the foreground to more distant areas, bear in mind that it is also vital to create a sense of space and recession. Colours become cooler (more blue) as they recede, as well as lighter in tone. If you are using a bright green or yellow in the foreground, make it progressively paler, and cool it with the addition of blue as you work towards the back of the picture, or the more distant areas will 'jump' forwards instead of taking their proper position in space.

Trees

Trees – either single specimens or groups – make a wonderful subject for the artist, offering attractions and challenges in winter and summer alike. It is a good idea to study them in winter, without their canopies, as these tend to disguise the structures in the same way as clothing obscures the forms of the human body beneath.

Characteristic features

Trees are enormously varied, with hundreds of different species and subspecies, each with its own characteristics of shape, foliage, colour and bark texture. Some are typical of certain places, or commonly associated with them, such as the English oak, the Mediterranean pine and cypress, and Australia's giant eucalyptus trees, so that you can give a sense of place by including them in your drawings.

The amount of detail you bring into tree studies depends on the kind of drawing you intend to make. If they are only one feature among many in a landscape, you will not want to dwell on details of foliage or bark texture, but you will want to give an idea of what type of trees they are. Most trees are recognisable even from a distance, simply by their distinctive shape and foliage colour, if you are working in summer.

Close-up studies

If you are drawing a close-up of an individual tree, always try to analyse the main shape first, and sketch it in lightly. Next, look for the way the branches grow out from the trunk, and the size of the trunk in relation to the spread of the canopy. Some trees are almost as broad as they are high, while others, like the cypress, are tall and thin, punctuating the landscape like a series of exclamation marks. The individual leaves that form the foliage mass also vary widely in both shape and growth habit, from the spiky, outward-thrusting leaves of the palm to the long, drooping leaves of the weeping willow, with a great many different rounded and oval shapes between these two extremes.

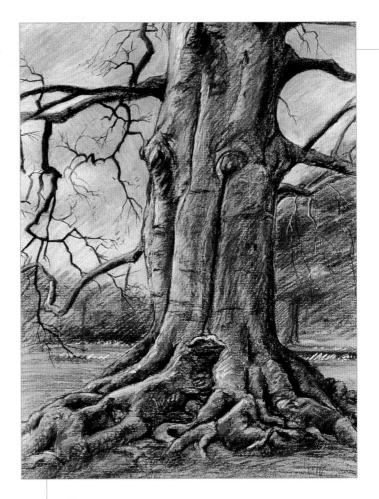

FOCUSING IN

The trunks of trees are often as exciting as the foliage, and sometimes more so, as they provide a wealth of colors, shapes and texture. In his hard-pastel drawing, Beech Tree, Roger Hutchins has exploited the wonderful fluted shapes revealed by the smooth bark of the tree, using the blue-grey paper colour to stand for the silvery highlights.

PASTELS: drawing with pastels 40
 PASTELS: paper colour 44

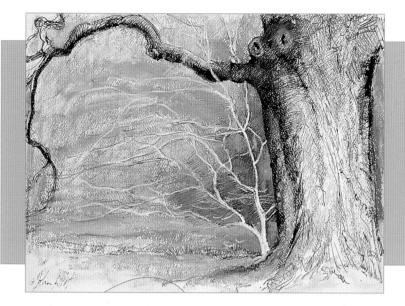

A FRAME WITHIN A FRAME

In this unusual drawing, the solid bulk of the tree trunk and the curving branch have been employed to frame and isolate the delicate white tree. John Elliot has used a combination of monochrome pen-and-ink work and colour 'washes' of soft pastel to soften the effect.

PEN AND INK: line and tone 30

TREE PORTRAITS

Even without using colour, you can make a very convincing 'portrait' of an individual tree, as John Elliot has in this sensitive pencil drawing. He has used different grades of pencil to achieve a range of tones, leaving areas of white paper where the clumps of leaves catch the light.

PENCILS AND GRAPHITE: combining grades 18

HELPFUL ADVICE

Although it is seldom either possible or desirable to draw every leaf of a particular tree, you may want to pick out a few here and there to make a more convincing portrait of your chosen subject.

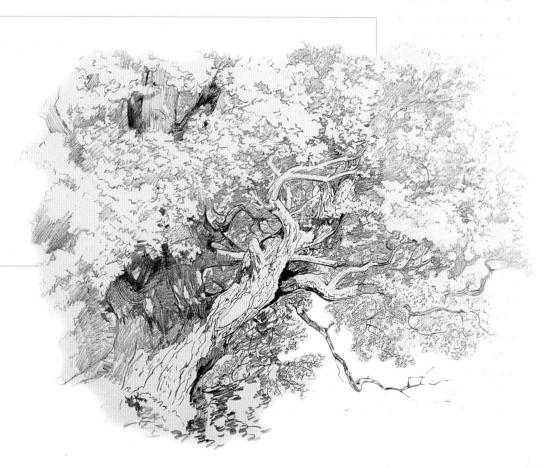

Landscape details

Landscape subjects can often be rather daunting – you look at a vista of fields, hills or wide plains and wonder where your drawing should begin and end. But unless your primary concern is capturing the feeling of space in a panoramic landscape, you might consider homing in on details and merely suggesting the surrounding space. Subjects such as a group of rocks, an old stone wall with foliage growing in front of it, or an ivy-clad tree trunk all make attractive and rewarding subjects, and you will find many more possibilities as you begin to explore the world of landscape. Remember to take a camera or sketchbook – or both – with you whenever you go out walking, as you may see promising subjects when you are least expecting them.

Using photographs

One advantage of landscape details is that they are easier to draw from photographic reference than wide landscapes. The latter are more subject to effects of light, and are not always served well by the camera – photographs tend to come out looking dull, with little sense of space, failing to recapture your

original excitement about the scene.

ABSTRACT VALUES

Ray Sparkes has created a semi-abstract composition by focusing in closely on the leaves and flowers of a buddleia tree, enlivening the image through the use of red/green complementary contrasts. The drawing is in oil pastel, with some use of turpentine to melt and spread the colour before adding further layers.

 OIL PASTELS: overlaying colours 55
 OIL PASTELS: blending with spirit 56

DRAMA THROUGH CONTRAST

In his drawing, Water and Rocks, Ray Mutimer has created a powerful image through the use of repeated swirling shapes and strong tonal contrasts. The dark areas were built up with black wax crayon applied very heavily (a similar effect could be achieved with black oil pastel), and the highlights were reinforced with white gouache.

OIL PASTELS: using oil pastels 54

LANDSCAPE IN MICROCOSM

Jane Peart's delightful coloured pencil drawing, Cornfield, shows only a tiny corner of a wider landscape, but nevertheless suggests the countryside that lies beyond. She has made the most of the textures of the old wood, cornstalks and leaves, and has brought in typical features of this type of landscape, such as the wildflowers and the chaffinch.

COLOURED PENCILS: building up colours and tones 62
 COLOURED PENCILS: blending 66

HELPFUL ADVICE

Whenever possible, work directly from the subject. Details won't change substantially from one day to the next, so you can always return if you can't finish a drawing in one session.

A WORLD BENEATH YOUR FEET

Carolyn Rochelle has seen the potential of sand and stones for a subject that combines elements of both landscape and still life. Her coloured-pencil drawing, Sandskrit, was built up gradually, starting with a slate blue watercolour wash and followed by layers of coloured pencil. The rich colours and smooth textures of the stones were achieved by burnishing, and a light pressure was used for the sand.

- COLOURED PENCILS: blending 66
- COLOURED PENCILS: burnishing 67

Buildings

Buildings offer more or less endless possibilities for the artist, with architectural styles and building materials varying widely from age to age and place to place. Some are also interesting because they offer an insight into the people who live in or use the building: a run-down or deserted farmhouse, for example, tells its own story, while a grand town house invites us to imagine the opulent lifestyles of its owners.

Careful observation

But buildings are not among the easiest of subjects, and require very close observation, especially if you are trying to make a 'portrait' that will be recognisable to others who are familiar with the building. The first thing to look for is proportion – the height of a wall in relation to its width, the size and placing of doors and windows, and so on. As you observe and draw, think about the structure – how thick or thin the walls are, and how the roof fits onto and overhangs the main walls. A common mistake is to draw windows and doors as though they are stuck onto the walls rather than set into them. Old castles, stone houses and cottages have typically deep-set windows because the walls are very thick, while the walls of newer buildings tend to be thinner, with the windows set closer to the outside edge.

Shapes and textures

If you want to create atmosphere and evoke a sense of place, you can pay less attention to structural detail and more to the overall shape, or to the pattern and texture of the building materials. Red-tiled roofs, for example, are typical of Mediterranean villages; cube-shaped houses with thick, whitewashed walls suggest Greek islands; while golden, onionshaped domes are a well-known symbol of Russia.

HOUSE PORTRAITS

If you enjoy drawing buildings, it is wise to build up your skills, as proud house or hostelry owners will sometimes commission artists to draw or paint their properties. But you will need to be accurate and give attention to detail, as Roger Hutchins has in this pen-and-ink drawing. The lettering was added with process white.

PEN AND INK: line and tone 30

HELPFUL ADVICE

If you are making a detailed close-up study, make sure you observe the proportionate size of building bricks, stones or planks, as these give an important clue about structure, period and place. It is easy to check simply by counting them off against the side of a window or door.

EFFECTS OF LIGHT

Sara Hayward's treatment in this watercolour drawing is more impressionistic – although the structure and proportions of the building have been carefully observed, she was equally interested in the play of light on the mellow brickwork. Notice how she has drawn with the brush rather than using the conventional watercolour method of light-over-dark washes.

BRUSH AND INK: drawing with a brush 32

DRAWING WITH THREE COLOURS

For this unfinished drawing, Martin Taylor has used three colors of conté pencil – black, sanguine (red-brown) and white, with the grey of the paper providing an additional colour. Conté pencils are ideal for architectural drawing, as they can achieve very precise, fine lines if kept well sharpened.

conte: crayons and pencils 24
 conte: working on toned paper 26

STILL LIFE AND INTERIORS

Still life is less popular with amateurs than landscape or figure drawing, but most artists regard it highly as a subject. This is partially because it gives scope for experimentation and helps to build up skills, and also because it provides an opportunity to draw and paint when the weather prohibits outdoor work.

Still life set-ups

The beauty of still life is that your set-up can be as simple or as complex as you wish, you can spend as long as you like over the initial arrangement and the drawing, and you can choose any objects that interest you. Fruit and vegetables, or a combination of the two, are perennial favourites, but there are countless other possibilities. You could start by looking around your home for ideas.

Still life themes

There are no real rules about still life set-ups, but it is wise not to make a random selection of unrelated objects. Try to create a theme (unless you want to create a deliberately surrealist effect by contrasting objects that would not normally be seen together). For example, fruit and vegetables have a natural relationship, as do man-made items such as crockery, ceramics and glassware, but if you were to include a football or an old shoe it would look odd and out of place.

Lighting

Lighting can present a problem, as you need good light to model forms – unless you are more interested in a flat-pattern effect. If you don't have adequate natural light, or the light source changes from morning to afternoon, try using a lamp to provide additional light and shade as well as cast shadows, which can be an important feature in the composition.

TAKING A HIGH VIEWPOINT

Dee Steane has chosen to look down on her subject, bringing in a pattern element that would not be present in an eye-level view. To emphasise this, she has contrasted the shapes of the peppers and chilies with the regular, mechanical pattern of the floor tiles, and has created an interesting series of two-toned shapes from the background on which the vegetables rest. The wash-off technique was used for this image, with the white areas coloured with watercolour.

MUNUSUAL TECHNIQUES: wash-off 96

EVERYDAY SUBJECTS

Lydia Marsh's pastel still life, Popcorn, demonstrates how an ordinary subject can be transformed into an exciting image through careful composition and colour balance. The large objects are placed at the top of the picture and slightly cropped at top and right, which has the effect of thrusting the pieces of corn forwards – we can almost feel them moving towards us.

COMPOSITIONAL DEVICES

What artists call 'the hidden triangle' is the basis of many compositions, and Sara Hayward has used an upside-down triangle for the arrangement of the fruit. The drawing is in coloured inks applied with a brush, and the lines have been strengthened with a dip pen and black ink. Like Dee Steane, the artist has chosen to look down on the subject, so that the squares of the cloth are only minimally affected by perspective.

✓ COLOURED INKS: inks and markers 76
✓ PEN AND INK: drawing implements 28

Interiors as still life

Some interiors form a branch of architectural drawing, while others can be seen as an extension of still life work. A detailed drawing of the interior of a church, cathedral or grandly decorated and embellished public room come into the former category. However, a study of a chair in the corner of a room, or a table in an alcove, or an area of a kitchen with shelves and cupboards, is more akin to still life.

Exploring possibilities

This kind of interior presents a wealth of opportunities. Although you have slightly less control over the subject than in classic still life painting, it is usually possible to move the smaller elements of the subject around to achieve a better balance or a more interesting effect. You can also, of course, choose to leave out anything that jars or detracts from the composition. You can also play with perspective and proportion, altering the spacing of window bars or bringing walls closer together to enclose a main centre of interest such as a chair or table.

Practical considerations

However, there are two potential problems. Firstly, if the room is small, it can be hard to find a good place to set up your easel – you need light on your drawing as well as on the subject. Secondly, many interiors are given their special charm by a particular lighting effect. A bedroom with the morning sunlight streaming over rumpled sheets is a lovely subject, but will be much less enticing when the sun has moved. So unless you have an unusually accurate visual memory you may have to rely on the camera to some extent, using a photograph as reference for the pattern of light and referring to the real thing for structure, proportions and detail. Here is where the digital camera really comes into its own, as you don't have to wait days or weeks for the film to be developed, by which time you may have lost sight of the original inspiration.

THE POWER OF VERTICALS

A composition based on horizontal and vertical lines can look bland and dull, but once diagonals are brought in, everything comes to life. In Bridget Dowty's charcoal drawing, Old Brewhouse Corner, the vertical formed by the sunlit window recess give stability to the image, while the two diagonals lead the eye to the array of shapes that form the centre of interest.

CHARCOAL: tonal drawing 22

HELPFUL ADVICE

Look around your own home at different times of day to assess various light effects, and don't neglect the possibilities of lamplight, or even moonlight.

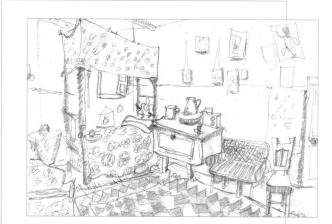

USING ARTISTIC LICENCE

Naomi Alexander has given a lively sparkle to her pencil drawing by stressing the patterns on the floor rug and bed as well as by avoiding perfect, straight lines. It is tempting to use a ruler when you are confronted by man-made objects and the regular structural features of an interior, but it can make a drawing look too mechanical, sacrificing the personal touch.

PENCILS AND GRAPHITE: drawing with pencils 16

EXPLOITING LIGHT EFFECTS

Not only does sunlight transform a room; it also helpfully creates strong highlights that define objects. In his lovely soft-pastel drawing, Sunlight in the Library, David Mynett has treated the various pieces of furniture quite broadly, leaving the dark and mid-tones vague but adding precise definition by drawing the sunlit edges in thick pastel.

PASTELS: drawing with pastels 40
 PASTELS: blending and colour mixing 42

EXPLORING TECHNIQUES

For this attractive drawing, Naomi Alexander has used a personal version of the wash-off technique, combining inks washed out under the shower with poster color and fibretipped pens. The composition is based on repeated curves, with those on the left in opposition to the chair backs and the object on the table.

UNUSUAL TECHNIQUES: wash-off 96

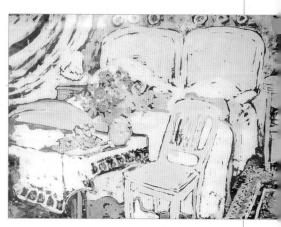

Floral still life

Drawing and painting indoor floral arrangements is a branch of still life, and a deservedly popular one – with both artists and patrons. Flowers are one of the few subjects that cannot always be done full justice in monochrome, but any of the colour media, from pastels and coloured pencils to watercolours and coloured inks, are suitable, as are many of the mixed-media approaches.

Creating movement

As in any still life subject, take care over the initial set-up, and explore various viewpoints and compositional arrangements before you begin. There are certain inherent problems in flower painting, which can be overcome if you are aware of them. One is that a carefully arranged vase of flowers can look rather dead and static, so you must find ways of creating a sense of rhythm and movement. You can do this either through your use of your chosen medium – varying pastels or coloured pencil strokes, for example, or by exaggerating natural features such as the curl of leaves and petals and the upward thrust of stems.

Backgrounds and foregrounds

You may also find that the foreground creates compositional difficulties, with blank spaces where nothing is happening on either side of the vase. There are many ways of solving this problem – you can place the vase on a patterned cloth, bring another object beside the vase (a device often used by flower painters is to cut one of the blossoms), or make a feature of shadows on the table top. Alternatively, you can either place the arrangement below your eye level so that you see more of the flower mass and less of the container, or you can simply crop out part of the vase as you would crop out the body in a head-and-shoulders portrait.

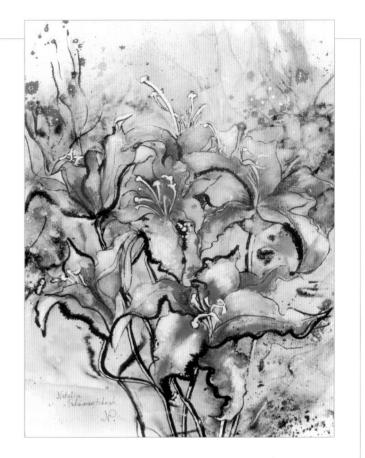

COMPOSITIONAL MOVEMENT

Natalia Palarmarchuk-Littlewood has achieved a lovely feeling of swirling movement in her drawing, Lilies, by slightly exaggerating the curves of the stems and stamens and omitting the vase which would anchor and restrict the flowers. She has worked in watercolour and ink, using the ink on damp paper so that it has spread out to make a wide, soft line beneath the petals.

LINE AND WASH: pen and wash 82

HELPFUL ADVICE

Even professional artists sometimes find it hard to get both sides of a vase exactly equal. If you have problems, draw a vertical line down the centre of the vase and sketch in one side. Cut a piece of tracing paper into the same shape, place it on the centre line, and flip it over. This will ensure that the second side is a mirror image of the first.

FLORAL STILL LIFE 151

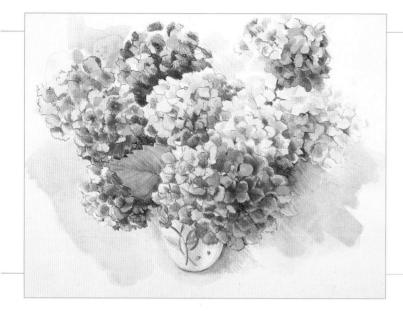

THE IMPORTANCE OF VIEWPOINT

Tall flowers look good from an eye-level or above eye-level viewpoint, but these spherical clusters of small florets are better seen from above so that they form a series of near-circles. This viewpoint also has the advantage of giving the flowers much more importance than the vase or container. Jane Hughes's study, Hydrangeas, has been worked in a combination of watercolour and coloured pencil, with the latter used mainly in the shadow areas to build up form and depth of tone.

S LINE AND WASH: watercolour and coloured pencil 84

PLACING THE VASE

It is sometimes quite acceptable to place the vase or container in the centre of the picture, as the flowers themselves will break the symmetry. However, in this composition, John Elliot wanted to exploit the delicate branch of flowers, showing them pushing upwards and out to the left, so the glass is placed closer to the right and cropped at the bottom. The drawing is in pastel, with the paper colour itself used as the background. It is left showing in and around pastel strokes in the foreground to create the lacy pattern of the cloth.

PASTELS: paper colour 44
 PASTELS: vignetting 46

NATURE

The natural world provides a rich and varied array of drawing subjects, from wildflowers and plants to birds and animals. The plant world gives you a chance to focus in closely on a subject that interests you, using one of the media that encourages detailed work. The animal kingdom presents a different kind of challenge – as you will need to build up your skills in rendering movement – but it is well worth the effort.

Plants and flowers

Flowers don't have to be arranged in pots or vases and painted indoors – the outdoor world provides a wealth of exciting subjects, giving you an opportunity to observe the plants in their natural habitat, possibly bringing in a few landscape details to make them look more 'at home'. You are, of course, limited by seasons – cut flowers are available at all times of the year, but few flowers bloom outdoors in cold or even temperate climates, and some nonflowering plants wither and die.

Making choices

The only real difficulty with plants and flowers as subjects is that they often present too many conflicting shapes, colours and details, and often need to be simplified to make a strong composition with an obvious centre of interest. A flowerbed in full summer, for example, may have been planted with the intention of making dramatic splashes of vivid and contrasting colours. Such a subject could be treated very broadly, with the minimum of detail, or you could home in on a plant or group of flowers that particularly interests you, generalising the background and surroundings. Your approach will partially depend on the medium you have chosen: the monochrome media are more suited to a detailed approach, while pastels, soft coloured pencils, or coloured inks allow you to exploit broad areas of colour.

SELECTING AND SIMPLIFYING

The colours, structures and shapes of poppies make them an everpopular painting subject, and Dee Steane has done full justice to the forms by focusing in on just three blooms. She has arranged them in an irregular triangle, set against the jagged leaf shapes, with the composition strengthened by the vertical and diagonal formed by the two bud-bearing stems. The rich blacks that give the drawing additional punch were achieved by the wash-off method, with watercolour and a touch of gouache used to lay washes on the white areas.

UNUSUAL TECHNIQUES: wash-off 96

CREATING SURFACE TEXTURE

Brian Halton has used an inventive collage method for this delightful study, Dandelion Head. He began by sticking tissue paper onto a piece of hardboard with PVA glue, pushing in pieces of string and yarn beneath the tissue layer to help build up the shapes. When the glue was dry, he painted over the textured ground with acrylic paints, scraping pastel over the top while the paint was still wet.

COLLAGE: drawing with torn paper 102

HELPFUL ADVICE

Make the most of the growing seasons and take a sketchbook and camera wherever you go. Once you start to look, you will find endless sources of inspiration, from humble wildflowers growing against a wall to lavish blooms in cultivated gardens or other public places.

TRANSFORMING MUNDANE SUBJECTS

A Brussels sprout plant might not be an obvious choice of subject, but Janet Whittle has seen the possibilities for exploiting contrasting shapes and textures to achieve an exciting composition. The pencil drawing for A Splash of Colour was completed first, using various different grades of pencil, and the butterfly was then added in strong, fairly dry watercolour.

PENCILS AND GRAPHITE: combining grades 18

Animals and birds

The human figure is often held up as the most difficult of all drawing subjects, but members of the animal world certainly compete for this title. Here you have to cope with the problem of movement as well as hair, fur and feathers, which obscure the underlying forms. But with patience and careful observation, you can learn to make successful drawings – and it is well worth the effort, as animals are enormously rewarding subjects.

Learning the subject

The best way to start is by sketching familiar animals, such as your own pets, or farm animals if you live in the country. Dogs and cats both tend to sleep a good deal, providing obligingly static models; horses, cows and sheep grazing in fields tend to move fairly slowly, repeating a series of characteristic movements. In order to learn the sequence of movements, make quick sketches, either side by side or one on top of the other. This forces you to analyse the way each movement affects the rest of the body. It also helps to train the memory, which is an important aspect of drawing – even a static subject involves a degree of memory, as you must look away from it while you commit it to paper.

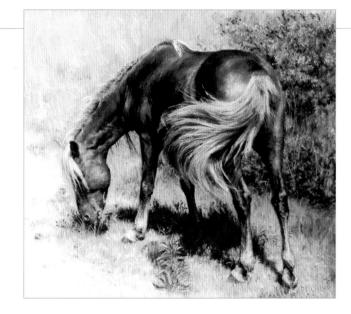

REPEATED MOVEMENTS

The movements of grazing animals are constant but repetitive, consisting mainly of changing leg positions and thus the distribution of weight. In her pastel drawing, Pony Nibbling Grass, Deborah Deichler has caught a moment when the animal has flicked its tail, adding both excitement and realism to the image. The drawing was worked on textured paper with hard and soft pastels and pastel pencils.

PASTELS: drawing with pastels 40PASTELS: paper texture 48

Animal anatomy

Most professional animal artists begin their careers by making studies of anatomy to learn and memorise the underlying structure of bones and muscles. This is certainly helpful in cases when depictions need to be extremely accurate, as part of zoological studies, but is seldom either practical or necessary for amateurs or non-specialist artists.

LOOKING FOR THE OVERALL SHAPE

Geoff Pimlott's delightful drawing, Duck Walking, was done very rapidly, using pen and ink and wash. The body of the duck is treated as a simple, almost stylised shape, but it is immediately recognisable.

PEN AND INK: line and tone 30
BRUSH AND INK: drawing with a brush 32

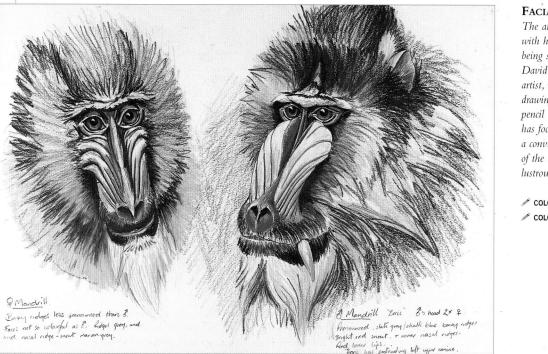

FACIAL FEATURES

The animal kingdom is hugely varied, with head shapes and facial features being specific to each individual species. David Boys is a professional animal artist, who spends much of his time drawing at zoos, and in this colouredpencil drawing, Mandrill Studies, he has focused in on the heads to produce a convincingly accurate representation of the noses, mouths, markings and lustrous brown eyes.

COLOURED PENCILS: pencil choices 60
 COLOURED PENCILS: building up 62

FACIAL EXPRESSIONS

Animals, especially dogs, assume different expressions according to their current activities or expectations, and in Max and Ball, Bridget Dowty has caught the dog's eagerness so well that even without the ball we would know he was waiting for something. She has worked with a combination of graphite pencil and charcoal pencil, which has allowed her to build up strong, dark tones.

 CHARCOAL: linear drawing 20
 PENCILS AND GRAPHITE: combining grades 18

HELPFUL ADVICE

When drawing animals, look for structural clues whenever possible – the bones and muscles of short-haired animals such as horses and cows can be seen quite clearly. If you have pets, try to learn by touch as well as by sight. Stroking the head, legs and body of a dog or cat will enable you to feel the shapes of the skull, leg bones and ribcage – and the animal is unlikely to object to this method of learning.

INDEX

Page numbers in *italics* refer to illustrations and captions

Α

Alexander, Naomi: Boris in Burgundy 134 Reclining Nude *102* pencil drawing *149* wash-off techniques *149* anatomy, animal 154 animals, drawing 154–155 bone structure 154, 155 Facial features *155* architectural subjects 85 *see also* buildings Atkinson, Anthony: In the Côtes du Rhone 138

В

balance line, figure drawing 130 ballpoint pen 29, 82, 129 shading with 8 Bartlett, Paul: Clive 132 Jim 137 birds 154 bitmap images 110 bleach, ink and 98 blending: coloured pencils 66 conté and oil bar 99 oil pastels 56-57, 95 pastels 42-43 with spirit 56-57 blot drawing 34-35 Boys, David: Mandrill Studies 155 bracelet shading 25, 92

bread (as eraser) 50, 51, 68 brush and ink 32–35, *131*, *133* brushes 32, 56 buildings 144–145 burnishing *61*, *67*, *68*, *143*

С

Canter, Jean: Bramley Apple 129 Georgian Row 37 canvas board 56 carbon pencil 84 charcoal: blending 9 crosshatching 20 and graphite pencil 155 hatching 20 lifting out 23, 137 linear drawing 20-21 shading 8 sharpening 21 tonal drawing 22 tones 21 charcoal pencil 20 children, drawing 134 cloning 118 clothing 134-135 collage 41, 100-103, 153 colour(s): building up 10-11, 43, 62-63 layering 55 receding 139 repeating 139, 139 colour contrast 124, 137 colour echoes/links 124, 138 colour mixing 10, 11 with coloured inks 78 with coloured pencils 62

with oil pastels 54-55 with pastels 42-43 colour sketches 128 coloured pencils: blended 61, 66, 129 building up 62-63 burnishing 61, 67, 143 choosing 60 colour mixing 10, 62 corrections 68 frottage 70-71 impressing 72-73 paper for 62, 63 scratching back 68 squaring up 69 tone 10, 60-61, 62-63 on transparent surfaces 65 water-soluble 60, 74-75, 86, 139 watercolour and 86-87, 151 complementary contrast 44, 44, 55, 133, 137, 142 composition 124, 125 figure drawing 132 floral 150 interiors 147 landscape 125, 138, 139 nature drawings 152, 152 Constance, Diana: Standing Nude 106 conté 24, 145 building up tone 25 and oil bar 99 sharpening 24 three-colour working 26 and toned paper 26-27

contrast: colour 124, 137 complementary 44, 44, 55, 133.137.142 shape 124 tonal 142 corrections: coloured pencil 68 conté 24 graphite pencil 18 pastels 50-51 Cottingham, David: linear drawing 131 Linear drawing 131 Cozens, Alexander 34 cropping 124 crosshatching 8, 9 with charcoal 20, 20 colour 10 with coloured pencil 62, 66 with conté 24 digital 114 with pastel 41 with pen and ink 28, 29 with pencil 16, 16 scraperboard 36

D

Dawson, Doug: Private in the Salvation Army 135 Sodaville Fog 128 The Steeple Light 45 Deichler, Deborah: Pony Nibbling Grass 154 Dowty, Bridget: Max and Ball 155 Old Brewhouse Corner 148 Weathered Cottages 139 drafting film 65 drawing tablet 110 drv-brush method 35

Ε

Elliot, John: flowers *151* a frame within a frame *141* patterned clothing *134* tree portraits *141* eraser: bread as 50, 51, 68 kneadable 22, 23, 24, 47, 50, 51, 68 plastic 67, 68 Ernst, Max 70 Evans, Matthew: Sailing 59

F

facial features: to define 26, 46 fiber-tipped pen 28, 30, 82 hatching 9 figure drawing 130-133 figure sketches 127, 129, 135 figures: clothed 134-135 reclining 132, 132, 133 seated 132, 133 standing 130, 131 fixing/fixative 49, 50 flesh tones 133 flowers 150-151, 152-153 focal point 125, 129, 134, 138 foreground 150 foreshortening 132, 132 form, describing 8, 9 format 125 frottage 70-71

G

gestures, capturing 136, *136* Gorst, Brian: Mediterranean Landscape *103* gouache 88–89, 96, *142* graphite 16, *16* graphite pencil 129 and charcoal *155* combining 18–19, *141*, *153* crosshatching 16, 16 grades 16 hatching 16 holding 17 and oil pastel *131* shading with 8, 18–19

Н

Halton, Brian: Dandelion Head 153 Harrison, Hazel: Rhododendrons 97 hatching: with charcoal 20, 20 to build up colour 10, 11 with coloured pencil 60, 62. 63,66 with conté 24, 25 with pastel 41 with pen and ink 28, 29 with pencil 16 scraperboard 36 Hayward, Sara: Fruit Bowl 63 light effects 145 Plant Pot 11 repeating colours 139 shadow colours 133 still life 147 Summer Landscape 74

'hidden triangle' 147
highlights: added 9, 21, 26,44, 55, 64, 89, 99
blending 27
burnishing 67
lifting out 23, 137
reserving 31, 90
horizon line 139
Hughes, Jane: Hydrangeas 151
Hutchins, Roger: Beech Tree 140
The Old Barn 27
Old Isleworth 42
White Swan inn 144
The Window, Evening 41

l'Anson, Mari: figure sketches 135 pencil sketch 125 Illustrator 110, 111, 114, 115 layers 117 impressing 72-73 ink(s) 28 acrylic 92 and bleach 98 brush and 32-35, 131, 133 Chinese 30, 30 coloured 76-79, 147 diluted 78, 94-95 pen and 9, 28-31 printing 104, 106 oil pastel and 94-95 watercolour and 150 white 78 interiors 148-149

J

James, Bill: Ballerina 124 Winding Creek 125

L

landscape 138-139 details 142-143 pattern in 126 layers (digital) 113, 116–117 lead-in lines 138, 139 Leonardo da Vinci 27, 34 life drawing 128, 130 lifting out 23, 98, 137 light effects 149 lighting: for interiors 148, 149 for still life 146 line: with conté 24 to describe form 8 with pastel 41 varying 83 line and wash: pastels 52 pen and ink 30-31 pen and wash 82-83. pencil and watercolour 84-85 water-soluble pencil 75 watercolour and coloured pencil 86-87 watercolour and pastel 88-89 location, working on 128 lost and found edges 8, 30

Μ

markers 76, 82 Marsh, Lorna: figure drawing 133 Nude Study 12 Marsh, Lydia: Popcorn 147 masking fluid 90-91 masking tape 91 masks (digital)117 Matisse, Henri 100 media, choosing 128-129 Melegari, Carl: Lou 121 Melling, David: Woman 136 memory, training 154 Michael, Gary: Bob Muldoon 47 Sedhu 9 monoprints: colour 106-107 monochrome 104-105 Moore, Henry 92 movement, depicting 28-29 animal 154, 154 Mutimer, Ray: Hedge 138 pencil sketch 125 Water and Rocks 142 watercolour portrait 136 Mynett, David: Sunlight in the Library 149

Ν

negative image 96 negative shapes 90 notes: visual 126 written 127

0

oil bar, conté and 99 oil paints (for printmaking) 104, 107 oil pastels 54, *142* blending 56–57, 95 digital 118 and graphite pencil *131* and ink 94–95 to overlay 55 in printmaking 107 sgraffito 58–59 washing off 55 "Old Master drawing" 26–27 Oliver, Alan: postures *127* tonal sketches *126* optical mixing 10, 11, 43 overlaying: coloured inks 78–79 coloured pencils 62, 66 oil pastels 55

Ρ

Paint Alchemy 114, 114 Painter 111, 112, 112 layers 116 photographs in 118-121 Palarmarchuk-Littlewood, Natalia: Lilies 150 pastel figure drawing 130, 131 paper: for charcoal 20 choosing 12 for collage 100 coloured 12, 26, 42, 44, 46, 64 digital 113 for coloured inks 78 for coloured pencils 62, 64 for conté 24 drawing with torn 102-103, 153 for frottage 70 for impressing 72 for masking tape 91 for monoprints 104 for oil pastels 56

oil-sketching 99 pastel 12, 12, 16, 24, 54, 64,88 smooth 12, 13, 24, 78 stretching 12, 13 textured 12, 13, 16, 20, 44, 48, 92, 154; digital 120 tinting 48, 52 velour 48, 50 for wash-off 96 watercolour 12, 13, 24, 30, 48, 49, 52, 64, 78, 84, 88 pastel board 48, 50 pastel pencil 40, 42, 130, 131, 138 pastels 11, 128, 133, 135, 154 blending 42-43 tiniting 50-51 mixing colours 42-43 oil see oil pastels paper for 12, 44 vignetting 46-47 watercolour and 88-89 wet brushing 52-53 Peart, Jane: Cornfield 143 Reflections in a Shop Window 129 Thistles 61 pen see ballpoint pen; fiber-tipped pen; pen and ink; pen and wash pen and ink 134, 144 hatching and crosshatching 28, 29 implements 28

linear drawing 9, 30 with pastel 141 tonal drawing 9, 30-31 water-soluble 82 pen and wash 82-83 pencil see charcoal pencil; coloured pencil; graphite pencil; pastel pencil pencil and watercolour 84-85 perspective 132, 132 photo-editing programs 110, 112, 118-121 photographs, working from 69, 126, 142, 148 on computer 118-121 Photoshop 111, 112, 112, 114, 115 lavers 116 Photoshop Elements 110, 112, 114 photographs in 118 Pimlott, Geoff: Duck Walking 154 pixels 110 plug-in filters 114 portraits 44-45, 46-47, 136-137 postures, capturing 127, 135 printmaking 104-107 profile portrait 137

R

registration (in printmaking) 106 Rembrandt 58, 136 resist: masking fluid 90–91 oil 92 oil pastel and ink 94–95 turpentine 92 wax 92–93 Rochelle, Carolyn: Sandskrit *143*

S

sandpaper, artist's 48, 50 scanners 110 scraperboard 36-37 selections (digital) 116, 117 self-portraits 137 sgraffito 56-57, 68, 94, 99 shading 8-9 colour 10 with graphite pencil 18-19 shadow: cast 55, 130, 146 colours 133 shapes, paper (for collage) 101 sketchbook(s) 12, 126, 142, 153 software 110 Sparkes, Roy: buddliea tree 142 Foliage 54 squaring up 69 Steane, Dee: Poppies 152 still life 146 Stewart, Charlotte: ballpoint sketch 129 Standing Nude 29 **Turning Figure 32** Stewart, Elinor K.: Fountain, Aix 82 From Trevereaux Hill 49 Redhead 131 St James's Park 89 still life 146-147

floral 150-151

Т

Taylor, Martin: conté drawing 145 texture: to describing 8 digital 113, 120 of paper 12, 13, 16, 20, 44, 48, 92, 154 suggesting 92-93, 143 surface 70-71, 88, 153 thumbnail sketches 18 Titian 136 tonal contrast 142 tonal drawing 20, 31 tonal sketches 126 tonal structure 18 tone: adjusting 18, 19 building up 8-9 with coloured pencil 60-61, 62-63 with conté 24, 25 deepening 10 with graphite pencil 16, 18-19 with pen and ink 30-31 scraperboard 36 torchon 22, 66, 67 Townend, John: self-portrait 137 tracing, digital 118 tracing paper 65, 72 in collage 102, 102 transferring images 69 transparent surfaces 65 trees 140-141 turpentine 55, 56, 57 resist 92

U

underdrawing 18, 84 underpainting 86

۷

vase: drawing 150 placing 151 vector images 110 velour paper 48, 50 viewfinder 124, 125 viewpoint, high 146, *147*, 151 vignetting 46–47 visual notes 126

W

wash-off 96-97, 146, 152 washes: ink 30-31 water-soluble pencil 74-75 watercolour 82-83, 82, 84-85 watercolour: and coloured pencil 86-87, 151 drawing with 136. 145 and ink 150 and pastel 88-89 pencil and 84-85 watercolour paper 12, 13, 24, 30, 49, 52, 64, 78, 84, 88 tinting 48 watercolour pencils see coloured pencils, water-soluble wax crayons 92, 142 wax resist 92-93 weather effects 57 wet brushing with pastels 52-53 white line drawing 72-73

in printmaking 105 white spirit 54, 55, 56 Whittle, Janet: A Splash of Colour *153* Woods, Jim: pattern in landscape *126* written notes *127* written notes *127*

Х

Xaos Tools 114, 115

CREDITS

Quarto would like to thank and acknowledge all the artists who have kindly allowed us to reproduce their work in this book. All credits given in text, apart from: pp 108 Carl Melegari; pp 109 (top) Hazel Harrison, (middle) Carl Melegari, (bottom left) Mark Duffin, (bottom right) Moira Clinch.

All other photographs and illustrations are the copyright of Quarto Publishing plc. While every effort has been made to credit contributors, we would like to apologise in advance if there have been any omissions or errors.

Quarto would also like to thank those artists who demonstrated specific techniques: David Cuthbert, Ruth Geldard, Brian Gorst, Jane Hughes, Roger Hutchins, Malcolm Jackson, Jane Peart, Ian Sidaway, Terry Sladden and Martin Taylor.

The author would like to offer sincere thanks to all the artists who either carried out demonstrations or provided finished images for this book. Thanks also to Sally Bond, the Designer, and Claudia Tate, the Picture Researcher, both of whose efforts have contributed to make this such an excellent and inspirational book.